KT-440-999

# CAPTURING THE NIGHT WITH YOUR CAMERA

## How to take great pictures after dark

## JOHN CARUCCI

**AMPHOTO BOOKS**

An imprint of Watson-Guptill
Publications/New York

*Page 1:* South Street Seaport, New York City. Canon F1, 28mm wide-angle lens. Exposure: 30 seconds at *f*/5.6 on Kodachrome 64.
*Pages 2–3:* Water tower at Jones Beach State Park, Long Island, New York. Canon F1, 24mm wide-angle lens. Exposure: 8 seconds at *f*/11 on Agfachrome 100 RS Professional film.
*Page 5:* Tree at twilight. Canon EOS-1, 20–40mm zoom lens. Exposure: 8 seconds at *f*/11 on Fujichrome Sensia 200.
*Page 6:* Pulitzer Fountain, New York City. Canon EOS-1, 20–35mm zoom lens. Exposure: 30 seconds at *f*/8 on Fujichrome 100 RD film.
*Page 8:* Fireworks. Canon EOS-1, 80–200mm zoom lens. Exposure: 30 seconds at *f*/8 on Kodak Ektapress 400.
*Page 9:* Light painting with penlight. Mamiya 645, 110mm lens, diffusion filter. Exposure: 2 minutes on Kodak Ektachrome 160T film.
*Pages 10–11:* Lower Manhattan. Canon F1, 28–85mm zoom lens. Exposure: 8 seconds at *f*/5.6 on Agfachrome 100 RS Professional film.
*Pages 24–25:* Queensborough Bridge, New York City. Canon EOS-1, 80–200mm zoom lens. Exposure: 8 seconds at *f*/8 on Agfachrome 100 RS Professional film.
*Pages 62-63:* Battery Park City, New York. Canon F1, 24mm wide-angle lens. Exposure: 8 seconds at *f*/11 on Kodachrome 64.
*Pages 74-75:* Waikiki, Hawaii. Canon F1, 24mm wide-angle lens. Exposure: 8 seconds at *f*/5.6 on Kodachrome 64.
*Pages 86-87:* South Street Seaport, New York. Mamiya 645, 55mm lens. Exposure: 8 seconds at *f*/8 on Agfachrome 50 RS Professional film.
*Pages 98-99:* Annie on the Rocks, Madison, Connecticut. Canon F1, 24mm wide-angle lens, Vivitar 285 flash set on manual. Exposure: 1/15 sec. at *f*/8 on Kodachrome 64.
*Pages 124-125:* Times Square, New York. Canon F1, 24mm wide-angle lens. Exposure: 8 seconds at *f*/8 on Agfachrome 100 RS Professional film.

Senior Editor: Robin Simmen
Editor: Liz Harvey
Designer: Areta Buk
Graphic Production: Ellen Greene

Copyright © 1995 by John Carucci
First published 1995 in New York by Amphoto Books,
an imprint of Watson-Guptill Publications,
a division of BPI Communications,
1515 Broadway, New York, NY 10036

**Library of Congress Cataloging-in-Publication Data**
Carucci, John.
   Capturing the night with your camera: how to take great photographs after dark / by John Carucci.
      p.   cm.
   Includes index.
   ISBN 0-8174-3661-8
   1. Night photography—Amateurs' manuals.  I. Title.
TR610.C37   1995
778.7'19—dc20                              95-13648
                                           CIP

All rights reserved. No part of this publication may be reproduced or used in any form or by any means—graphic, electronic, or mechanical, including photocopying, recording, or information-storage-and-retrieval systems—without the written permission of the publisher.

Manufactured in Hong Kong

1 2 3 4 5 6 7 8 9 / 03 02 01 00 99 98 97 96 95

**John Carucci** is a professional photographer who works for the Associated Press. His night photographs have been published in many newspapers and magazines.

Special thanks to my wife, Kathie, for her diverse roles throughout this project; her assistance in picture editing and proofreading paled in comparison to the inspiration she provided; Robin Simmen, for having the faith in me to do it; and Liz Harvey, for helping it all make sense.

   I would also like to thank the following people who contributed to this book in some capacity: Albert, Annie, Anthony, Brian, Casmo, Charlie, Chelsea, Christine, Claudia, Courtney, Dad, Dawn, Denise, Dominick, Fran, Ilona, Janine, Joann, Kyle, Linda, Mame, Mary, May-May, Mike, Mom, Nana, Pam, Peter, Photo Guy, Roseann, Sal, Santos, Tim, and Toni.

   And thank you to everyone concerned with the production of this book.

To the memory of Frances Carucci

FOR KATHIE, JILLIAN, AND ANTHONY

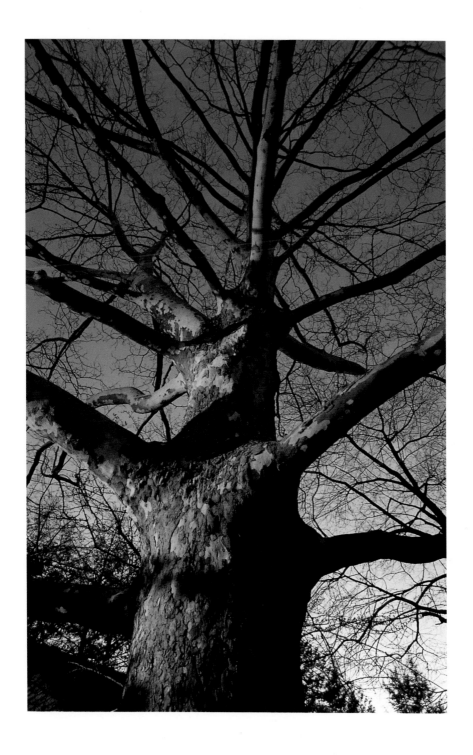

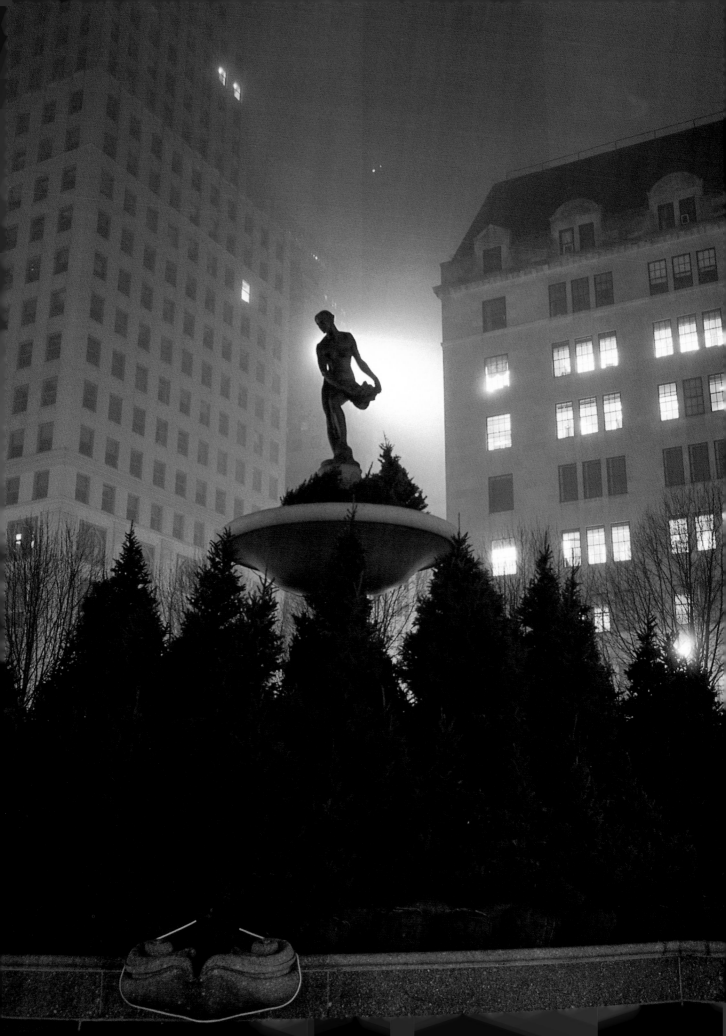

# CONTENTS

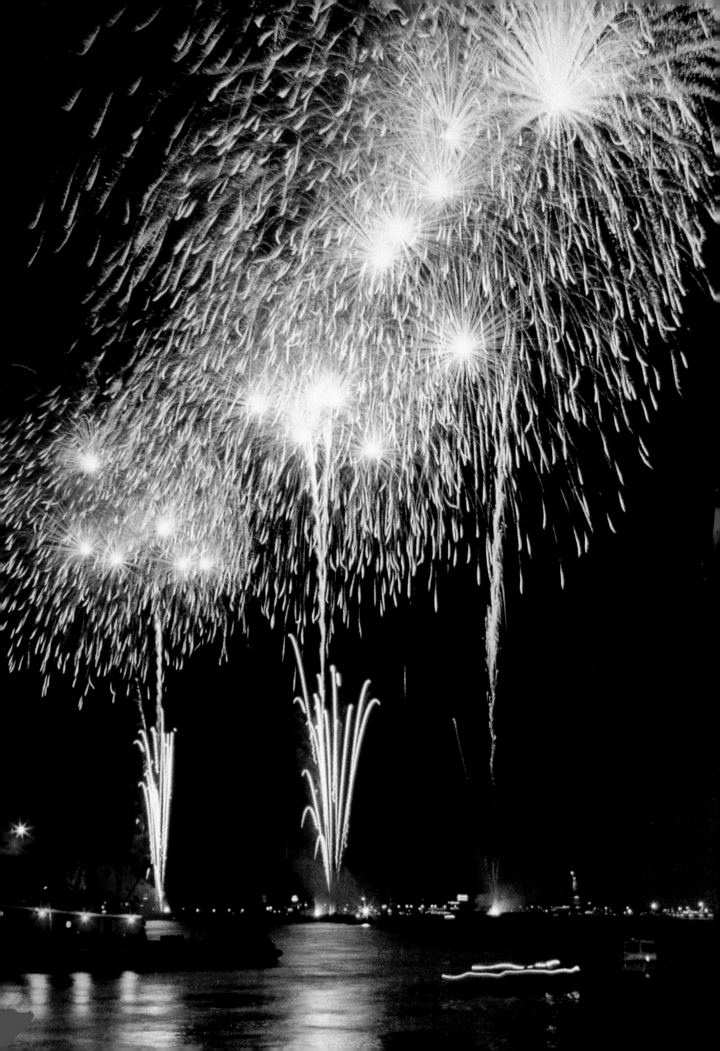

# INTRODUCTION

The potential for creative photography increases when the sun goes down. In an extraordinary way, the night becomes a great time to take a photograph. Shooting at night provides a brave new world of endless possibilities. Night photography is more an interpretation than a replication of the world. The night is devoid of a constant light source. While the moon does provide illumination, it isn't a constant light source. The moon's shape and, as a result, the intensity of its illumination differ throughout its cycle. So, because moonlight lacks the consistency of sunlight, the quality of night light is arbitrary and unpredictable. As such, photographers must rely on artificial illumination.

The night is a time when color reproduction doesn't have to be realistic to be provocative. The limited light and the length of time it takes to successfully expose night scenes frequently result in the subject becoming a collection of light. The nighttime photograph introduces you to a world where streaks of light wind through cityscapes, where ghosts may be found lurking on street corners, and where you're entranced by a city of light. Of course, if you don't want to depict the world this way, you can use electronic flash to expose your subject at a fraction of a second; this produces a true-to-life image.

You don't need a looking glass or even a crystal ball to access this dimension; all you need is a camera. Photographs become your link to the nighttime world, which is often unseen by the naked eye. The essence of night photography is to capture the mystique of darkness.

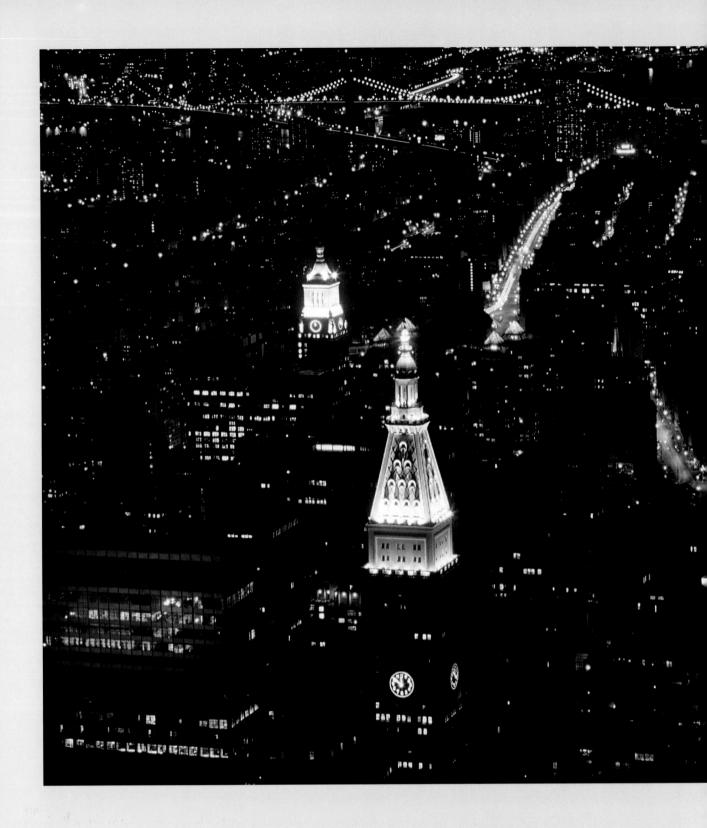

# THE MANY FACES OF NIGHT

Every exposure contains a universe that the photographer controls. Subjects that require long exposure times become a collection of light on a single frame of film. Whatever happens while the shutter is open is registered as a single image. But time isn't the only deciding factor for a successful image. Other faces—influential factors—determine the appearance of a night photograph as well.

For example, the time of night controls the color of the sky and the amount of ambient, or available, light present. Inclement weather conditions also correspond to and affect the image. Artificial illumination plays a role in the color and ratio of the light. And, of course, the type of film you choose has the final say since it reproduces the image according to its inherent qualities. The addition of electronic flash can intensify your photographs by introducing yet another element. And when you combine these variables, the results are seemingly boundless. Your ability to understand the nature of each variable, individually and together, determines the success or failure of your night photographs.

Unlike a studio situation where you have active control over the subject, lighting, and exposure, night photography assigns you a passive role in terms of controlling the light. I sometimes think of night photography as studio photography gone mad. After you seek out the subject, you must wait for the artificial lights to be turned on, for the background to be the right color, and/or for the weather conditions to be conducive before you can shoot. Night photography, then, is a challenging but fulfilling art form.

# TIME OF NIGHT

Twilight is the transition period between the day and the night. The sun has set, but some light is still present for a short time. At twilight, illumination is reflected from the sunlit portion of the atmosphere. The sun is skimming the night with light until the earth rotates farther away. The many hues of the deepening sky provide optimal conditions; unfortunately, they are present for only a limited time. Because this time period is fairly short—approximately 20 minutes—it is important for you to set up your camera and compose the scene while waiting for the best light.

As the twilight sky fades, it changes from a purplish tone to a deeper blue and finally to a dark shade. As the sky darkens, its color temperature rapidly increases. Color temperature is the measurement of light as it pertains to the Kelvin scale. Your eyes adjust to the fading light, so you don't notice subtle changes; however, film is consistent in its reproduction and records color based on the temperature of light in a scene.

By this time, no ambient light is present. But night subjects often need every last bit of available light in order to maintain detail in their darker areas. Shooting a daylight-balanced film in these lighting conditions can help. This type of film is designed to reproduce a full spectrum of color when shot either in daylight or with an electronic flash. If you're photographing daylight film in the early morning or the late afternoon when color temperature is warm, your subject will reproduce with a warm cast. Conversely, if you're using daylight film in twilight, which is similar to open shade where the color temperature is high, your subject will reproduce with a cool cast.

At twilight, your subject is dependent primarily on illumination from an artificial-light source (the only exception is occasional moonlight). In general, this isn't a problem if the subject is evenly illuminated; however, when the scene contains some dark areas or the illumination is uneven, there is a good chance that the photograph will be unsuccessful. The wide light ratio, which is the difference between light values in a scene, might be too extreme for a particular film to handle and, therefore, might result in a high-contrast image. For example, you might be faced with a 10-stop difference between the shadow and highlight areas in a scene, but the film you're using is equipped to deal with no more than a three-stop difference.

Nevertheless, if you find yourself photographing a subject at twilight and are still intent on producing a successful photograph, you'll be glad to know that some solutions to this problem exist. By isolating a portion of the scene, you can make your subject appear more evenly illuminated. Another solution is to use a flash to expose the darker sections of your subject.

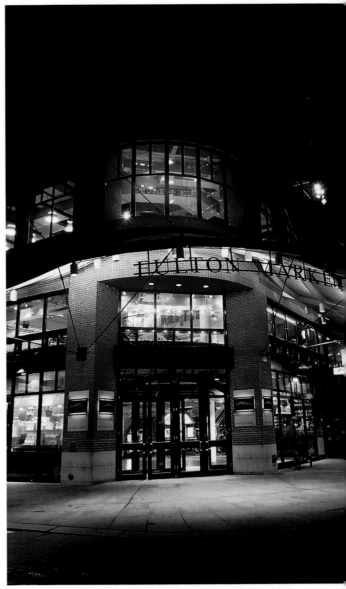

I photographed the plaza at New York City's Fulton Fish Market an hour after twilight, when ambient light is no longer present. Because this shot is dependent solely on artificial light, it has a yellowish cast. With my Canon F1 and a 28mm wide-angle lens, I exposed Kodachrome 64 for 15 seconds at *f*/11.

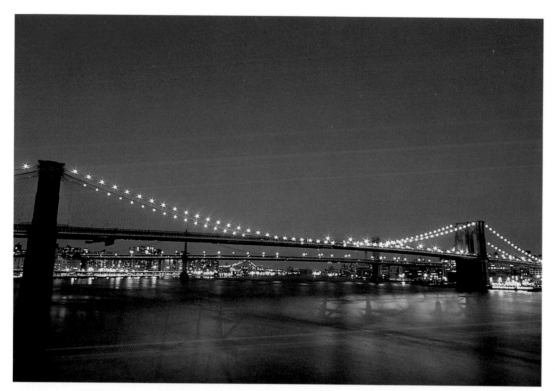

I made this shot of the Brooklyn Bridge at late twilight, at the point when the sky is a purplish blue. Basing the entire exposure on the available light in the scene, I shot Agfachrome 100 RS Professional film at f/8 for 8 seconds; I used my Canon F1 with a 24mm wide-angle lens.

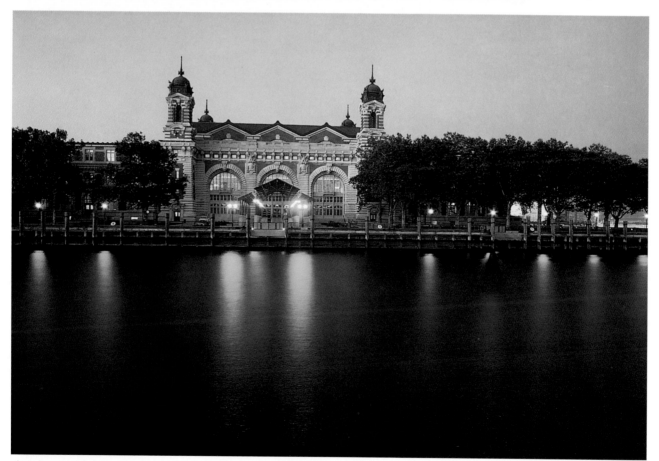

Shooting at twilight has many benefits. In this image of the Main Arrivals Building on Ellis Island taken at early twilight, the considerable amount of ambient light present enabled me to maintain detail in the dark areas of the scene. At the same time, the sky was dark enough for the subject to stand out. Here, I used my Canon F1 and a 24mm wide-angle lens, and exposed Agfachrome 100 RS Professional film for 8 seconds at f/11.

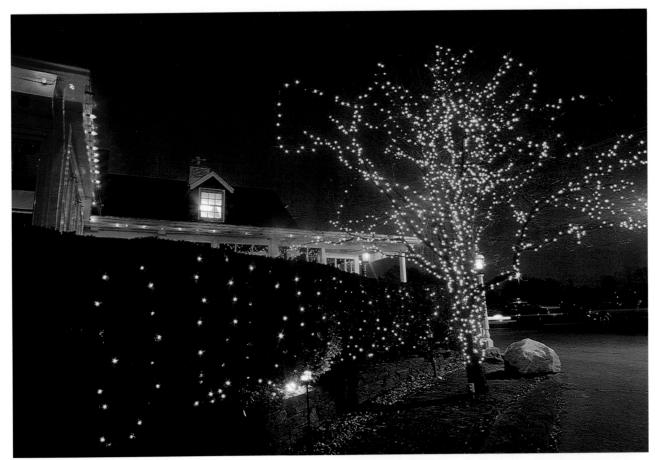

I photographed these outdoor holiday lights at the deepest time of twilight, before the sky goes dark. The subject is the light source as it stands out against the deep blue sky. Using a 24mm wide-angle lens and my Canon F1, I let the camera's internal meter determine exposure. I bracketed this frame one stop more than the camera suggested, exposing the scene at ƒ/11 for 8 seconds on Ektachrome 100.

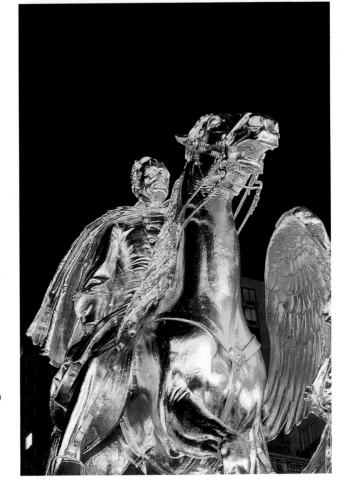

Sometimes it is possible to shoot a subject against a dark sky. This photograph works because a nearby street lamp provided even illumination. The entire statue received the same amount of light, so the presence of ambient light wasn't necessary. Working with my Canon F1 and a 100mm telephoto lens, I exposed for 30 seconds at ƒ/11 on Fujichrome 100.

# INCLEMENT WEATHER

Inclement weather conditions are an arbitrary face of night photography. Bad weather can often result in good pictures. Overcast skies, thick fog, and heavy downpours are benign. Because their photographic results aren't always predictable, it is important that you do some detective work. Observe the conditions, and keep a record of them. Then when your film comes back, you'll be able to make adjustments for the next time. And since film type plays such a big part in determining the final outcome of inclement-weather shots, I suggest using a certain film consistently. This practice will enable you to achieve more predictable results.

Another objective of inclement-weather photography is protection from the elements. Start off with a good defense to minimize the possibility of mechanical failure. Keeping yourself dry is important; keeping the camera and lens dry is essential. For example, whenever you shoot in the rain, it is a good practice to hold a large golf umbrella over the camera to prevent it from getting wet. (Naturally, this oversize umbrella protects you, too.)

I've seen many photographs ruined by apparent drops of water on the lens. When drops of water or humidity settle on the lens, they can distort the image through anything from halation, which causes unwanted halos to appear around highlights, to diffusion. A simple preventative is to check the lens for moisture after each exposure. To keep the lens dry, I use lens tissue or a nonabrasive cloth to blot, not rub, the lens dry.

Although these precautions may be a bit time-consuming, they are necessary for producing good photographs in the rain and snow. Raindrops or snowflakes on the lens can cause flare and weaken the color in a scene. The amount of time you spend checking the lens for moisture is minor in comparison to the time—and the potentially great shots—you'll lose if rain or snow is on your lens. I find these precautions to be low-cost insurance policies.

Finally, keep in mind that each weather condition is unique. As such, you must vary the approach that you take to photograph in a particular type of weather in order to achieve the image you want. Understanding the weather and its effect on film is invaluable for successful night photographs.

## OVERCAST CONDITIONS

The least problematic shooting condition occurs when the night sky is overcast; the cloud cover enables the subject to separate from the sky. On a clear night, subjects photographed against a dark sky often merge into the background. But on an overcast night, the sky is full of clouds that provide a lighter background for the subjects to stand out against. As long as these cloudy conditions remain, you can photograph throughout the night without the threat of an impossibly dark sky.

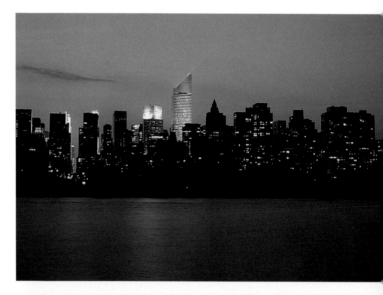

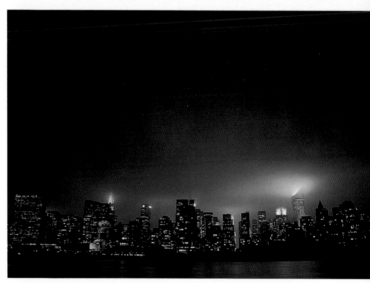

These two photographs emphasize weather conditions. Working with my Canon F1 and a 24mm wide-angle lens, I made one shot on a clear night right after the sun went down (top). The abundance of available light explains the magenta/blue cast in the scene. Here, I exposed Ektachrome 100X for 8 seconds at ƒ/11. I photographed the midtown skyline on another night during a rainstorm from the same location (bottom). The overcast sky enables the skyline to separate from the background, and the reflected light forms a glow above the skyline and adds a mystical touch. For this shot, I used my Canon F1 and a 24mm wide-angle lens. The exposure was 30 seconds at ƒ/8 on Agfachrome 100 RS Professional film.

## FOGGY CONDITIONS

Another form of inclement weather that affects your night photography is fog. Here, the atmosphere is misty, so shooting in these conditions offers the benefit of a natural diffusion filter. But fog imposes some limitations, too. For example, the farther away your subject is, the softer it is rendered on film. And as the camera-to-subject distance and the thickness and extent of the fog increase, the less defined your subject registers.

You can avoid this problem simply by carefully looking at the scene. Out of habit, photographers tend to compose fog images as if the weather conditions were normal. Keep in mind that when a portion of a scene is obscured, this approach is no longer viable. Judge each scene according to the specific weather conditions at the moment. For example, if the top of a building is partially visible and the rest of the scene is obscured, base your composition on the top portion of the scene.

## RAIN

Rainy weather provides an opportunity for producing interesting photographs. Saturated rain clouds fill the sky and act as a background. In these situations, you'll often notice a color cast, which is influenced both by the film type and by artificial-light pollution. The latter is a result of artificial illumination bouncing off low-lying clouds; this reflection of light sources is a frequent by-product of rain. These pools of intense color add zest to otherwise stagnant compositions and often become the subject itself.

Color casts are also caused by each film's own specific balance in terms of reproducing color in a scene; this characteristic is exaggerated when it comes to artificial-light sources. Suppose, for example, that you photograph a subject under tungsten illumination using two different daylight-balanced films, Fuji Velvia and Agfachrome. Fuji Velvia will reproduce the scene with a significantly warmer tone than Agfachrome will.

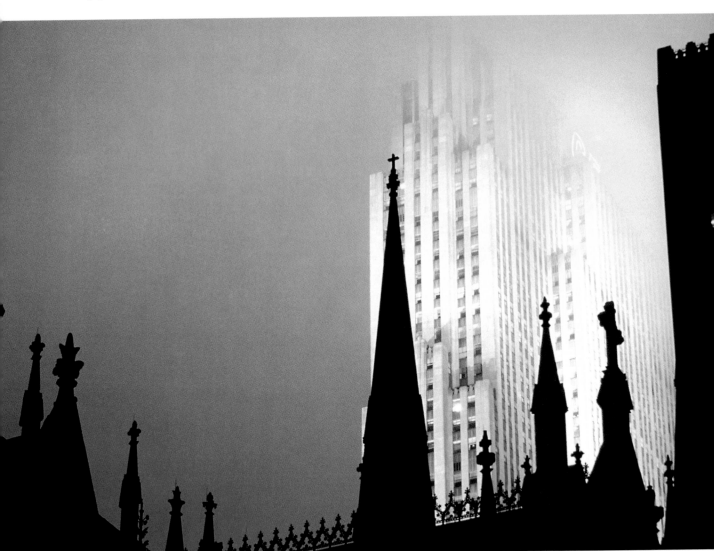

The spires of New York City's St. Patrick's Cathedral are silhouetted in dense fog. The spires are well defined, but the building in the background is heavily diffused. For this shot, I used a 50mm standard lens on my Canon F1 and exposed Agfachrome CT 100 at ƒ/11 for 20 seconds.

## SNOW

An unpredictable inclement-weather situation is the night snow scene. Nature's fallen, glistening crystals are often impossible to photograph as a neutral white because the snow takes on a color cast. The actual color depends on several variables indicative of night photography. First, you need to closely examine the color of the snow at night. You shouldn't recall it from visual memory because your eyes play tricks on you. The color of an object is defined when it is viewed under a full spectrum of color. When the spectrum is limited, the color changes yet your mind continues to recall the original color. Such colors are called memory colors.

This occurs frequently with objects with neutral tones, such as grays and whites. For example, if you view a gray object under a sodium-vapor light source, you'll detect that the illumination has a yellow-green cast. As a result, the object takes on a yellow-green color cast, too; it is no longer gray. Snow falls into this category. The best time to shoot a snow scene is at twilight when the cool remnants of ambient light make the snow appear to be blue. The overall effect is a crisper scene.

When you shoot after a rainstorm, you discover that puddles of saturated-color reflections often fill some voids in a composition. To effectively render this night subject with my Canon F1, I chose a 28–85mm zoom lens and exposed Agfachrome CT 100 at *f*/8 for 8 seconds.

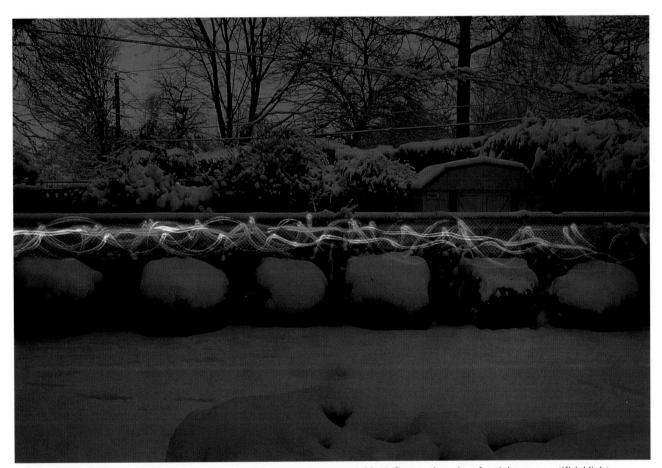

When ambient light is no longer present, one or more of the following variables influence the color of a night scene: artificial light, reciprocity failure, and light pollution. To create this shot of snow, I trudged through the scene several times while shining a flashlight with red and green gels at my camera. Working with my Canon F1 and a 28–85mm zoom lens, I exposed for 90 seconds at *f*/11 on Agfachrome 50 RS Professional film.

# ARTIFICIAL LIGHTING

Devoid of natural light, most subjects at night are illuminated by an artificial-light source. Most outdoor scenes include high-intensity discharge lamps (HIDs), each of which corresponds to a different color temperature: sodium-vapor, 2200K; mercury-vapor, 3800K; and multivapor, 3200K–5500K. And because these light sources can't produce a full range of wavelengths—a full spectrum of color—there is never a critical color correction. In fact, most HIDs produce only one color that affects subjects. For example, sodium-vapor lamps have a yellow cast, and mercury-vapor lamps have a green cast. Naturally, when the dominant cast is subdued, the result is a colorless image. This color-cast problem is intensified when a scene contains more than one form of artificial illumination.

Fluorescent lighting is a common form of interior artificial illumination. Keep in mind that even if you're shooting a building exterior, the structure's interior illumination is the primary light source in the picture. In fact, the glow of fluorescent light in each window is essential to the photograph. There are at least seven types of fluorescent bulbs, each with its own color. These range from green to cyan. As you study your subject and compose your shot, you'll often notice that the color of the fluorescent light differs from floor to floor, which adds to the random quality of the cityscape.

Tungsten lighting, another artificial-light source, is sometimes used for outdoor illumination but it is primarily an interior light source. As an incandescent-light source—this light is created as a by-product of heat—tungsten lighting is able to produce a full spectrum of color. You can achieve this either by using film specifically balanced for tungsten light or by using an 85-series filter with daylight-balanced film. Tungsten light plays a critical role when I shoot one of my favorite subjects, a private house at twilight. Because of the tungsten light in every window, the house glows from inside against the cool blue sky.

But regardless of the light source—natural or artificial—you need to understand the physical properties of the light in order to successfully capture it on film. (Refer to the artificial-lighting chart in Chapter 4 for specific information on correct filtration and appropriate film choices.)

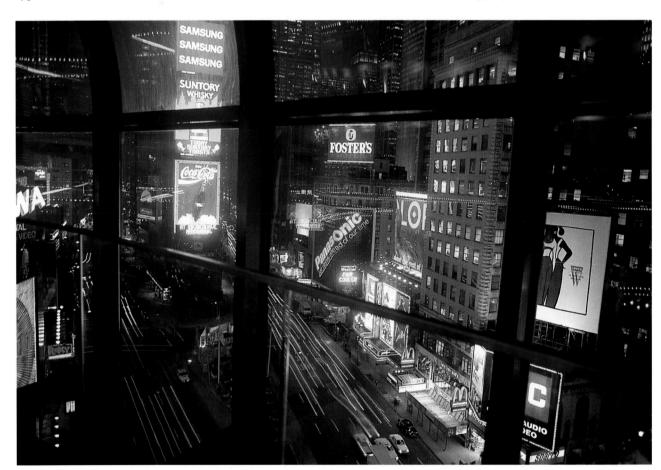

I made this shot from a window overlooking Times Square. To determine exposure, I took a reflected-light reading of the scene. With my Canon F1 and my 28–85mm zoom lens, I shot Agfachrome 50 RS Professional film at f/5.6 for 10 seconds.

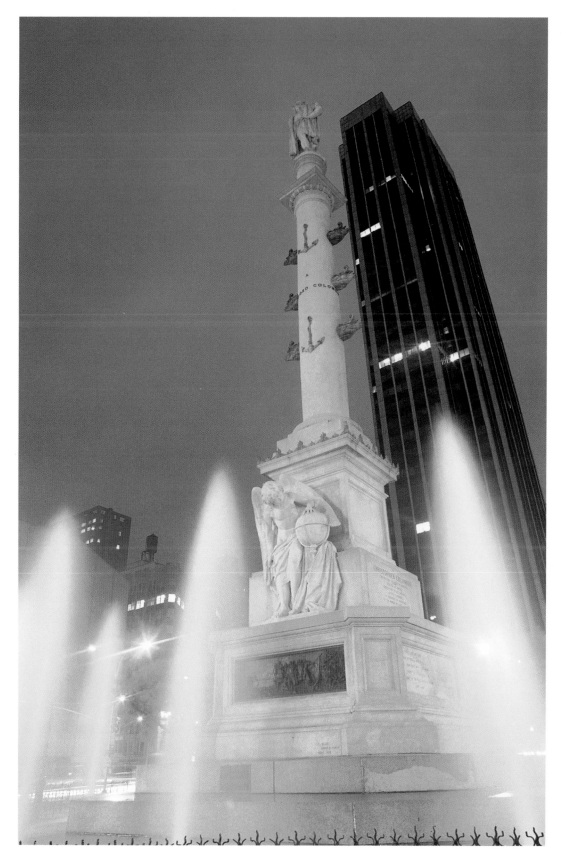

This shot of New York's Columbus Circle at twilight reveals the temperature of its light source; a sodium-vapor lamp caused the yellow rendition. When you photograph a subject that is illuminated by a warm light source at twilight, the rich blue color of the sky complements it. Here, I used my Canon F1 with a 28–85mm zoom lens. The exposure on Agfachrome 100 RS Professional film was 8 seconds at ƒ/8.

# LENGTH OF EXPOSURE

Unlike shooting in daylight or with flash with their typical exposure times of a fraction of a second, shooting at night requires exposure times that range from several seconds to several minutes or even longer. All that happens within the camera's view is collected on a single frame. A variety of results is possible; these depend on the length of time the shutter remains open. Passing cars become streaks of light, people become blurs, and stars—celestial bodies, not celebrities—become a series of streaks after 15 or 20 minutes. What entrances me is that each photograph becomes a random collection of light that can never be duplicated in exactly the same way.

The long exposure times night photography demands enable you to introduce optional elements into your images. For example, you can increase the exposure on dark portions of a scene via an electronic flash. Alternatively, you can fire off a series of flash pops to simulate a motion sequence when exposure times are longer; each time you trip the flash, it freezes the moving subject. By doing a series of flash pops, you capture the subject in different stages of motion. And when exposure times are several minutes long, you can even walk into the scene and highlight your subject with a flashlight. For example, you might decide to call attention to a street sign via localized illumination.

But when exposure times exceed several seconds, reciprocity failure becomes a concern. Because the film no longer accumulates density—absorbs light—at the same rate, the color layers of the film's emulsion aren't exposed equally. This leads to a color shift. As the initial exposure increases, the color balance is altered. This dominant color cast varies among film brands. Also, each color film responds differently to reciprocity failure, so no general corrective filtration exists. With professional films, suggested filtrations are printed inside the film box. This is a good starting point because both the shooting conditions and the artificial light source(s) influence the color cast.

Kodak Lumière, for example, is a neutral-based film that can successfully handle exposure times of up to 10 seconds with color correction. Longer exposure times require a 5CC (color-compensating) blue filter because the blue layer, which is yellow-sensitive, doesn't receive the same exposure as the other two film layers. Kodachrome 64, on the other hand, requires a filter correction for exposure times that exceed 1/10 sec. A 5CC red filter compensates for the cyan cast, which results from the red-sensitive emulsion layer not being exposed at the same rate as the blue and green layers. Clearly, color casts usually aren't detrimental to night photography when their effects are understood and manipulated advantageously.

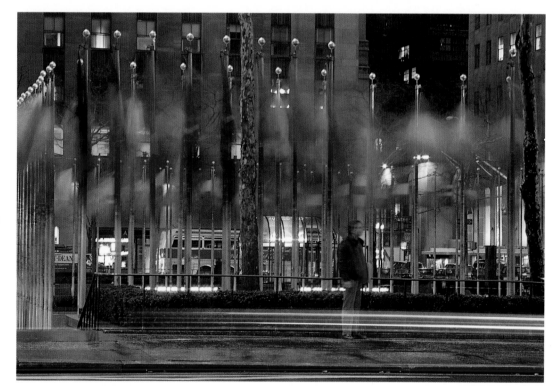

The duration of a night photograph often becomes a collection of time and light. The only elements of this Rockefeller Center scene that aren't in motion are the balls on top of the flagpole and the sidewalk. Shooting with my Canon F1 and my 28–85mm zoom lens, I exposed Agfachrome CT 100 for 15 seconds at ƒ/8.

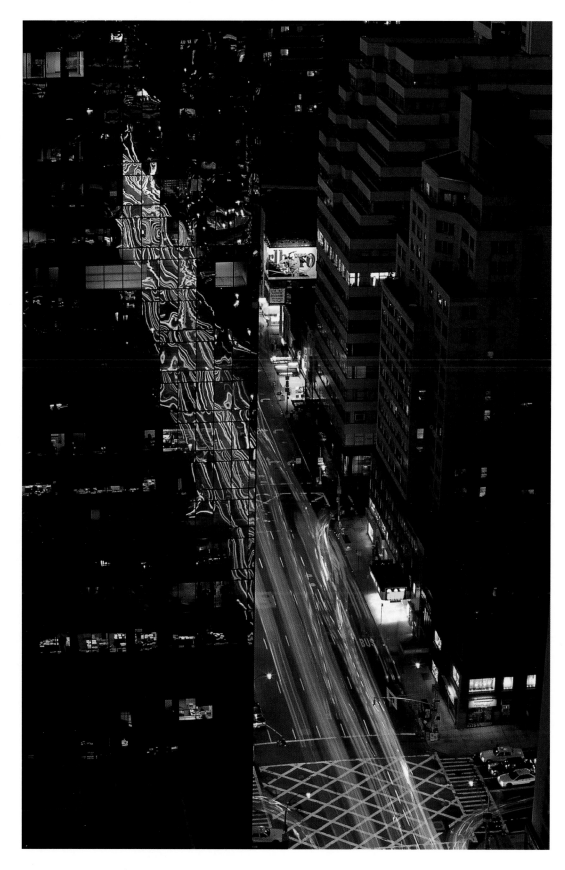

By shooting long exposures of night subjects, you can accumulate extended amounts of time on a single frame of film. In this picture, the lengthy exposure transformed traffic patterns into streaks of light. Working with my Canon EOS-1 and an 80–200mm zoom lens, I exposed Ektachrome 100 for 45 seconds at *f*/11.

# FILM

Film is perhaps the most crucial link in the many faces of night photography since it is a variable that supersedes any prevailing conditions. With the extensive diversity of film types and speeds available on the market, it is important to find the "right" film for each situation. Although I use slide film for most of my night photography, I think that it is beneficial to begin with color-negative film; this type of film is more forgiving because it offers five additional stops of exposure latitude. So, if a color-negative film is underexposed by two stops or overexposed by three stops, achieving a satisfactory image will still be likely.

Despite this advantage, I prefer slide film, even though it has an exposure latitude of only 1 to $1^{1}/_{2}$ stops. There is no color or tonality (see below) discrepancy with slide film: what you see in the scene is what you record. I find that too many variables in terms of a scene's color or tonality come into play when I shoot negative film. While it true that these films can be adjusted for a specific color balance during the printmaking stage, that color choice is subjective. So, unless you do your own printing, you'll lose control of the final image.

In addition, each film has a distinct quality. People often assume that films with different speeds, which are indicated by ISO ratings, behave differently, but the real misconception occurs when they believe that all daylight-balanced films with the same ISO rating respond the same way. The many kinds of slow-speed daylight film provide a wide range of color balance and other characteristics. You'll find that certain brands are best for use with a specific type of light or weather condition.

Tonality and grain structure vary among the different film speeds as well. With the advent of new grain structures and emulsion layers, films with the same ISO rating can produce completely different results in terms of both color and grain. The tonality of a film determines how it reproduces a subject in regard to contrast, color balance, and resolution. The other critical characteristic of film is its grain structure. This refers to the size of the silver halides that make up a film's emulsion. Naturally, a fine-grained film has smaller halides than a coarse-grained film. And once again, a film's ISO rating doesn't guarantee a predictable, specific result. For example, Kodak Lumière, an ISO 100 film, has a finer grain structure than other ISO 100 films have.

Film choice is quite subjective. No two color films are exactly alike, so the only way to decide which is best for you is to try them out in various shooting situations. Cool films, such as Ektachrome or Agfachrome, seem to handle artificial-light conditions rather well. And these films are less apt to exaggerate the yellow or green cast of artificial light than warm films, such as Fujichrome Velvia. But Velvia reproduces scenes with more color saturation. I regularly use Kodak Lumière 100 because its all-around tonality, coolness, and almost nonexistent grain structure

make it a great choice for most night-photography subjects. Remember, a film's color balance shouldn't stop you from using that particular film if you like some of its other qualities; CC filters enable you to customize the color balance of any film type. Finding the right combination is merely a matter of experimenting.

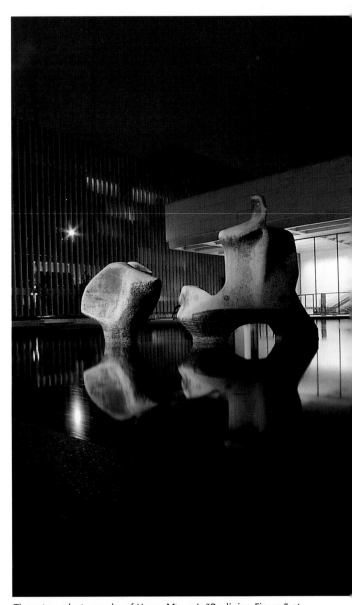

These two photographs of Henry Moore's "Reclining Figure" at Lincoln Center differ even though I shot them within minutes of one another, without filters. For one shot, I used Fujichrome Velvia and exposed for 20 seconds at ƒ/8 (right). The result is considerably warmer, sharper, and more saturated than the shot I made with Agfachrome CT 100, which has a cool magenta cast (above). Here, I exposed for 15 seconds at ƒ/8. Even though the cooler picture is darker overall, the highlight areas on the sculpture are almost washed out. The interior lighting in these two photographs also reveals the predominant color casts. Although I feel each of these two images is usable, films vary greatly, so the only way to successfully shoot at night is to understand the characteristics of your film type.

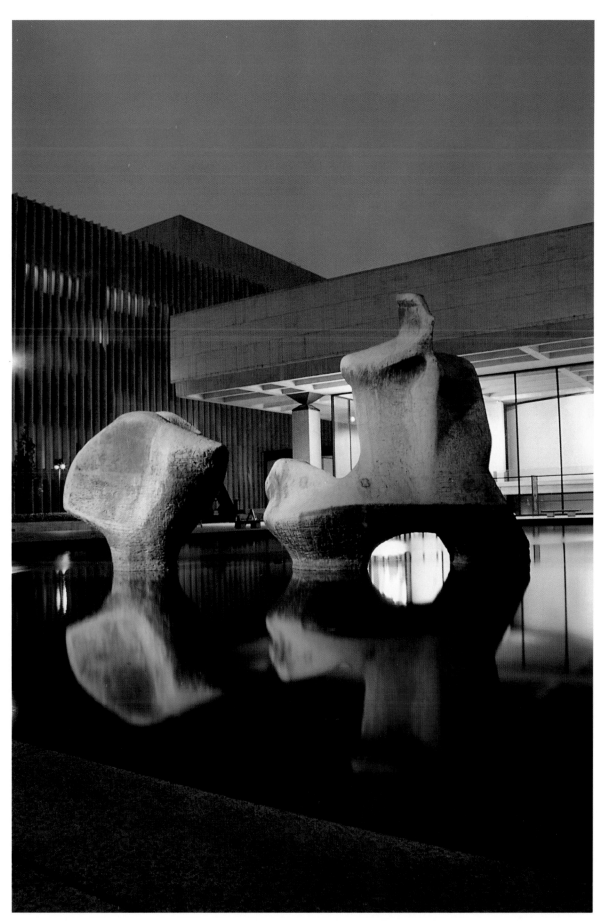

# FLASH

Electronic flash is the exact opposite of long exposures. In this world, bursts of light that last only 1/2000 sec. are able to illuminate a subject. Flash provides you with the luxury of bringing light to inadequately or ineffectively illuminated scenes. The importance of using electronic flash for night photography is twofold. First, it is a necessity for photographing people because "breathing" subjects are incapable of staying completely still for several seconds. Second, the light from a flash unit produces a full spectrum of color, which is something that other forms of artificial light can't do.

People need to be illuminated by electronic flash at night for several reasons. The lengthy exposure times aren't conducive to creating a sharp photograph. While it is true that you can use a fast film with an ISO rating of, for example, 1600, this will produce grainy images. And unless you're shooting a close view of the subject, much of the detail in the scene will be lost.

Another factor to consider is that the illumination from an artificial-light source is rarely flattering. In addition to producing a full spectrum of color, electronic flash can control both the quality and direction of light. If you photograph another person under artificial light using a daylight film, the following will happen. A sodium-vapor light will provide a yellow-green flesh tone, a mercury-vapor light will produce a green or cyan flesh tone, and a tungsten bulb will produce an orange flesh tone. But if you use an electronic flash in these situations, you'll be able to override the existing light and provide a light temperature similar to that of daylight.

When shot at night, inanimate objects benefit from electronic flash, too. Suppose you use flash for a statue illuminated by a sodium-vapor light source from a distance of 10–20 feet—depending on the flash unit's output—the statue will exhibit its daylight color. [A flash unit with a guide number (GN) of 120 is adequate for this distance; see page 116.] But the color of the rest of the scene will still be influenced by the artificial light. And when you combine flash with a long exposure time, you can create an image that simultaneously renders "two time planes." In the final photograph, the subject is frozen, yet the surrounding world reveals a passage of time. For example, during an 8-second exposure, a person photographed on a brightly lit avenue will be frozen by the flash. The traffic, however, will reproduce as red and white streaks. With the exception of the primary subject, the whole world appears to have moved.

The blending of these major elements of night photography permits each photographer to capture night subjects based on an individual interpretation of them. Furthermore, photographers can take advantage of other variables to personalize a scene. Alternative effects, such as colored filters, multiple exposures, and various processing techniques, all expand the faces of night.

I made this shot of Isamu Noguchi's "News" shortly after dark. I used flash in order to override the artificial light. For this closeup, I chose my Canon F1, a 28–85mm zoom lens, and Ektachrome 100.

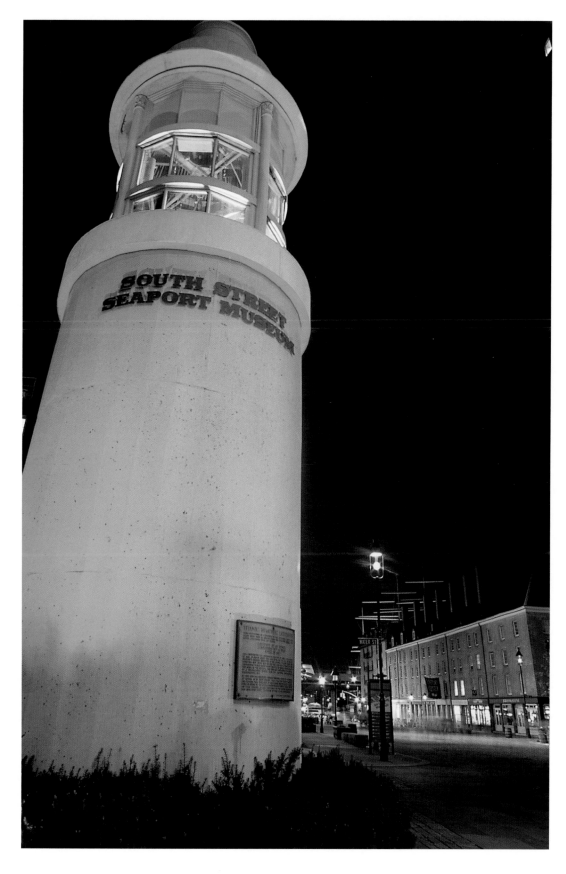

Long exposure times enable you to step into a scene and provide specific areas with supplemental illumination. I used several pops of flash for this shot of the lighthouse at New York's South Street Seaport. Because I was shooting tungsten film, the flash bathed the subject with a bluish cast. A wide-angle lens enabled me to get close to the subject and to exaggerate the size of the lighthouse in relation to the background. With my Canon F1 and a 24mm wide-angle lens, I exposed Fujichrome 64T for 15 seconds at *f*/8 and used three pops of flash from my Vivitar 285.

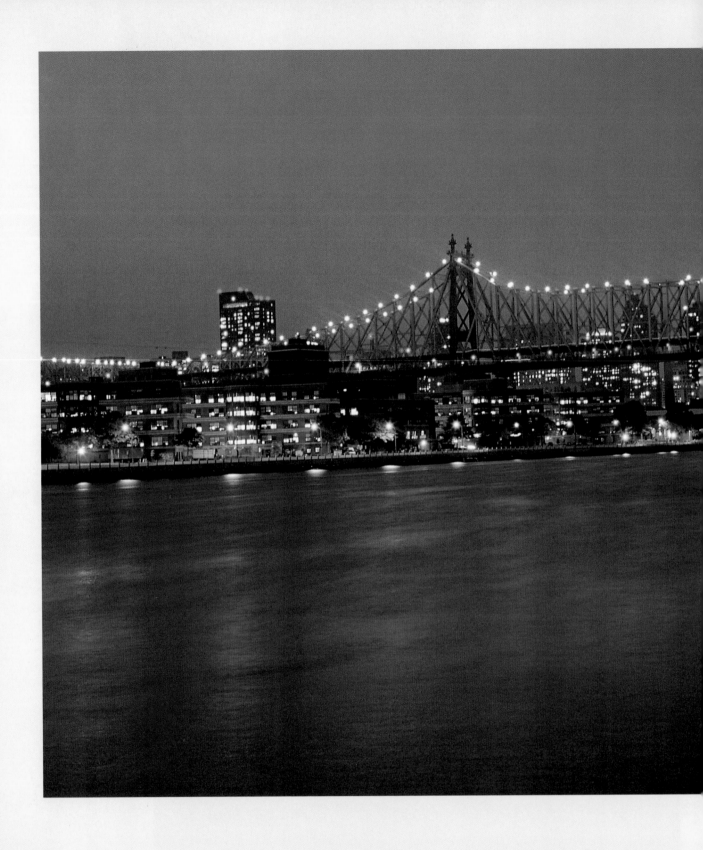

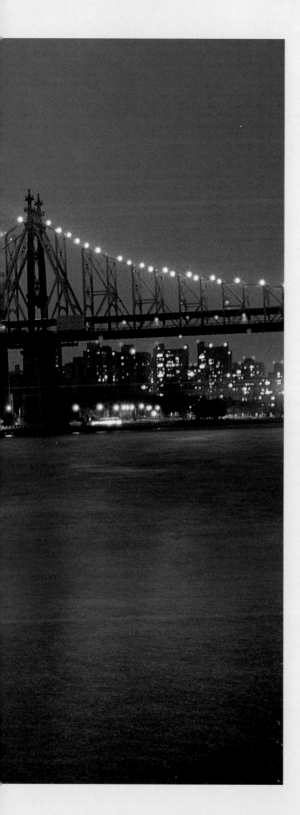

# CHAPTER TWO

# EQUIPMENT

The first piece of hardware a photographer thinks about is the camera, but the most influential tool is the photographer's mind. It isn't the sophistication of the equipment that creates a compelling photograph, but the ideas in your imagination. Still, the only way to translate your cognitive inspirations to film is to understand all of your camera equipment.

The evolution of camera technology has changed some of the photographer's concerns, and for the most part the picture-taking process has been getting easier, thanks to today's cameras and film. When you hold your camera, you have in your hands the technology of a sophisticated photographic computer—one that can assess all the characteristics of a scene and render a technically perfect image. Automatic focus, metering, and multiple-exposure modes put complete control at your fingertips and easily enable you to capture the average scene. Unfortunately, night shots are rarely average. This is why mastering the fundamentals of your equipment is the first step in successfully creating nighttime images.

You'll find that most gear needed for day photography can be used in some capacity for night photography; the only difference is in the way they're used. Also, while some pieces of equipment are optional during the day, they are critical at night. For example, a tripod is necessary at night because the limited light conditions call for exposure times that go beyond the handheld range. And sometimes long exposures require the use of electronic flash.

# CAMERAS

You can produce a night photograph with almost any type of camera; however, you'll have the most control if you work with a camera that permits you to manually determine exposure. Photographers have created extraordinary night images with every camera format, from 35mm cameras—today's most popular cameras—to 2¼ roll-film cameras, to 4 × 5 view cameras, to 8 × 10 view cameras. Although an 8 × 10 view camera provides the largest images, its size and lack of mobility often make it impractical. While a 35mm camera results in images that are more than 50 times smaller than those produced by the 8 × 10 view camera, it offers photographers the most control. So, the 35mm camera is the most logical choice for night photography.

In its most basic form, a camera is a light-tight box with a pinhole that lets some light in; it requires a light-sensitive material to expose in order to produce images. Although this model of a camera is perhaps crude, it is still functional. Today's sophisticated cameras are nothing more than feature-packed, light-tight boxes. Two types of 35mm cameras are available: the single-lens-reflex (SLR) camera and the rangefinder camera. The SLR system consists of a camera body, a variety of interchangeable lenses, and assorted accessories. The camera body is the heart of the SLR system. It houses all the controls and adjustments for the shutter, automatic-exposure modes, and viewfinder information. The camera's through-the-lens (TTL) viewing confirms sharp focus and provides precise image framing, which enable you to more effectively compose while using each focal length. A rangefinder camera's viewfinder is located above the lens and, as a result, can't see through the lens. But 35mm rangefinder cameras do have an advantage over 35mm SLR cameras. Their quiet operation make them preferable for photographing stage performances.

Although each 35mm SLR camera has different features, the various SLR systems have many similarities. These include:
- An eye-level viewfinder
- TTL viewing
- A focal-plane shutter, which is a shutter curtain that lies across the film plane and sweeps across the frame during exposure

- A shutter-control dial, which determines the duration of the exposure (see below)
- A built-in means for measuring light, ranging from match-needle metering, to the most contemporary, multisegment metering (see below)
- A hotshoe for mounting a flash on the camera
- An exposure-compensation dial.

The shutter-control dial dictates the length of an exposure. Some cameras offer shutter speeds as fast as 1/8000 sec. and as slow as 30 seconds. The "B" or "Bulb" setting is also indicated on the shutter-control dial.

Match-needle metering is a way to measure exposure through the camera by adjusting the shutter speed and/or aperture setting until the needle in the viewfinder indicates the proper exposure. Multisegment metering is a more sophisticated way to determine exposure. This mode divides the image in the viewfinder into segments. The actual number of segments differs with each camera manufacturer, but cameras usually have six or eight segments. Each section of the scene is then analyzed independently from the others via the camera's databank. It looks for patterns of situations that would ordinarily fool the light meter, such as backlighting.

Newer 35mm SLR cameras have many other computer-oriented functions that provide some or all of the following features:
- Automatic-exposure modes, such as shutter-priority, aperture-priority, and program-exposure
- An autobracketing mode that exposes three consecutive frames at different settings of ½- to ⅓-stop increments
- Autofocus
- An autofocus assist beam
- A built-in motordrive
- TTL operation for metering and flash control
- A light-emitting diode (LED) readout.

Some newer 35mm SLR cameras also permit photographers to choose from several metering patterns. These include:
- Center-weighted metering
- Multisegment metering
- Partial-spot metering
- Spot metering.

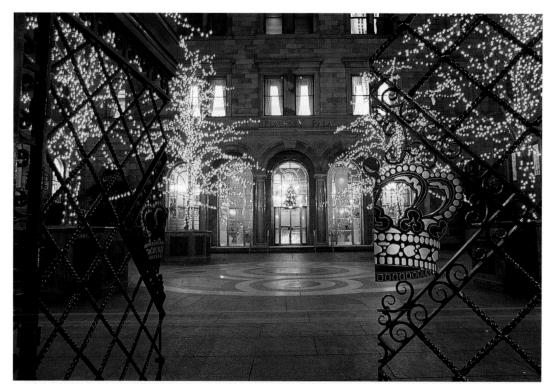

One night after work, I came across this hotel courtyard. I was so intrigued by the illumination that I decided to photograph the scene. I exaggerated the warmth of the artificial lighting via my film choice. Shooting with my Canon F1 and a 24mm wide-angle lens, I exposed Fujichrome 100 RD Professional film for 20 seconds at ƒ/8.

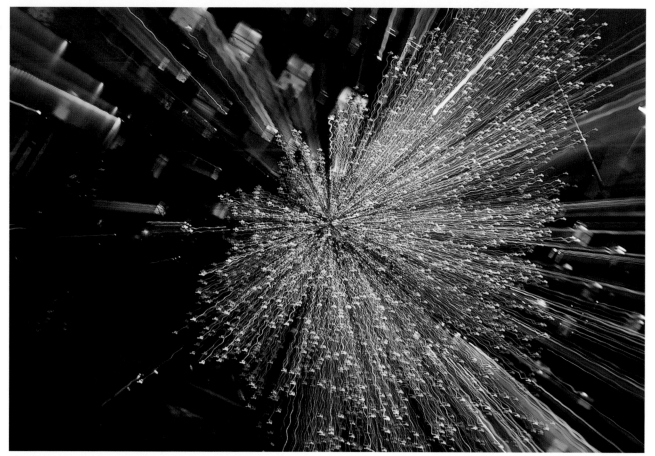

This Christmas tree was transformed into a set of light streaks when I changed my lens' focal length from 200mm to 80mm during a long exposure. Tilting the horizon helped exaggerate the effect. With my Canon EOS-1 and my 80–200mm zoom lens, I exposed Fujichrome Velvia for 4 seconds at ƒ/11.

# AUTOMATIC-EXPOSURE MODES

The automatic-exposure modes aren't always the best choice for night photography. When your camera selects the shutter-speed and aperture settings, you can't dictate how your subject will look in the final image. For example, you can't control depth of field because the camera may select an aperture that is inappropriate. Depth of field in a scene increases when the aperture setting is high (i.e., *f*/11) and decreases minimally when the aperture setting is low (i.e., *f*/4). The camera doesn't know your intention, so it chooses an aperture setting on its own.

Similarly, when the automatic-exposure mode selects the shutter-speed setting, it isn't aware of how you want the subject to be rendered on film. A slow shutter speed of several seconds may be appropriate for capturing the passing taillights on cars, but not for stopping the action of a football player. If the situation were reversed and your camera chose a faster shutter speed, the cars would appear to be stationary objects rather than streaks of light, and the football player's movements would be frozen. Of course, another possibility exists: the camera might select a shutter speed of 1/60 sec., which is an all-purpose, handheld shutter speed. As a result, neither subject would be rendered correctly.

You should also keep in mind that high-contrast night scenes can fool the camera's exposure meter. Exposure meters work by averaging all of the light values in a scene to an 18-percent-gray tone. This is an accurate method for determining exposure during the day, but it isn't as precise at night. Another possible problem is that automatic-exposure modes don't account for reciprocity failure. Whenever an exposure time is longer than one second, film no longer acts in a predictable manner. The sensitizing of the film's emulsion doesn't develop quickly enough, and underexposure results.

Despite these potential concerns, you can gain an advantage several ways when using automatic-exposure modes at night. Changing the density of the film through exposure compensation can resolve some dilemmas by increasing or decreasing exposure while still in the automatic mode. The exposure-compensation dial can adjust automatic exposure in ¹/₃- to ¹/₂-stop increments as well as in 2-to-3-stop intervals in either direction. Another function of the more sophisticated cameras is autobracketing. This feature enables you to shoot three consecutive frames at preselected densities with one touch of the shutter button. This function ensures that one of the three exposures will have the correct density. These functions help photographers use automatic-exposure modes at night to their fullest capacity; however, there is no substitute for understanding the fundamentals of photographic exposure.

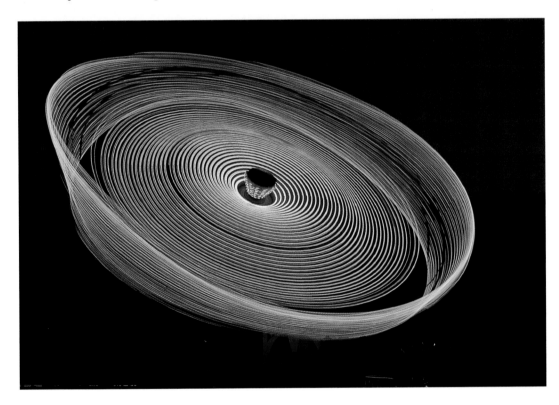

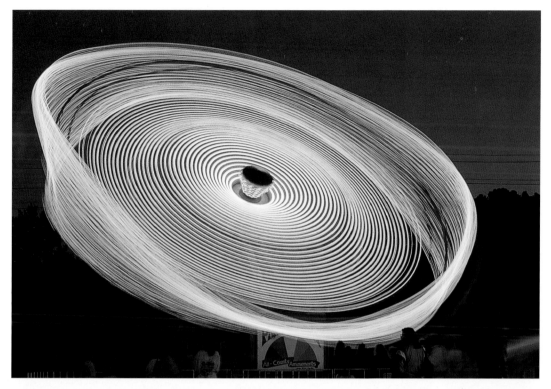

Autobracketing is a useful feature that enables you to capture three or more consecutive exposures of one subject with just one push of a button. When I came across this Tilt-a-Whirl ride, I knew that it was an ideal candidate for autobracketing. Shooting with my Canon EOS-1 and an 80–200mm zoom lens mounted on a tripod, I set the camera on shutter-priority mode. Programming the camera to shoot three exposures, one stop apart, I exposed Fujichrome Velvia for 8 seconds at *f*/22 (far left), *f*/16 (top left), and *f*/11 (bottom left). The streaks of light become wider with each successive increase in aperture size.

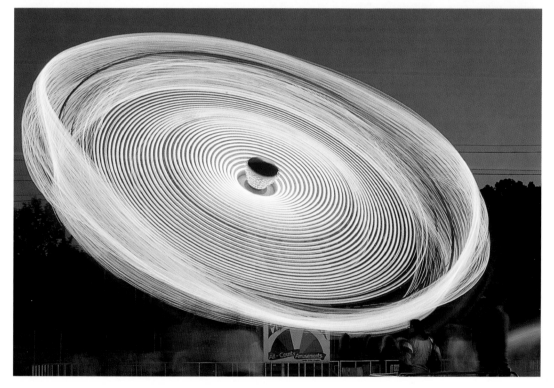

## SHUTTER-PRIORITY MODE

With this automatic-exposure mode, the photographer sets the shutter speed, and the camera then selects the appropriate aperture setting for that exposure value. In this mode, depth-of-field control is passive.

## APERTURE-PRIORITY MODE

With the aperture-priority mode, the photographer determines the aperture setting, and the camera chooses the appropriate shutter speed for that exposure value. In this mode, control over the duration of the exposure is passive.

## PROGRAM-EXPOSURE MODE

If you opt for this automatic-exposure mode, the camera will select both the shutter-speed and the aperture settings. When you use the program-exposure mode, an indicator usually tells you if the shutter speed is too slow for you to handhold the camera.

## EXPOSURE COMPENSATION

This feature enables you to manually alter the density of automatic exposure over a 2- to 3-stop range in either direction, usually in $1/2$- or $1/3$-stop increments.

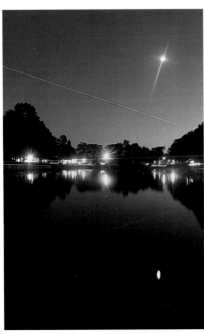

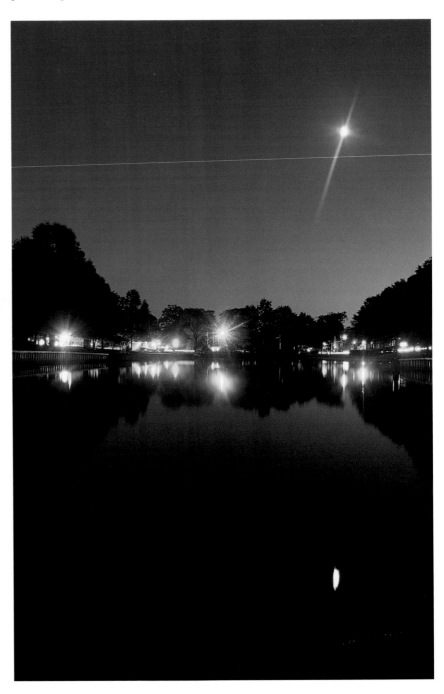

Because of the nature of long exposure times, extraneous activity can invade the frame. These photographs are identical, except for the airplane's light trail. After noticing that it passed through the 45-second exposure (above), I shot another frame in order to eliminate it from the final image (right). Working with my Canon F1 and a 24mm wide-angle lens, I exposed at $f$/11 on Kodak Lumière 100X.

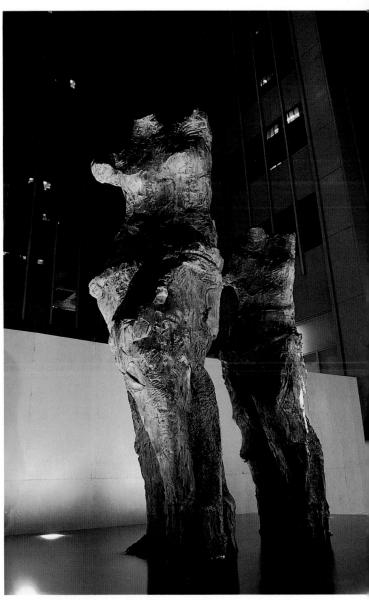

The aperture-priority mode provides the ease of automatic exposure by enabling you to select the aperture setting while the camera selects the shutter speed. This mode is helpful when you want to control depth of field in a scene. Here, the tree in the top portion of the frame was about 20 feet away from the camera, while the building was several hundred feet away. Despite this difference, the tree and the building appear equally sharp because the aperture setting produced maximum depth of field. Shooting with my Canon EOS-1 and a 50mm standard lens, I exposed Agfachrome CT 100 at an aperture-priority setting of *f*/22.

To effectively record Jim Dine's "Looking Toward the Avenue" sculptures on film, I used my Canon EOS-1's program-exposure mode. As a result, the overall image is slightly underexposed, but the highlight details are perfect.

## THROUGH-THE-LENS FLASH METERING

TTL flash metering provides a more accurate means of automatically determining the necessary strength of the flash than metering with a unit mounted on top of the camera. With TTL flash metering, the intensity of light is measured through the camera lens rather than controlled by a sensor on the flash unit, and is automatically cut off when enough light is produced.

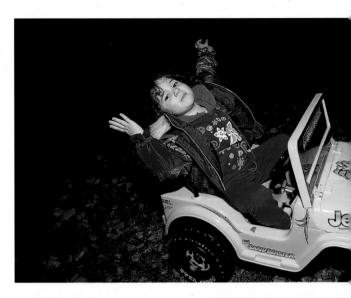

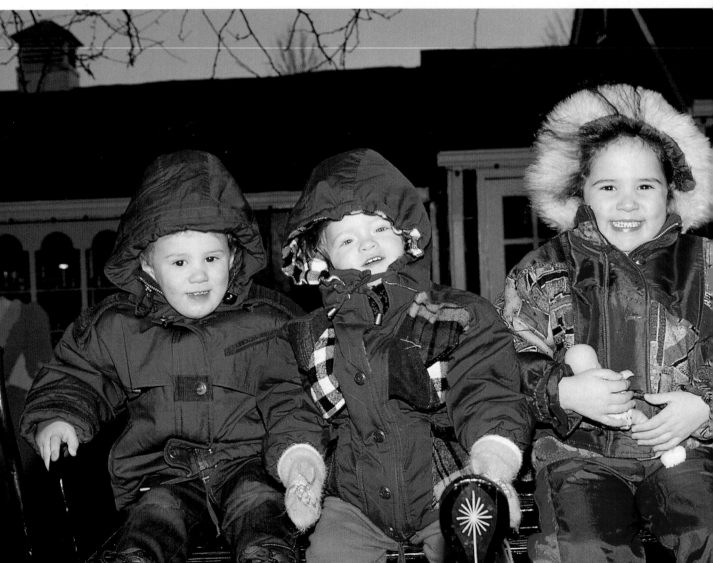

TTL flash metering simplifies the process of matching the amount of flash required by the available light in a scene to that source of illumination. For this portrait of a friend, which I shot in a city plaza, I used my Canon EOS-1 and a 50mm standard lens (right). I set my Canon 430EZ flash on TTL and exposed for 1/30 sec. at ƒ/8 on Fujichrome Velvia. I photographed these three children at twilight on a cold winter night (bottom). Here, I used direct flash and a slow shutter speed. Shooting with my Canon EOS-1, a 50mm standard lens, and a Canon 430EZ flash set on TTL, I exposed Kodachrome 200 film for 1/15 sec. at ƒ/8. For this candid shot of my daughter, Jillian, sitting in her bright yellow jeep, I chose a telephoto zoom lens (top). With my Canon EOS-1 set on program, an 80–200mm telephoto zoom lens, and a Canon 430EZ flash set on ATTL, I exposed Fujichrome Velvia for 8 seconds at ƒ/5.6.

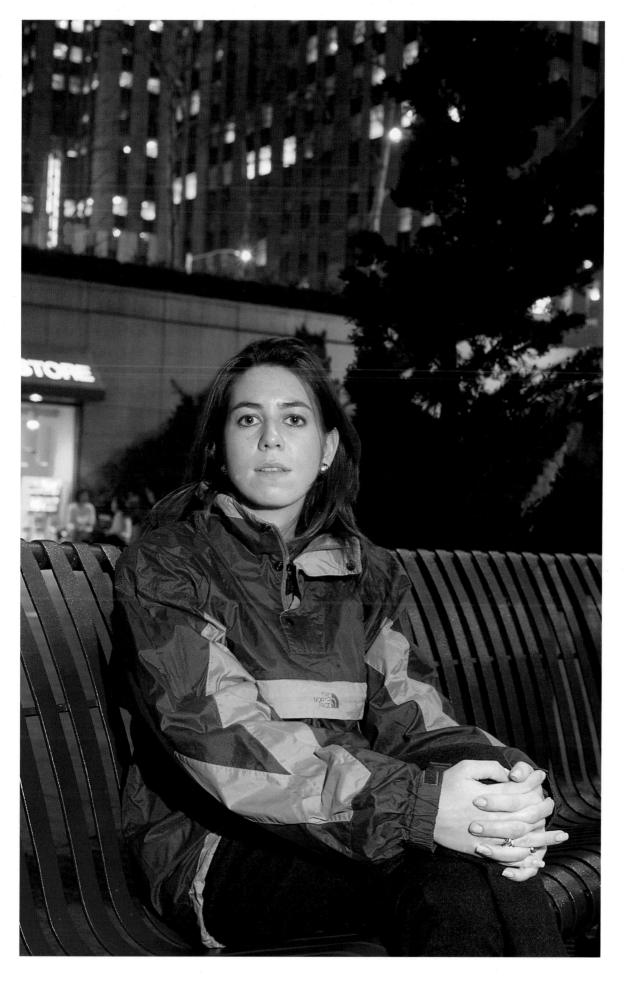

# AUTOFOCUS CAPABILITIES

Photographers often experience a certain magic when they look through the viewfinder and discover the virtues of their camera's autofocus functions. The first time I used an autofocus feature, I focused on objects in the distance and then on objects close by. I repeated this over and over, wondering how the autofocus function worked and whether or not it was practical. The "whirrrr . . . beep" sounds became music to my ears as I continued to lightly touch the shutter-release button and watch the viewfinder image jump into focus. Autofocus capabilities seem more appropriate for capturing moving subjects, namely people, than for shooting long exposures of inanimate objects. Autofocus has also increased the proficiency of many photographers, at least in terms of producing sharp images on film.

In addition, while autofocus isn't always required for night photography, it can come in handy. Night scenes are filled with both animate and inanimate subjects. The autofocus function enables you to increase the percentage of sharp images whether you're shooting musical performances, sporting events, or candid portraits. Each time the subject moves, the camera automatically refocuses, thereby eliminating human error and ensuring a sharp image. This is especially important when you work with a 200mm or 300mm telephoto lens; because of the increased magnification of the subject, focus has to be exact. And while inanimate objects, such as illuminated office buildings, aren't as dependent on autofocus as moving subjects are, autofocus can make it easier for you to effectively record them on film. But remember, autofocus is only a choice; you can switch your camera to manual while taking full advantage of its other features.

The quality and functions of autofocus differ with each camera and within the various price ranges for cameras. Basically, there are two types of autofocus systems. Active autofocus is found in rangefinder cameras and point-and-shoot cameras, while passive autofocus is found in SLR cameras. Naturally, each system has its own method of determining focus.

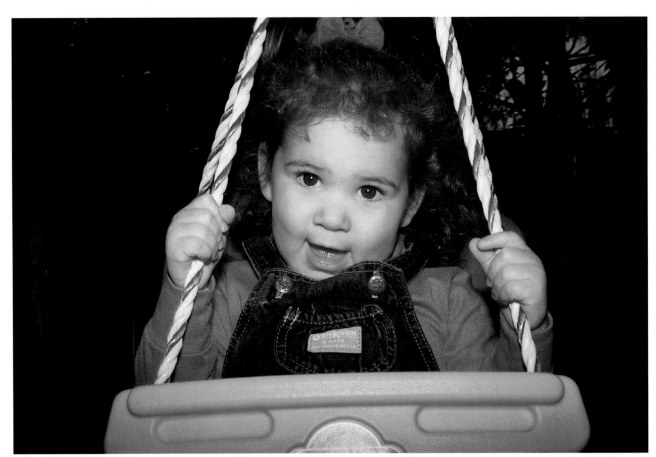

Selecting the autofocus mode on my camera enabled me to photograph my daughter, Jillian, while she was swinging. I placed an orange filter over the flash to enhance the warmth of this portrait. Here, I used my Canon EOS-1 set on program, a 28–80mm zoom lens, a Canon 430EZ flash set on automatic TTL, and Ektachrome 400X.

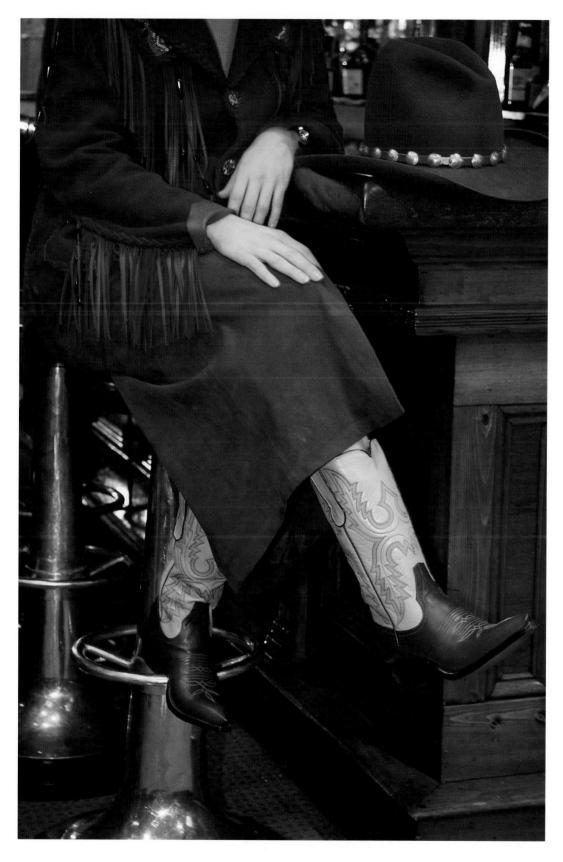

For this western scene, I used the autofocus mode on my camera because I was continually changing my shooting angle. A Norman 200B portable strobe bounced into a small, white umbrella provided the illumination. With my Canon EOS-1 and an 80–200mm zoom lens, I exposed Fujichrome 100 at $f$/11 for 1/60 sec.

## ACTIVE AUTOFOCUS

Active autofocus is the predominant system with point-and-shoot cameras. Some of these cameras are quite sophisticated and offer parallax correction, which adjusts the size of the frame in the viewfinder to the size and placement of the final image. When the lens axis and viewfinder axis don't coincide, the placement of the image on film will be higher. This could lead to part or all of the subject's head getting cut off or the inclusion of unwanted elements at the bottom of the scene. Parallax correction compensates for the difference in position in order to prevent portrait beheadings and flat-top hairstyles.

All point-and-shoot cameras have two sensors for controlling the focus. The first sensor emits an infrared beam that bounces off the subject. The second sensor detects the returning beam and assigns focus to a predetermined zone. The camera doesn't measure the distance; rather, it derives the distance from the angle formed by the two beams. If the resulting angle is small, the subject is close to the camera; if it is wide, the subject is farther away.

Active autofocus doesn't focus exactly on the subject; the camera assigns a zone that covers an area that provides acceptable focus throughout. This is similar to depth of field. Each camera differs in respect to the number of zones it offers. Obviously, the more zones a camera can assign, the more control over sharpness you have. Less expensive cameras may have four or five zones of focus, and more expensive cameras may have dozens or even hundreds of focusing zones. Active-autofocus systems provide several advantages. These include:

- Can focus in low light
- Doesn't need to focus on a linear target
- Focuses more quietly than passive-autofocus systems
- Camera lens doesn't move in and out of focus while tracking a subject.
  The disadvantages of active-autofocus systems are:
- Limited focusing distance
- Focuses on the center of the frame, resulting in "mis-focus" when the subject is off-center
- Zone focus is sometimes inaccurate
- Can't focus on detail
- Can't focus through glass.

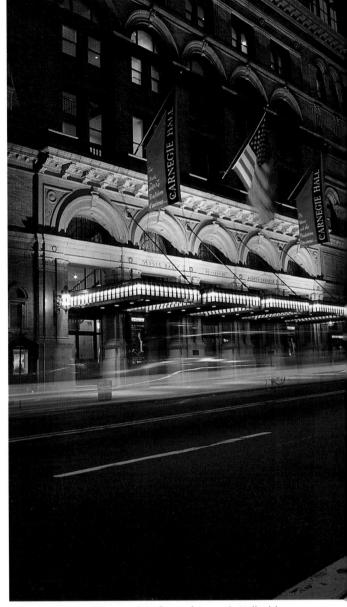

I made this shot of light trails in front of Carnegie Hall with a camera that uses an active-autofocus system. It emits an infrared beam to determine subject distance. Working with my Konica Hexar and its fixed 35mm lens, I exposed Fujichrome Velvia at $f$/8 for 8 seconds.

## PASSIVE AUTOFOCUS

Passive-autofocus systems work when a charge-coupled-device (CCD) sensor determines the sharpness of the image through the camera lens. The sensor focuses precisely on the subject instead of in a zone of focus. Passive autofocus works when the autofocus circuitry tells the focusing mechanism in the lens which direction to turn in order to achieve focus. When focus is achieved, the lens stops turning and the shutter-release button can be depressed.

Most passive-autofocus systems don't allow you to take a picture unless the image is in focus. Some systems do, however, permit you to depress the shutter before focus is achieved. This feature is especially useful when you're photographing a continuously moving subject, such as a football player or a deer in the wild. And some systems even allow you to focus manually. The advantages of passive-autofocus systems include:

- Focuses precisely on the subject
- Can focus through glass or mirrors
- Infrared focus-assist beams to ensure accurate focus.
  The disadvantages of passive-autofocus systems include:
- Can't focus in darkness
- Has trouble focusing on subjects that lack detail
- Servo-focusing drains batteries.

Clearly, the advantages of working with a 35mm SLR camera outweigh the disadvantages. While 35mm SLR cameras don't offer the image size of a medium- or a large-format camera, they produce most of the professional-quality pictures you see in newspapers, magazines, and advertisements. You can maintain sharpness and saturation relative to the size of the final image. In addition, the SLR is a powerful tool that fits into the palm of your hand. Its built-in light meters, interchangeable lenses, and various exposure modes simplify the technical side of pursuing a subject, thereby enabling you to concentrate on aesthetic concerns. Of course, there are disadvantages to using an SLR, but they very rarely impede your ability to capture a professional-quality image.

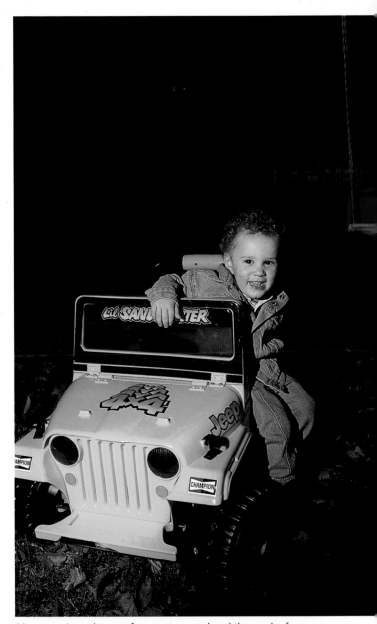

My camera's passive-autofocus system produced the precise focus in this picture of my son, Anthony, driving his car. Shooting with my Canon EOS-1 and an 80–200mm zoom lens, I used the program-exposure mode and Fujichrome Velvia. My Canon 430EZ flash held off-camera and set on automatic TTL provided the illumination.

# TRIPODS AND CAMERA STABILITY

When it comes to successfully shooting long exposures, using the best camera body, the sharpest lens, or the finest-grain film doesn't matter if you don't mount your camera on a sturdy tripod first. Without this critical piece of gear, the results of your efforts will be dismal. A tripod is a three-legged device that has a provision for mounting a camera on its "head." With the camera securely attached to the head, you can tilt and pan to adjust the lens' view of the scene. The legs of the tripod extend, so you can adjust the height of the camera.

The most common reason for using a tripod is preventing unwanted camera movement from degrading the sharpness of the photograph. But this isn't a tripod's only function. A tripod provides you with the opportunity

to concentrate on your subject because the camera is no longer "attached" to your eye. Instead, the camera is perched on top of a platform, allowing for maximum control of composition; you can arrange the elements in a scene more precisely when using a tripod than you can when handholding your camera. In addition, such alternative techniques as painting with light, painting with flash, and detail lighting, require long exposure times, which make the tripod mandatory. In a sense, it enables photographers to exert control of the universe in every exposure.

A tripod is the night photographer's best friend, but in order to fully reap its benefits, you need to use it properly. Merely mounting your camera on a tripod

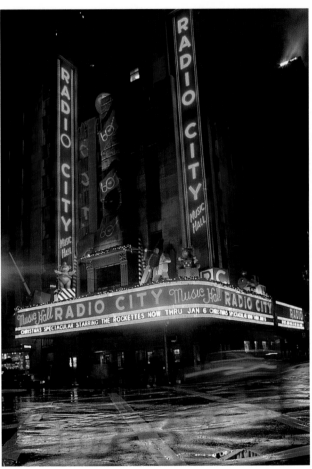

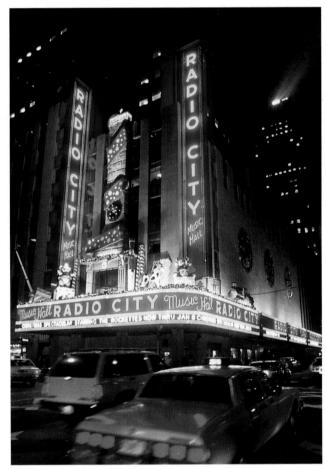

Some night subjects are bright enough to allow you to handhold your camera, but not without a sacrifice. Your options regarding grain structure, depth of field, and exposure lengths are limited. For one shot of Radio City Music Hall, I mounted my Canon F1 and 28–85mm zoom lens on a tripod and achieved good detail and adequate depth of field (left). I exposed for 8 seconds at $f$/8 on

Agfachrome 100 RS Professional film, which has a fine grain structure. On another occasion, I took a handheld shot of the same scene with my Konica Hexar camera, which has a fixed 35mm lens (right). This image, shot at $f$/2 for 1/15 sec. on Ektachrome 1600, has an overall rough quality, a prominent grain structure, and limited depth of field.

doesn't guarantee sharp images; you must use the tripod as efficiently as possible. A tripod is only as strong as its weakest link. You can attain optimal stability, which in turn leads to maximum image sharpness, by following several important steps. These include:

- Firmly plant the tripod on a flat, stable surface, not on sand, mud, or rocks
- Be aware of ground vibration from subways, traffic, or weak ground
- Adjust the tripod to a comfortable height (it should be at eye level)
- Always raise the tripod by extending the legs (raising the centerpost is a last resort)
- Angle the legs out to their maximum position

- Tighten all knobs, clips, and levers
- Reduce vibration by using a cable release
- Whenever possible, use the "B" (Bulb) setting, which keeps the shutter open as long as you hold the button down, or the "T" (Timer) setting instead of a preset shutter speed
- If you must use a long preset shutter speed (i.e., 8 seconds) and you don't have a cable release, you should use the self-timer control in order to reduce the vibration associated with manually pushing the shutter-release button
- Hang a heavy weight, such as a full, one-gallon milk container, from the centerpost to counteract inertia, thereby achieving maximum stabilization.

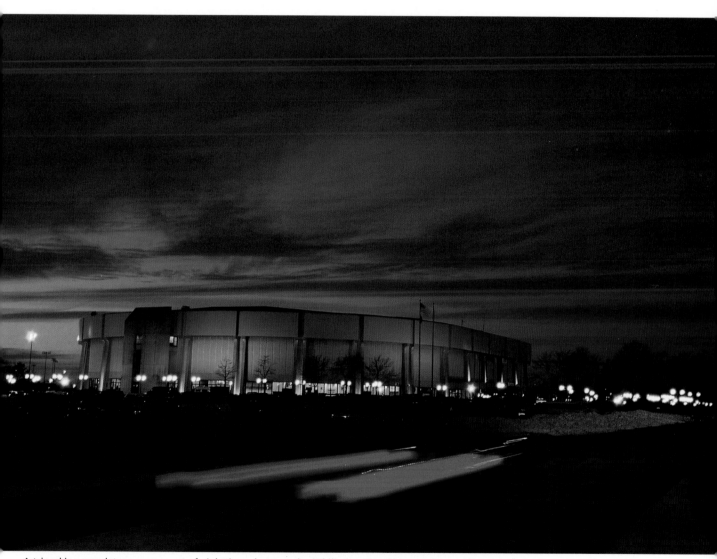

A tripod is a mandatory component of nighttime photography. While shooting this sports/concert arena under an orange and purple sky, I realized that a long exposure was needed in order for me to capture the red light trail. I also knew that I had to securely mount my camera on a tripod to accommodate the exposure time. I made this shot with my Canon EOS-1 and a 20–40mm zoom lens. The exposure was 5 seconds at ƒ/11 on Kodak Lumière.

# LENSES

Human vision can differentiate 10 million gradations of light and 7 million shades of color. Depth perception enables us to distinguish the distance of objects near and far. Essentially, photography becomes our world transferred to film. The camera lens acts like an eye during the picture-taking process; a camera is nothing without a lens. A lens can be as simple as a pinhole in a piece of aluminum foil or cardboard, or it can be as complex as those made of aspherical glass. This is high-quality optical glass that consists of more than one radius of curvature; this feature helps compensate for certain lens aberrations.

Camera lenses permit us to change the magnification of a subject, making it smaller or larger than it actually is. Lenses are differentiated by two functions: focal length and maximum aperture. The focal length controls the magnification of the subject and the angle of view. Each lens in conjunction with subject distance can alter perspective. The 50mm standard lenses emulate the same field of view as human vision. Wide-angle lenses provide an expanded angle of view and range in focal length from the 7.5mm fisheye lens to the 35mm wide-angle. Telephoto lenses supply a narrow angle of view; they begin at focal lengths of 70mm and can exceed focal lengths of 2000mm.

Both wide-angle and telephoto lenses can change the proportional values between objects in a scene. For example, a 300mm telephoto lens can make a distant object appear larger on film because it views the scene at an 8-degree angle. This lens also can make an object appear six times closer than it is, and it yields an image size about 40 times larger than a fisheye lens does. A fisheye lens includes everything in front and to the side of the camera within a 180-degree angle; this type of lens bends light rays to the point where it creates a curved image. Objects closest to the lens seem proportionately larger than the objects farther away.

When I look through my final images, sometimes I find that I didn't efficiently use my lens' focal length. This is particularly noticeable when I "underlensed" my subject. Simple "underlensing" results either because I used too long a focal length or because I didn't get close enough to my subject. If I shot negative film I can fix this problem merely by enlarging the image, but I can't solve it if I used slide film. Night scenes are filled with extraneous elements—darkness, spectral highlights, and flaring lights—but you must avoid including them in a picture by filling the viewfinder with your primary subject.

The other distinguishing feature of a lens is its maximum aperture, which essentially is the aperture setting that permits the most light to enter the lens. Lenses with a lower aperture number are considered faster than those with a higher aperture number. This number is indicated on each lens as the "F" number that precedes the focal length. For example, you might have an F1.4 50mm standard lens.

Each focal length—wide-angle, standard, and telephoto—has a maximum aperture that is common to the various lenses that fall under that category. The 50mm standard focal length usually offers a fast lens with a maximum aperture of F1.8, although some standard lenses are even faster, with an F1.0 designation. A wide-angle lens may have a maximum aperture of F2.8; again, some are faster. Because of the size and magnification power of telephoto lenses, they are the slowest lenses. Most have maximum apertures of F4 or F5.6. Telephoto lenses with a faster maximum aperture are available, but they are heavy and cost significantly more than their slower counterparts.

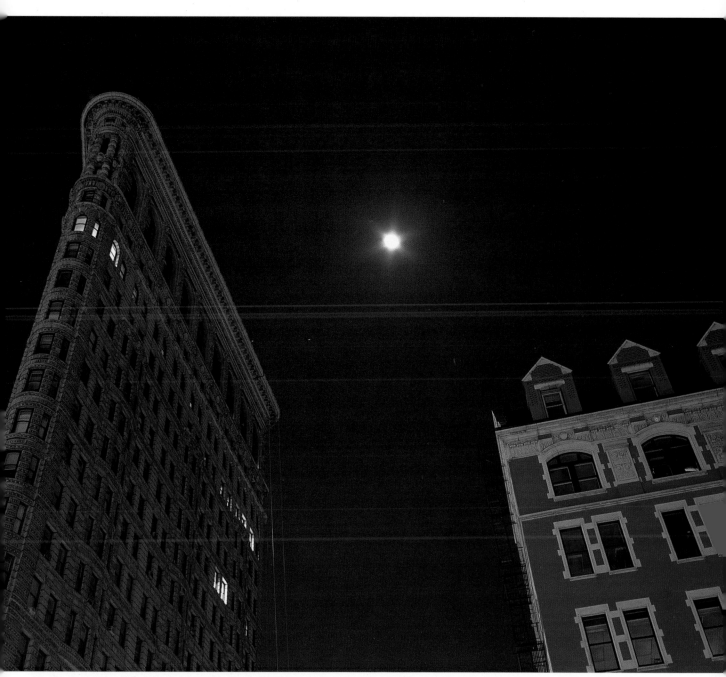

For this shot of New York's Flatiron Building and the moon, I used my 120 rollfilm camera. This format's 55mm lens, which I used here, provides an angle of view that is slightly wider than that of the 35mm format's 35mm wide-angle lens. Working with my Mamiya 645, I exposed Agfachrome 100 RS Professional film for 2 minutes at f/5.6.

# ULTRAWIDE-ANGLE LENSES

Ultrawide-angle lenses provide the most expanded view of a subject from a confined space. They reproduce objects on film with a decreased magnification, thereby rendering the elements in a scene smaller than a standard, or even a wide-angle, lens does. Ultrawide-angle lenses also offer the greatest depth of field because their apertures have the smallest diameters. In fact, the diameters are so small that they barely have to be focused to be sharp.

Ultrawide-angle lenses produce two types of perspectives: circular and rectilinear. Fisheye lenses have the most extreme angle of view; this perspective provides a distorted image of everything in front of and to the side of the camera. For example, a 7.5mm fisheye lens with its 180-degree angle of view produces a circular image on film (see chart).

Rectilinear wide-angle lenses, on the other hand, are corrected to reproduce the linear portion of a scene without distortion. Keep in mind, however, that these lenses are quite expensive; prices range from $600 to $2,000. I reserve mine for special situations, such as shooting architectural interiors, when rendering straight lines is imperative.

## ULTRAWIDE-ANGLE LENSES

| Focal Length | Angle of View |
|---|---|
| 7.5mm fisheye circular | 180 degrees |
| 15mm fisheye rectilinear | 180 degrees |
| 14mm rectilinear | 150 degrees |
| 18mm | 100 degrees |

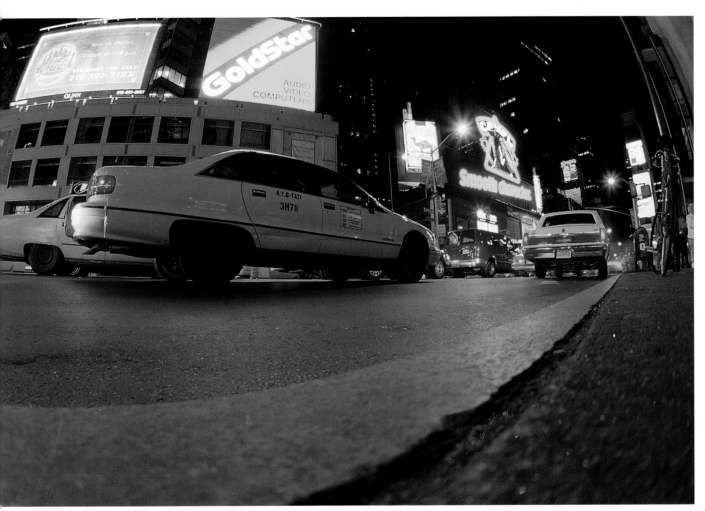

To maximize the distortion my ultrawide-angle lens produced, I rested my camera on the curb rather than a tripod while shooting this city scene. Working with my Canon EOS-1 and a 15mm fisheye lens, I exposed Ektachrome 100X at *f*/5.6 for 4 seconds.

# WIDE-ANGLE LENSES

Because a wide-angle lens reproduces objects on film smaller than a standard lens does, it provides a more expanded view of a scene (see chart). Furthermore, when the main subject is close to the lens, a wide-angle lens makes it seem much larger than objects in the background, thereby distorting the relative sizes in the scene. An inherent characteristic of all wide-angle lenses is keystoning. This distortion is a result of linear convergence, which occurs when the film plane isn't parallel to the subject. Here, horizontal or vertical lines in a scene appear to expand at points close to the lens and to merge at points farther away. Although a keystone effect is sometimes desirable, this kind of distortion isn't suitable for all subjects.

Wide-angle lenses offer extensive depth of field and hyperfocal distances. This distance indicates the starting point at which a lens records subjects in focus and continues to infinity. In this range, every element in the scene will be sharp. This figure differs with each focal length, as well as aperture setting. A 24mm wide-angle lens set at $f/11$, for example, has a hyperfocal distance of 5 feet to infinity.

The covering power of a wide-angle lens is ideal for night-photography subjects. For example, it isn't always practical to take a few steps backward—into traffic, perhaps—to fit the subject in the viewfinder. A moderate 28mm or 35mm wide-angle lens provides a more expanded view of the scene than a 50mm standard lens does. And distortion will be minimal if the camera is parallel to the subject.

## WIDE-ANGLE LENSES

| Focal Length | Angle of View |
| --- | --- |
| 20mm | 94 degrees |
| 24mm | 84 degrees |
| 28mm | 75 degrees |
| 35mm | 63 degrees |

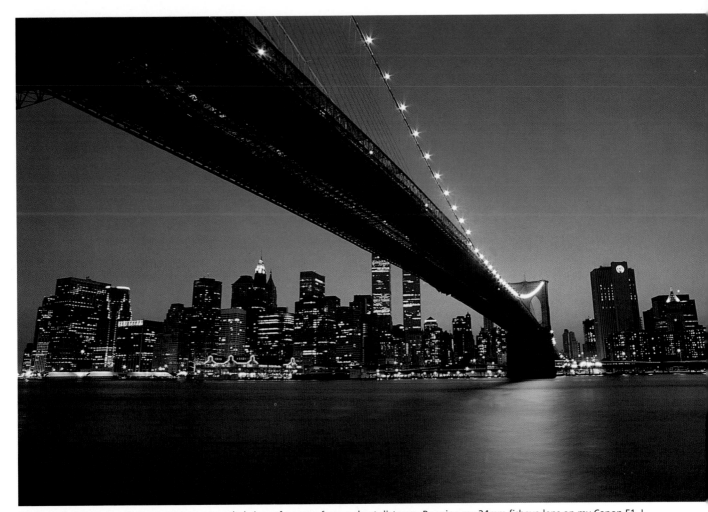

Wide-angle lenses permit you to get an expanded view of a scene from a short distance. By using my 24mm fisheye lens on my Canon F1, I was able to include the Brooklyn Bridge in this image of the Lower Manhattan skyline. The exposure was 8 seconds at $f/5.6$ on Agfachrome 100 RS Professional film.

# STANDARD LENSES

The standard lens is the most common focal length because it provides the same angle of view that the human eye does (see chart). The numerical designation of each standard lens depends on the camera format, but you can roughly determine these figures by measuring the film diagonally. For example, in the 35mm format, the film measures 43mm diagonally, making the 50mm lens the standard lens.

The 50mm standard lens has several virtues. It is the least expensive lens and the fastest lens in the 35mm SLR system. In addition, the lens' typical maximum aperture of F1.8 enables you to handhold your camera when shooting in low-light situations. If a lens with that F number isn't fast enough, for a little more money you can buy a lens with a maximum aperture of F1.4, which is almost one stop faster than F1.8. The standard lens offers moderate depth of field. Focusing on an object that is 10 feet away would produce images that vary in sharpness depending on the aperture setting. For example, an aperture of $f/1.8$ would provide an image with a sharp-focus range extending from 6 inches in front of the object to 9 inches behind it, $f/16$ would provide a range of 6 to 24 feet, and $f/22$ would provide a range of 5 feet to infinity.

STANDARD LENSES

| Focal Length | Angle of View |
| --- | --- |
| 50mm | 47 degrees |

The direction of the artificial light enhances this profile of a cobra. Here, I held my Sunpak 522 flash off-camera in front of the snake. To create this portrait, I used my 50mm standard lens in order to include some of the snake's body. Shooting with my Canon F1, I exposed for 1/60 sec. at $f/8$ on Kodachrome 64.

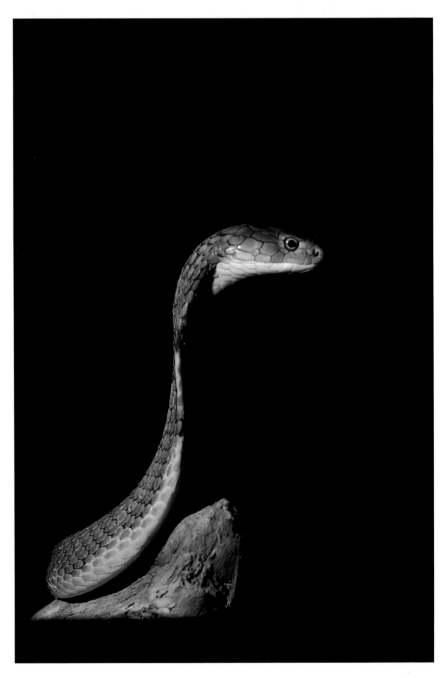

# TELEPHOTO LENSES

A telephoto lens allows distant subjects to appear closer than a standard lens does. So, if you were shooting a football game, rock concert, or cityscape and wanted to bring the action close, you would use a telephoto lens. Telephoto lenses cover a broad range of magnification levels that are appropriate for specific types of subjects. A short telephoto lens, for example, is an excellent choice for shooting a night portrait. The human face is rendered best in pictures in which the perspective is compressed. Wide-angle lenses tend to emphasize the subject's prominent features, such as the nose or ears, by reproducing them larger than they actually are and out of proportion with the rest of the face.

Telephoto lenses are also the ideal choice for isolating a portion of the scene. The human eye is able to pick out a pattern or small detail from a nightscape while not paying attention to the rest of the scene. You might, for example, focus on a neon sign, façade pediment, or reflection, and at the same time ignore everything else but that particular element of the scene.

As lens focal length increases, depth of field diminishes. Naturally, then, telephoto lenses offer less foreground-to-background sharpness than other lenses do (see chart). But limited depth of field isn't necessarily a drawback. When focus is limited to a shallow area, the background is subdued, thereby allowing the subject to jump out from it. I find this effect to be especially successful for night portraiture.

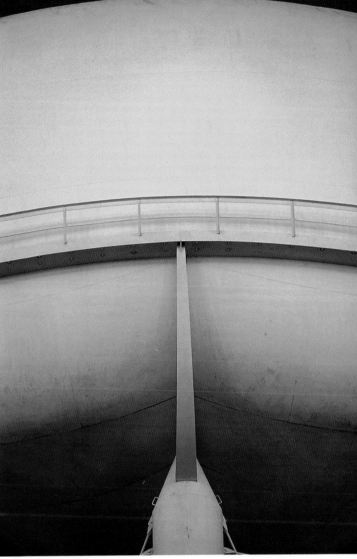

Using a telephoto-lens setting can make a common object, such as the water tower in this closeup, appear abstract. Shooting with my Canon EOS-1 and an 80–200mm zoom lens, I exposed Kodak Lumière for 30 seconds at ƒ/8.

## TELEPHOTO LENSES

| Fixed Focal Length | Angle of View |
| --- | --- |
| 70mm | 34 degrees |
| 85mm | 30 degrees |
| 100mm | 24 degrees |
| 135mm | 18 degrees |
| 200mm | 12 degrees |
| 300mm | 8 degrees |
| 400mm | 6 degrees |
| 500mm | 5 degrees |
| 600mm | 4 degrees |
| 800mm | 3 degrees |
| 1000mm | 2.5 degrees |

# MACRO LENSES

A macro lens is usually a standard or a short telephoto lens that you can extend beyond the typical focusing distance, thereby enabling you to reproduce small objects at a 1:2 ratio. For example, you can record insects, coins, and flowers at half their true size on film. The addition of extension tubes will further increase the ratio to 1:1, thereby permitting you to duplicate an object its actual size on film.

Using a macro lens requires a sensitivity to certain functions. Because of the proximity of the subject, focus must be precise. Even when you stop down the lens to $f/32$, the margin of sharpness is very shallow. The subject is only inches way, so any sudden motion will blur the image; as a result, a tripod is a necessity. In addition, you should trip the shutter via a cable release. If you don't have one, use your camera's self-timer switch to help reduce vibration.

Lighting a macro subject poses another potential problem. Off-camera flash units can provide texture lighting, but they are hardly capable of producing even illumination. You should consider getting a ring light, a type of flash specifically designed for macrophotography. This is a circular light that goes around the lens to produce a direct, balanced illumination.

I made this extreme closeup of the insignia on the signal light of a truck with a macro lens. Here, the subject was part of the light source because light passed through it. I determined exposure by taking an incident-light reading of the illumination by holding the meter's bulb directly on the signal light. Working with my Nikon F3 and my 105mm macro lens, I exposed for 1/2 sec. at $f/11$ on Ektachrome 64T.

# ZOOM LENSES

While the fast speeds, relatively compact sizes, and minimal weights of single-focal-length lenses are advantageous, the versatility of zoom lenses makes up for their less convenient speeds, sizes, and weights. Furthermore, optical technology has improved each of these potential drawbacks. Years ago photographers shied away from using zoom lenses and preferred single-focal-length lenses for their optical superiority. Today, however, zoom lenses are capable of producing sharp images with excellent color reproduction and little image distortion.

A zoom lens combines a variety of focal lengths into one lens. So, instead of having to carry three or four separate lenses, you need to bring along only one. Zoom lenses come in focal lengths as wide as 18mm and as long as 400mm. Because no one lens can cover both extremes, zoom lenses are divided into three categories: wide-angle zoom lenses, wide-angle-to-telephoto zoom lenses, and telephoto zoom lenses.

The current workhorse in my camera bag is a wide-angle zoom, the Canon EOS 20–35mm F2.8 lens. Having this single lens is the equivalent of carrying four separate lenses: a 20mm, a 24mm, a 28mm, and a 35mm. I find that this wide-angle zoom lens' optical quality, speed, and weight exceed the acceptable range.

The next group consists of zoom lenses that cover both the wide-angle and telephoto ranges and are, perhaps, the most frequently used lenses. Some popular focal lengths are 28–80mm, 35–105mm, and 35–135mm. These lenses often don't have a constant aperture setting, such as a 28–80mm F2.8/3.5 lens. Those that do are a little faster, but they are considerably more expensive—up to five times as much—than their variable-aperture counterparts.

Telephoto zoom lens have been around for quite some time. Their focal lengths range from 70mm to 400mm; the most common is the 80–200mm length. If you require an even closer view for a shot of a concert or sports event, you can add a lens extender (see page 127). Telephoto zoom lenses can be several stops slower than their single-focal-length counterparts. Moderately priced telephoto zoom lenses offer a variable aperture of F4.5/5.6. If you require more speed, you can get faster lenses; however, these are considerably more expensive than slower lenses.

Naturally, using a zoom lens does have some disadvantages. Rarely are they the exact focal length that they claim to be. Their focal lengths are rounded off. Depending on the manufacturer, the focal lengths could be off a millimeter or two. This discrepancy doesn't noticeably affect image size unless the wide-angle measurement is off. In this case every millimeter counts. A lens that claims to be an 18–35mm lens may actually be a 19–34mm lens. Finally, because zoom lenses tend to have a higher maximum aperture than fixed-focal-length lenses do, handholding the camera in low-light conditions isn't always possible. Almost every manufacturer produces fast zoom lenses, but they are more expensive.

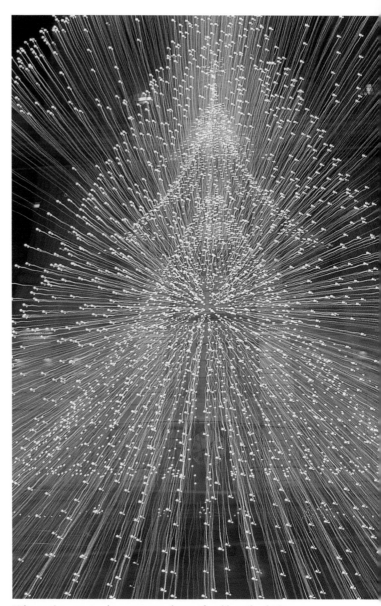

When using a zoom lens, you can change focal lengths during a long exposure. Because zooming is never an exact science, the effects vary widely. With a little practice on your part, however, you'll be able to predict the results better. To photograph this holiday-lighting display, I began by composing the scene at the widest setting on my zoom lens. I then switched to its maximum focal length to create this effect. Working with my Canon F1 and a 28–85mm zoom lens, I exposed Fujichrome 100 at ƒ/8 for 4 seconds.

# FILM CHOICES

Every artist needs a medium. For photographers that medium is film, and they have more than 100 types to choose from. The variations in grain structure, film speed, and color rendition ensure that a film exists for almost every particular circumstance. The film that produces the best results is a subjective choice. Quite simply, the best film to use is the one you think gives you the best results. The quest for finding the "right" film for a night photograph is a continual process.

Most films are designed to produce a full spectrum of color under daylight conditions. The illumination from either the midday sun or an electronic flash unit corresponds to daylight film, but the illumination from other light sources doesn't. Many forms of artificial light require corrective filtration. The only exception is tungsten light, which can be reproduced with a full spectrum of color without the use of a conversion filter or a specially designed emulsion.

The physical characteristics of film determine the outcome of a photograph's appearance. This includes the way each film reproduces color, contrast, and tones. At night, artificial-light sources have diverse reactions to the

Here, I photographed the statue of Atlas against the backdrop of St. Patrick's Cathedral on a foggy night in New York City. I decided to shoot tungsten film in order to enhance the blue highlights on the sphere. Working with my Canon F1 and a 24mm wide-angle lens, I exposed at f/5.6 for 20 seconds on Fujichrome 64T.

Film is, perhaps, the most variable factor in terms of night photography. Each type renders a nighttime subject in a unique way. I made these three photographs of Atlas, a statue located in midtown Manhattan, on three different days using three different films: Kodachrome 64, which has a slight green cast (above); Fujichrome 100, which has a strong green cast (right); and Fujichrome 64T, which has a strong blue cast (far right). I didn't use any color-correction filters.

film. One film may provide a warm tone, while another may result in a cool cast. Some films saturate color in a scene, while others produce less saturated images. If you like the characteristics of a specific film, but find that its inherent qualities lead to a particular color bias in your final images, you can use corrective filtration to fine-tune the film to the light source.

Some final points about film. Film is the cheapest link in the photographic chain, so don't be stingy with it. Make sure that you fully understand the various effects of a film. I've seen many pictures that didn't succeed because the photographers didn't take the time to test the film or to use a color-correction filter. You should also be sure to bracket because determining exposure at night is rarely an exact science. When using slide film, bracket three frames, normal exposure, underexposure, and overexposure, at $^1/_2$- to 1-stop intervals. When using negative film, bracket two frames, normal exposure and overexposure, again by $^1/_2$ to 1 stop. And always use the finest-grain film. Since your camera is mounted on a tripod, the duration of exposure can accommodate a slow, fine-grained film in order to preserve detail in the image.

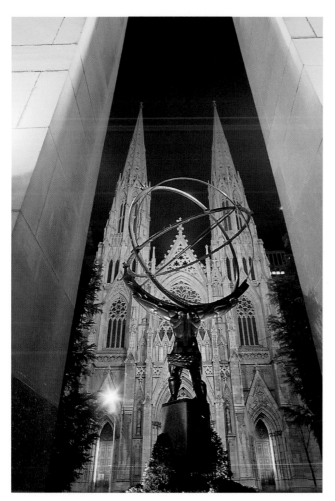

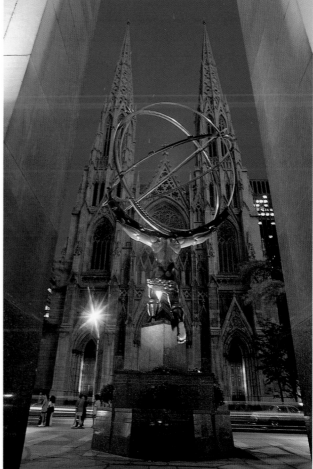

# FILM CHARACTERISTICS

Film is divided into three types: color-transparency (or color-slide), color-negative, and black-and-white-negative. Films also come in a variety of speeds. Film speed is a measurement of the film's sensitivity to light and is designated by an ISO rating. The higher the ISO number, the faster the film and the more sensitive it is to light. The lower the ISO number, the slower the film and the less sensitive it is to light. Kodachrome 25 is the slowest color-transparency film, and Ektachrome 1600 is the fastest. Kodak Ektar 25 is the slowest color-negative film available; Konica 3200, the fastest. Kodak Tech Pan is the slowest black-and-white-negative film; Kodak T-Max 3200, the fastest.

Another film characteristic, grain structure, is a result of film speed. Faster films have more prominent grain structures than slower films. However, with the development of contemporary film technology, grain has become less apparent. For example, not long ago ISO 400 films had prominent grain structures; each grain was nearly the size of a Rice Krispie. Today, the grain structure of an ISO 800 film is hardly noticeable.

Similarly, in the early 1980s, another great stride took place. Kodak introduced VR 1000 color-negative film. At the time it was the fastest color film on the market, but the grainy quality of this color film made each picture look like a Seurat painting. Comparable films now offer twice the speed and only half the grain.

Color rendition is another attribute of film. Color film is made up of three layers: blue, green, and red. Each color layer permits light of its particular hue to pass onto the film but absorbs complementary-color light. If all the film layers were of equal sensitivity, all color would reproduce evenly. But what makes a film unique is the difference of color sensitivity in each of these layers. Films with an increased sensitivity to red and green produce warmer tones than those films with a bias to blue.

The trend today favors warm films. These films are excellent for daylight or flash photography, but they aren't necessarily good choices for photographing objects under artificial light. With the exception of mercury-vapor and fluorescent lamps, every artificial-light source emits a certain amount of yellow light. Using a warm-balanced film exaggerates this bias and results in a dominant yellow or green cast. I find that the best transparency films for night photography aren't popular choices for daylight shooting. These films often have a color balance that leans toward magenta or blue. European-made films, like Agfa films, seem to offer this balance.

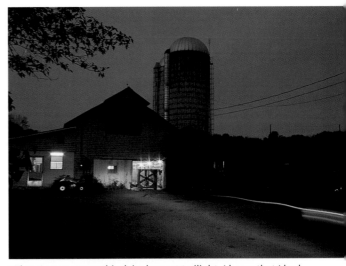

When I came across this dairy barn at twilight, I knew that I had to choose a film fast enough to avoid an excessively long exposure time yet with a grain fine enough to reproduce detail. I chose Kodak Lumière because its grain structure is almost nonexistent. Working with my Canon EOS-1 and a 20–35mm zoom lens, I exposed for 8 seconds at f/8.

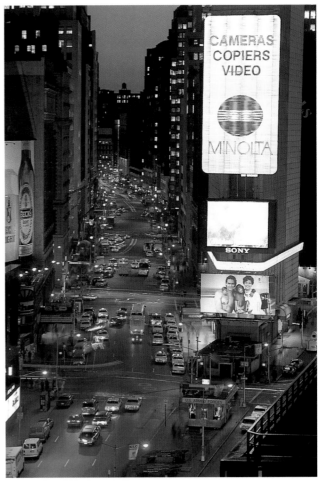

I shot this overhead view of Times Square at dusk using an ultrafine-grain film. The amount of ambient light was sufficient to prevent the need for a lengthy exposure. With my Canon F1 and a 28–85mm zoom lens, I exposed Agfachrome 50 RS Professional film for 4 seconds at f/4.

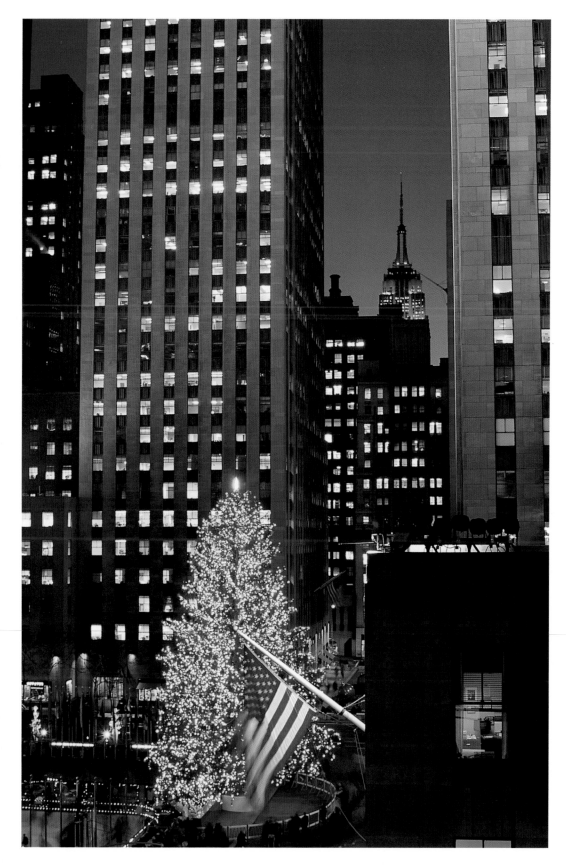

An ultrafine-grain film is perfect for scenes that contain a great deal of detail. For this shot of Rockefeller Center, I selected Fujichrome Velvia. The Christmas tree, the Empire State Building, and the windows are all sharply rendered. With my Canon EOS-1 and an 80–20mm zoom lens, I exposed for 30 seconds at f/8.

# COLOR-TRANSPARENCY FILM

Since color-transparency films produce the highest-quality—sharp, saturated—images, they are the best choice for images that are going to be published. A slide can go directly to the separation process, whereas a negative must be converted to either a print or a duplicate slide first. This process produces an image this is another generation away from the original.

The color of artificial-light sources affects the color balance of the film, so it is important to know how a particular film will react in a given situation, as well as to understand the corrective filtration that may be necessary. Keep in mind, however, that exposure determinations must be exact when you shoot slide film; these films aren't very forgiving and offer minimal exposure latitude. Most transparency films are balanced for daylight illumination, which means that you can expose the film under a 5500K light source, such as sunlight or electronic flash. Other slide films are balanced for tungsten illumination (3200K) and photoflood illumination (3400K).

Transparency films cover a range of film speeds. Kodachrome 25 is the slowest, finest-grain film available. A 35mm image shot on this film can be enlarged to a 24 × 30-inch print with very little apparent grain. Unfortunately, the film's limited sensitivity to light makes it impractical for night photography. ISO 100 films are a better choice: they have a two-stop advantage over ISO 25 films, with only slightly more grain.

Medium-speed films, such as Ektachrome 400X and Fujichrome 400, have a more prominent grain structure than ISO 100 films, but what they sacrifice in grain they make up for in sensitivity to light. ISO 400 films are two stops faster than ISO 100 films. This increased speed shortens the duration of exposure. For example, if the suggested exposure for an ISO 100 film is 4 seconds at $f$/5.6, the equivalent exposure for an ISO 400 film will be either 1 second at $f$/5.6 or 4 seconds at $f$/11 (this smaller aperture setting will increase depth of field in the image made with the ISO 400 film).

Fast films with ISO ratings of 1000 or higher offer exceptional sensitivity to low light, but there is a trade-off: they are notorious for producing large globs of grain. For most applications, the grain structures are acceptable as long as an image isn't blown up too much. The actual size of an acceptable enlargement depends on several variables: the accuracy of exposure, the subject's detail, and color balance. Both Kodak and Fuji manufacture ISO 1600 slide films. Since these films are two stops faster than ISO 400 films, they would require an exposure of just $^1/_4$ sec. at $f$/5.6 for the shooting situation discussed above.

Transparency films are divided into two types: E-6 processed films and Kodachrome-processed films. The more common E-6 films can be processed at most photo labs in a fairly short amount of time, usually three to five

When I came across this scene, I was more impressed with the neon colors than the subject. I determined exposure by taking a reflected-light reading and then compensated by increasing the aperture by two stops. Shooting with my Canon EOS-1 and an 80–200mm zoom lens, I exposed for 15 seconds at $f$/8 on Kodachrome 200.

hours. Home kits are available for consumers, but I don't recommend processing transparencies at home because if the time or temperature is off even slightly, the film will be ruined. Kodachrome films, on the other hand, can't be processed at home. The complex procedure involved is called K-14. Although some large photo labs process Kodachrome, the majority doesn't. Most Kodachrome film is processed by Kodalux. Fortunately, Kodalux's turnaround time is fairly quick, usually overnight. (Kodak also sells an infrared color-transparency film for scientific as well as creative use. This film must be developed in a special process called E-4.)

Despite the forgiving nature of color-negative film and the narrow latitude for acceptable exposure of transparency film, I trust slide film more. The actual color of the scene is not necessarily captured accurately on negative film. During processing, the photofinisher can arrive at any number of color balances, all of which are acceptable but none of which may be true to the subject. With transparency film, however, the subject's color and density are reproduced exactly the way the film was physically sensitized by them. The result is an accurate image of the scene.

The need to shoot more images of the same subject in order to guarantee a successful picture doesn't prevent me from favoring slide film. At night, I bracket exposures with at least three frames of a single subject in $^1/_2$- to 1-stop increments. Although working with slide film is more time-consuming, I still prefer the final images it creates to those captured on negative film.

No two color-transparency films reproduce color the same way. Each slide is a one-of-a-kind master of the scene. And each film manufacturer has specific combinations of chemicals and dye layers that make its films unique. As a result, I find that no slide film is ideal for every situation. Discovering which film works best in what conditions comes from experimenting and keeping notes. Transparency films produce dramatic images, but they aren't always user-friendly. You need to understand their qualities and limitations in order to use them efficiently.

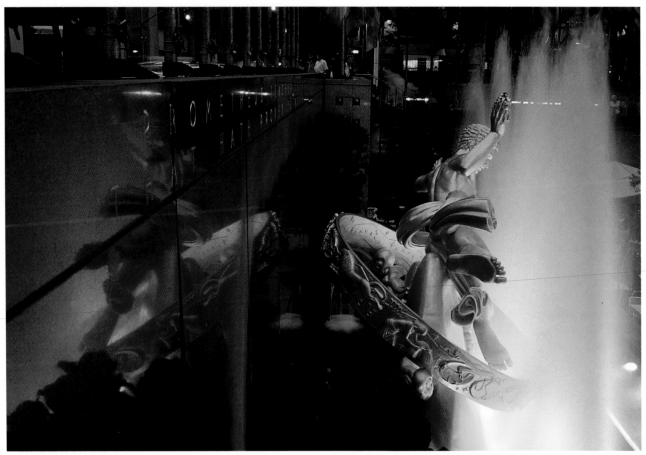

The moment I saw this statue and its reflection, I realized that my choice of film would be critical. I wanted to capture the vibrant orange and purple lighting, so I decided to shoot color-transparency film. Slide film records richer colors than print film does. Working with my Canon F1 and a 28–85mm zoom lens, I exposed Agfachrome 100 RS Professional film for 8 seconds at ƒ/8.

# COLOR-NEGATIVE FILM

Color-negative film is the most forgiving film to work with at night because of its exposure latitude of five stops: three stops of overexposure and two stops of underexposure. One benefit associated with using color-negative film for night photography is that the color, density, and contrast of the images can be controlled after the image has been taken, during the printing stage.

Color-negative film is developed via a process called C-41, available at one-hour and other commercial photo labs. If you choose to develop your own color film, you'll find that home processing is fairly simple as long as you maintain the required 100°F temperature. Most manufacturers, including Beseler and Unicolor, have simplified the process to two steps: developer and bleach/fix. Afterward, you wash the film and then put it through a stabilizer solution. You can dry it with a hairdryer. The entire process, from dry film to prints, takes about 20 to 30 minutes.

Printing color-negative film is similar to printing black-and-white-negative film; the only exception is that you must develop color film in total darkness. During the printing stage, the image created from a negative is subject to interpretation. You can adjust the color any way you want. This is particularly important in terms of night photography. Unlike daylight photography, in which you have a clear idea of correct color, night scenes offer many acceptable options.

For example, you can reduce the contrast in a scene by burning in, which involves adding density to a localized area, or dodging, which involves preventing light from reaching a localized area. You can also alter the color in a scene through filtration if you feel an image should be cooler than it is, if you want to minimize an unacceptable color cast produced by artificial light, or if you need to correct an exposure that is off by a stop or two.

Enjoying the virtues of color-negative film requires photographers to print their own negatives. The ability to alter image color, density, and contrast might actually be a drawback if you don't do your own color printing. Photofinishers determine the color and density of your final images, and these individuals might not have any idea of how your subjects actually looked. The number of variables is sometimes too high to guarantee acceptable results.

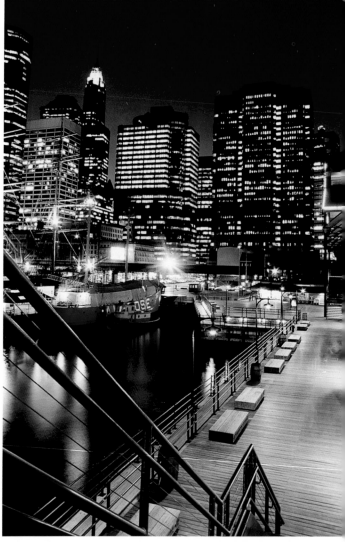

Shooting from the South Street Seaport, I recorded this view of Lower Manhattan on a fine-grain negative film and printed it on Kodak Supra RA-4 paper. With my Canon F1 and a 24mm wide-angle lens, I exposed Kodak Ektar 25 film at $f$/5.6 for 30 seconds.

# BLACK-AND-WHITE FILM

Black-and-white films have many redeeming qualities for night photography. First, they aren't affected by the color of artificial-light sources, so you never have a problem with color balance. Second, these films provide a four-stop exposure latitude, which ensures that you end up with at least one printable frame. But most important, black-and-white negatives give you the most creative control over your images.

Black-and-white negative film can be processed in a wide range of developing agents, each of which produces a specific result. You can choose among fine-grain developers, which permit image enlargement without noticeable graininess; high-contrast developers, which increase contrast; and low-contrast developers, which reduce contrast. When the negative is printed, various darkroom techniques, such as burning in, extend your control over the final images.

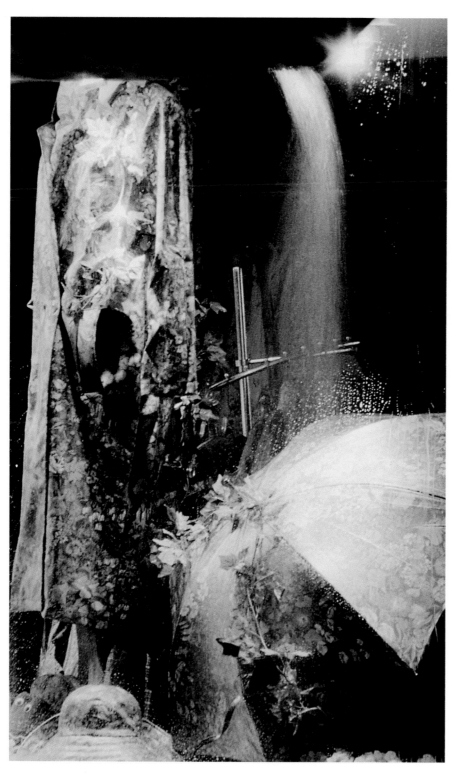

The use of black-and-white film offers photographers maximum control over their final images. They can alter the contrast to some degree, as well as burn in or dodge some areas of the prints. Limitations do exist, though. Black-and-white scenes that consist solely of shadow and highlight areas rarely produce successful photographs. Ideally, subjects should contain a range of middle tones. I made this shot of a store-window display during a rainstorm. I positioned my camera so that the water running off the canopy would land near the umbrella inside the store window. Shooting with my Canon AE-1 and a 28–85mm zoom lens, I exposed Kodak Tri-X Pan Professional 400 film for 8 seconds at f/8.

# FILTERS

The use of certain types of filters helps to counteract the detrimental effects of artificial light on color film. Each of the many light sources that exist has its own light temperature. As mentioned earlier, this characteristic plays an important role in night photography. Unfortunately, only two types of film are available: daylight-balanced and tungsten-balanced. Filters enable films to successfully adjust to the temperature of the light source.

Most of the time, filters are thought to be used for special effects, but this is hardly the case. A high-quality photographic filter can improve the appearance of an image without viewers knowing that a filter was used. Becoming proficient with filters requires practice and careful observation. In order to successfully use filters to enhance your nighttime photographs, you must understand the qualities of each filter in relation to the characteristics of the film you're shooting.

## STAR FILTERS

A star filter produces a dazzling effect by transforming intense spots of light into starbursts. This type of filter is used primarily to create a specific effect; however, you can also use a star filter to correct a problem in the scene. Anytime a light source produces a spectral hot spot—a bright point of light—viewers become distracted: their eyes are drawn to that point of light and away from the photograph's center of interest. The star filter is able to convert such points of light into a series of stars. If no such illumination exists in a scene, a star filter won't have any effect.

When you use a star filter, the beam of light itself is broken down and follows the four or six linear paths etched into the filter. Its horizontal and vertical lines are reminiscent of a screen. When a bright light hits the filter, it flares across the etched lines. The effect of each

When composing this street scene, I decided that a 10CC blue filter would tone down the yellowish glow from the street lamps. With my Canon F1 and a 24mm wide-angle lens, I exposed Ektachrome 400X at *f*/11 for 8 seconds.

star filter differs according to the number of lines it has. Star filters with four lines produce a four-point star, and those with six lines produce a six-point star.

Another distinguishing characteristic of star filters is the spacing among their lines. When the lines on a star filter are close together, they produce long, narrow stars; consequently, the greater the space between lines, the broader the effect. When the lines are far apart, a halo effect is produced at the center of the star.

All star filters aren't created equal, so you should experiment with each type in order to discover the one that works best for you. Remember, these filters aren't appropriate for every lighting condition. They require at least one point of light to convert into a star. But when points of light are present, a star filter can add pizzazz to an uninteresting scene, as well as correct the spectral hotness of unwanted illumination.

## GRADUATED FILTERS

Sometimes the brightness of part of a scene takes away from the image. One way to solve this problem is to use a graduated filter. This is a half-clear, half-colored glass filter that goes over the lens. As its name implies, the filter's color starts subtly in the middle and gradually increases the saturation of that color toward the edge.

Graduated filters come in a variety of colors, as well as in a neutral-density (ND) form. These filters are useful when you shoot slide film because it doesn't offer the custom-printing control of burning and dodging. Graduated filters are most often used to tint a portion of a scene or to balance a bright portion of a scene. Suppose that you're shooting a sunset. The sun has disappeared, but the sky isn't a deep enough blue. Using a blue graduated filter will make the sky appear darker than it otherwise would, yet the brightness of the scene won't be affected.

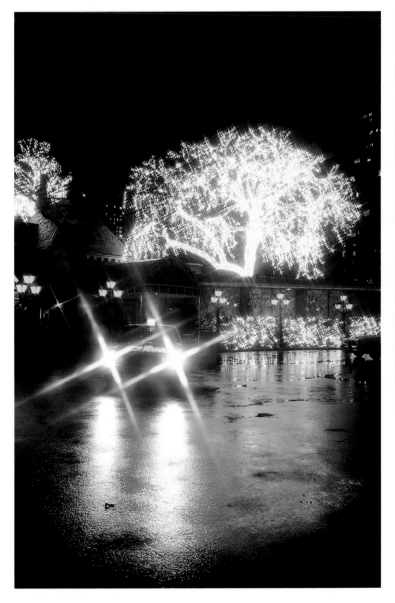

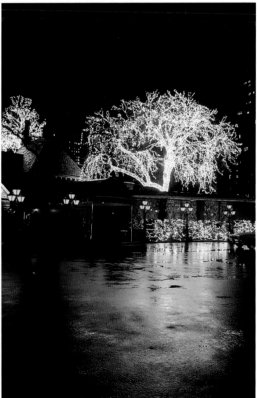

Star filters create subjects out of points of light. I often shoot scenes with and without a star filter, as I did here (above). I prefer the shot made with the star filter (left). Working with my Canon F1, I waited for a car to come toward my 28mm wide-angle lens to enhance the effect. The exposure was 15 seconds at f/11 on Kodachrome 64.

## LIGHT-BALANCING FILTERS

These filters slightly alter the color of a light source by either warming it up or cooling it down. They also balance the subtle color differences between tungsten and photoflood lighting, or between daylight and flash. The 81-series filters have different degrees of orange that can warm up an image. These intensities are indicated by the filter's designation. The 81 filter provides the least amount of warmth. The letter after the filter number signifies its strength; the higher the letter, the warmer the filter. All of these filters alter exposure by $1/3$ stop.

| Filter | Effect |
|--------|--------|
| 81A | Eliminates the coolness of images shot with electronic flash |
| 81B | Balances tungsten film (3200K) for photoflood lamps (3400K) |
| 81C | Balances tungsten film for electronic flash |
| 81EF | Balances Type A film (3400K) for daylight photography |

The 82-series filters have different degrees of blue that can cool the tones in a photograph. Again, the higher the letter of the filter designation, the deeper its color and the stronger its effect on a subject.

| Filter | Effect |
|--------|--------|
| 82 | Provides the least amount of blue among the filters in this series. It alters exposure by $1/3$ stop. It tones down the light, or adjusts the color temperature, by approximately 100K. |
| 82A | Reduces the excessive warmth of a scene. It alters exposure by $1/3$ stop. |
| 82B | Balances tungsten film (3200K) for use with a Type A film (3400K)is bluer than the 82A filter. It alters exposure by $2/3$ stop. |
| 82C | Balances Type A film (3400K) for use with a tungsten-light source (3200K). It alters exposure by $2/3$ stop. |

## COLOR-CONVERSION FILTERS

Suppose that you come upon a tungsten-lit subject when your camera is loaded with a daylight-balanced film. If you shoot anyway, your photographs will have a warm orange tone. Instead of settling for this, you can use a color-conversion filter to balance the light source and the film. Two types of color-conversion filters are available: those that balance tungsten or photofloods to daylight film, and those that balance daylight to tungsten film. The 80-series are blue filters that enable you to shoot daylight film under both tungsten and photoflood lighting. Be aware that with these filters, the higher the letter of the filter designation, the weaker the filter is.

| Filter | Effect |
|--------|--------|
| 80A | Balances daylight film (5500K) for tungsten light (3200K). It alters exposure by two stops. |
| 80B | Balances daylight film (5500K) for photoflood lamps (3400K). It alters exposure by $1 2/3$ stops. |
| 80 | Balances daylight film (5500K) for clear flash or strobe. It alters exposure by one stop. |

The 85-series orange filters permit you to shoot tungsten-balanced or photoflood-lighting-balanced film in daylight. Once again, the higher the letter of the filter designation, the deeper its color and the stronger its effect on a subject.

| Filter | Effect |
|--------|--------|
| 85 | Balances Type A film (3400K) for daylight (5500K). It alters exposure by $2/3$ stop. |
| 85B | Balances tungsten film (3200K) for daylight (5500K). It alters exposure by $2/3$ stop. |
| 85C | Warms up daylight film (5500K) and eliminates some of the coolness of tungsten film (3200K). It alters exposure by $1/3$ stop. |

## COLOR-COMPENSATING FILTERS

You can finesse color correction by using a color-compensating (CC) filter. These filters come in six colors: red, green, blue, cyan, magenta, and yellow. Within each group is a series of densities ranging from the lightly tinted 5CC filter to the heavily saturated 80CC filter. I consider CC filters to be an asset because they help fine-tune the film to the light source. CC filters control the color balance of a photograph as follows:

| Filter | Color of light prevented from reaching film |
|--------|---------------------------------------------|
| Cyan | Red |
| Magenta | Green |
| Yellow | Blue |
| Red | Cyan |
| Blue | Yellow |
| Green | Magenta |

## FLUORESCENT-LIGHT FILTERS

Fluorescent-light-correction filters help neutralize the green cast associated with most forms of fluorescent lighting. I find these filters to be more useful when I shoot negative film than when I shoot slide film. Since each of the seven types of fluorescent lighting has its own filtration for neutral rendition, fluorescent-light filters can only approximate the required effect. For critical color correction of transparency films, you should use CC filters instead. Fluorescent-light filters, which alter exposure by one stop, work as follows. The FL-D magenta filter balances daylight film for fluorescent lighting, and the FL-B magenta/orange filter balances tungsten film for fluorescent lighting.

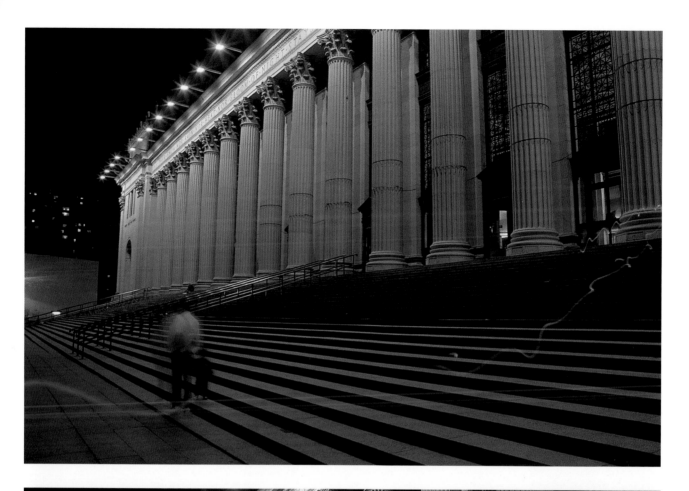

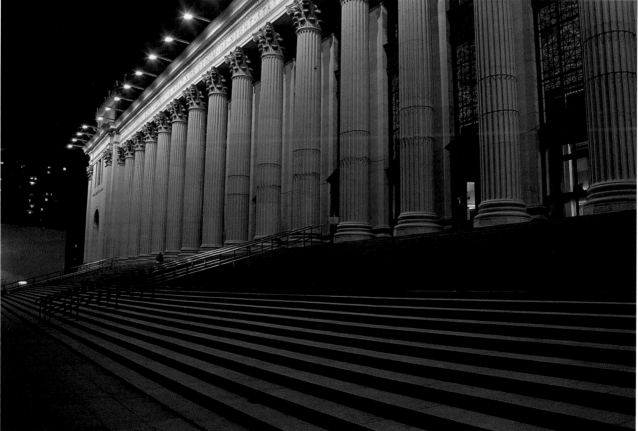

This pair of images shows the effect of an 80B color-conversion filter. Because I used daylight-balanced film, the frame shot with the filter reproduced the scene with a warm color cast (top). The frame shot without the filter recorded the scene with a cool cast (bottom). With my Canon F1 and a 28–85mm zoom lens, I exposed at *f*/8 for 15 seconds on Agfachrome CT 100 film.

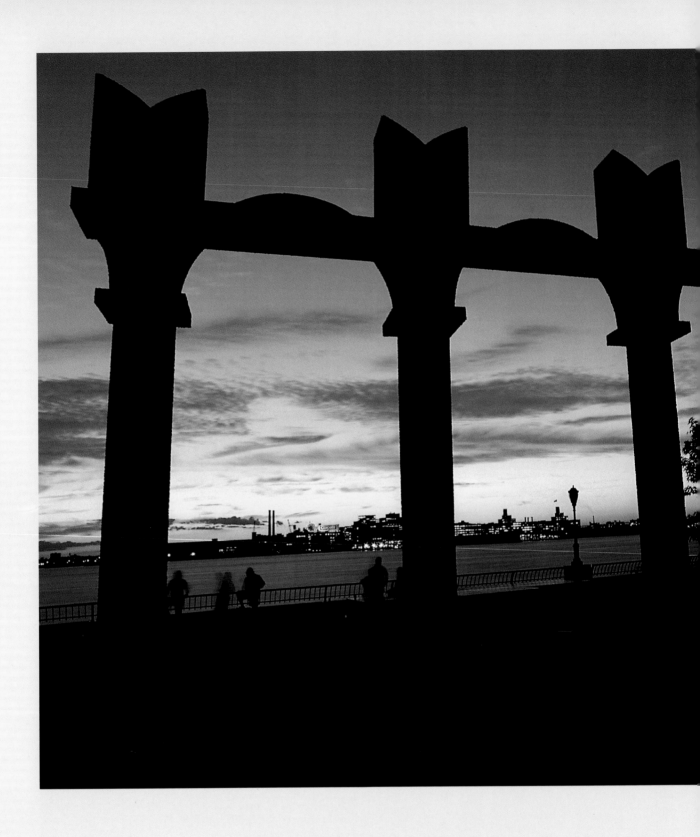

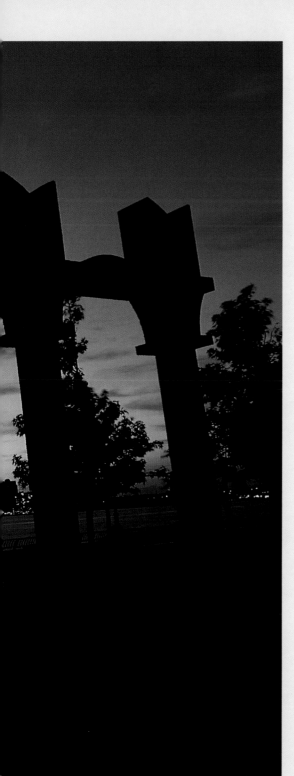

# CHAPTER 3

# DETERMINING EXPOSURE

Exposure is the link between your intention and execution of a photograph; it transfers your ideas to film. You can't record on film the charm of a night portrait, a twilight cityscape, or a fireworks display unless you expose film. Keep in mind, however, that determining exposure at night is far less predictable than it is during the day.

Unlike daylight subjects, which have a consistent light source, nighttime subjects are illuminated by various forms of artificial light. And when you combine this variable with the changing levels of ambient light and each film's exposure latitude, you'll understand why accurately calculating exposure is difficult.

The most noticeable characteristic of a night scene is its lack of middle tones. Unfortunately, this feature is the nemesis of accurate exposure. A night subject consists of a shadow area that surrounds a highlight, and is often completely devoid of middle tones. So, when you base the exposure on either the highlight or shadow area and don't compensate for the other part of the scene, a miscalculation results. Solving this problem requires a thorough understanding of the tools and techniques used for measuring light.

# THE EFFECTS OF LIGHT

All of your latent conceptions about a photograph can become possibilities when you understand light and its many effects. Optimal exposure relies on discerning the variations of three elements: film speed, shutter speed, and aperture setting. All three are interrelated, and adjustments follow a math-friendly formula: When the numerical value of the shutter, aperture, or film speed is doubled or halved, a one-stop change in exposure results. For example, an ISO 200 film is twice as sensitive to light as an ISO 100 film is, and only half as sensitive to light as an ISO 400 film is.

The light sensitivity of the film you're using establishes the base for exposure; the ISO rating indicates the film speed, which measures the film's level of sensitivity. The higher this number is, the more sensitive the film is. The film speed is a constant value that determines the scene's exposure value; this is the sum of the intensity and duration of light as it strikes the film. Many shutter-speed and aperture-setting combinations exist within the same exposure value. Exposures of 1 second at $f$/8, 2 seconds at $f$/11, and 1/2 sec. at $f$/5.6 allow the same amount of light to enter the lens and reach the film. While newer SLR cameras have a sensor that "reads" the DX coding on film cassettes and automatically sets the film speed, you'll need to manually set the film speed on older cameras.

## SUGGESTED EXPOSURES FOR SHOOTING TYPICAL NIGHT-PHOTOGRAPHY SUBJECTS

| Subject | Suggested Exposure for ISO 100 Film (unless otherwise indicated) |
|---|---|
| Amusement-park ride | 1/8 sec. at $f$/2.8 |
| Amusement-park ride in motion | 4 seconds at $f$/16 |
| Automobile light trails | 20 seconds at $f$/11 |
| Campfire | 1/30 sec. at $f$/2.8 |
| Candlelit subject | 1/2 sec. at $f$/2.8 |
| Cityscape at early twilight | 1 second at $f$/2.8 |
| Cityscape at twilight | 2 seconds at $f$/2.8 |
| Cityscape with dark sky | 4 seconds at $f$/2.8 |
| Fireworks | Shutter held open at $f$/8 |
| Floodlit subject (building, statue) | 1/2 sec. at $f$/2.8 |
| Holiday lighting | 1/2 sec. at $f$/2.8 |
| Light painting (flashlight at 5 feet) | Bulb at $f$/4 |
| Light painting (outlining the subject) | Bulb at $f$/5.6 |
| Moonlit subject | 30 seconds at $f$/2.8 |
| Neon sign | 1/30 sec. at $f$/2.8 |
| Reflection on wet pavement | 8 seconds at $f$/2.8 |
| Rock concert | 1/250 sec. at $f$/4 (using ISO 1600 film) |
| 75-watt light bulb (interior illumination) | 1/2 sec. at $f$/2.8 |
| Snow scene | 15 seconds at $f$/2.8 |
| Stadium sports (football, baseball, soccer) | 1/250 sec. at $f$/4 (using ISO 1600 film) |
| Star trails | 2 hours at $f$/8 |
| Store-window display | 1/30 sec. at $f$/8 |
| Street scene | 1/8 sec. at $f$/2.8 |
| Theater marquee | 1/2 sec. at $f$/2.8 |

The shutter speed controls the length of time that light enters the lens. Most cameras have preset shutter speeds ranging from 1/8000 sec. to 30 seconds. The "B" (Bulb) setting on the shutter dial permits you to manually open and close the shutter for variable long exposures. The higher the number value of the shutter speed set on the dial, the shorter the amount of time light passes through the lens. Each shutter-speed setting remains open for half as long as the setting on one side of it, and twice as long as the setting on its other side.

For example, a shutter speed of 1/30 sec. allows one stop less light than 1/15 sec., but one stop more light than 1/60 sec. When you increase the shutter speed, the aperture setting must be decreased in order to maintain the same exposure value. Suppose that the indicated exposure is 1/15 sec. at $f/8$, but you want to use the next highest shutter speed, 1/30 sec. In addition to changing the shutter-speed setting, you must open up the aperture by one stop to $f/5.6$.

The duration of exposure for a night photograph can exceed several seconds. During this period, everything that the camera sees is collected on the same film frame. The resulting photograph doesn't record a point in time, but rather an accumulation of time.

The aperture controls the amount of light that enters the lens. Each lens contains a series of numerical values known as $f$-stops. A lens' maximum aperture is the $f$-stop that allows the most light into the lens, while the minimum aperture allows the least light to enter. Typically, a lens with a maximum aperture of $f/2.8$ has the following settings: 2.8, 4, 5.6, 8, 11, 16, 22. The difference between adjacent values is equivalent to one stop of exposure. Notice that these figures represent the size of the lens opening in terms of fractions: 1/2.8, 1/4, etc. This is why an aperture of $f/2.8$ is larger than an aperture of $f/22$. When you adjust the aperture setting by opening up the lens, you let more light into the lens. Conversely, when you stop down, you let less light into the lens.

The shutter-speed setting and the aperture setting are interchangeable as long as the same amount of light strikes the film. When you double the intensity, you must halve the duration. Conversely, when you halve the intensity, you must double the duration. Suppose that you have to drive 30 miles to get to the beach. If you drive at 30 miles per hour (mph), it will take you an hour to get there. But if you decided to drive at 60 mph, it would take you only half an hour. You would arrive at the shore either way, but the length of time it would take you would differ. This is because intensity and duration are interchangeable values that yield the same results when balanced. The shutter speed and aperture work together the same way. When you change the shutter speed by one stop, you must adjust the aperture accordingly in order to maintain reciprocity.

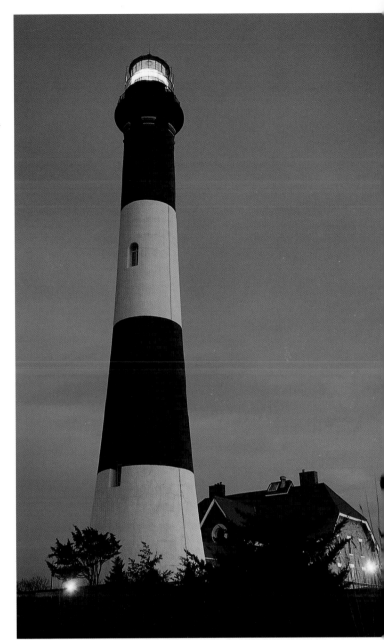

I made this shot of a lighthouse at Robert Moses State Park on New York's Fire Island at twilight. I determined exposure by taking a reflected-light reading of the deepening sky. Working with my Canon EOS-1 and a 20–40mm zoom lens, I exposed Kodak Lumière for 8 seconds at $f/11$.

# USING A LIGHT METER

In order to understand how light meters, whether TTL meters or handheld units, work, you must know how light meters measure exposure. First and foremost, all light meters—incident-light meters, reflective-light meters, and spot meters—see the world as a middle-gray tone. By measuring 18 percent of the light reflecting from a subject, the meter determines an average exposure. This is accurate when the scene includes middle tones, but rough when it doesn't. Since most night scenes don't contain middle tones, accurately exposing the contrast between the shadow and highlight areas is challenging.

When you begin using a light meter, you must first understand that it is a tool. A light meter is as important to a photographer as a ruler is to a carpenter; both are unable to do their jobs without their respective measuring devices. Precise measurements are the foundation for success for these two professionals. I wouldn't trust carpenters who consistently cut cabinet doors an inch short because they didn't measure properly, nor would I trust photographers whose exposures are inconsistent.

By itself, a light meter is actually nothing more than a paperweight, an inanimate object incapable of thinking for itself. I can't emphasize this enough. If you haphazardly point your light meter at a highlight, it will assume that the brightest portion of the scene is a middle tone. This will result in underexposure.

The effects of misreading a scene depend on the type of film used. Negative films yield a faintly exposed frame of film that prints with little or no contrast. Transparency films render the opposite effect. The resulting slides will be very dense, and their colors will be too saturated. Some transparency films can benefit from underexposure, which produces deep color saturation, as long as it doesn't exceed the film's inherent exposure latitude, which is usually just a half or a whole stop.

Overexposing transparency film, on the other hand, is disastrous. Unlike negative films that have a high tolerance for absorbing extra exposure of up to three stops, slide film doesn't successfully tolerate being overexposed. Even one stop of additional exposure can weaken color and wash

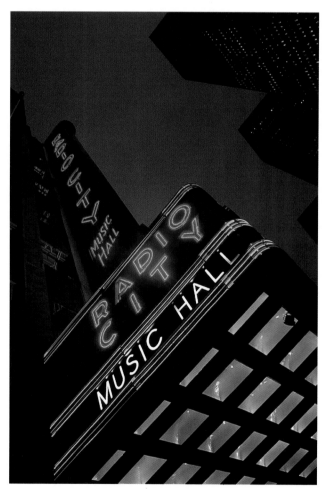

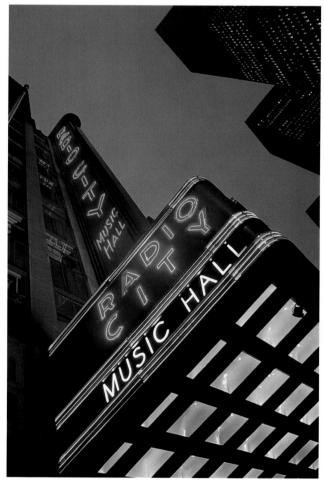

When I first started shooting the Radio City Music Hall marquee, I took a reflected-light reading. The neon lighting fooled the meter into thinking that the scene was brighter than it actually was, resulting in slight underexposure (left). The suggested exposure,

f/11 for 2 seconds, produced an acceptable shot. But the second picture with its 1-stop increase in exposure time, to 4 seconds, is better (right). For both shots, I used my Canon F1, a 24mm wide-angle lens, and Agfachrome 100 RS Professional film.

out the highlight areas. This often occurs when the section being read is a shadow area, and the meter is fooled into thinking that it is a middle tone. Subsequently, all the values in the scene reproduce lighter than normal; this results in a loss of detail in the middle tones, washed-out highlights, and a lack of rich blacks.

Clearly, overexposing slide film often renders an unusable image. To prevent mistakes like this, you must consciously meter the light values in a scene. Improper metering results in a miscalculation of exposure, which is counterproductive in terms of your time and effort.

Another way to measure the light values in a scene is to take an incident reading. This is a measurement of the light itself, independent of tones, in the scene. Most light meters contain a plastic dome that slides across their sensor probe. This feature enables you to take an incident reading. It is especially appropriate for subjects that are their own light sources, such as neon lights and illuminated signs and decorations. Simply place the meter's dome on the light source to measure its average brightness.

The incident-reading technique is an accurate means of measuring exposure, but it isn't practical for every shooting situation. Suppose that you're standing on the roof of New York City's Empire State Building and want to photograph the top of the Chrysler Building. It isn't feasible for you to walk the 10 blocks to the Chrysler Building to take a reading. If, however, you're shooting at twilight, you can take an incident reading from the top of the Empire State Building, deduce its brightness, and then set the exposure, but a better choice would be to take a reflective reading of the twilight sky.

A reflected-light meter is the most common type of handheld light meter. As its name implies, it measures the light reflecting from a subject. It has a range of coverage between 30 degrees and 50 degrees, and it bases its reading on the average of all the light values in the scene as middle tones. Sometimes, however, a reflected-light meter's angle of view is too expansive and permits unimportant light values from the shadow or highlight areas to influence the reading. This, of course, results in an incorrect exposure. A solution to this problem is to isolate a portion of the scene of average light value—a middle-gray tone—and to base the exposure on it.

A more accurate (and slightly more expensive) type of reflective-light meter is a spot meter. By looking through a scope, you can read a portion of the scene at approximately 1 degree. A spot meter is useful in determining exposure for a variety of night-photography subjects; however, it is especially beneficial for scenes that have few or no middle tones, such as concerts and performances. Often conventional meters are fooled by this type of photography, in which a dark stage is illuminated by spotlights. But spot meters are able to base exposure on a small section of the scene, thereby producing the most accurate measurement possible. In these shooting situations, it is essential to

accurately expose the performers under the continually changing stage lights. A spot meter can isolate a hard-to-find middle tone, which is most likely on the performer. Pictures that contain people should never be bracketed. It isn't sensible to miss a compelling gesture or expression because the subsequent frame of the bracketed set was under- or overexposed.

Using a spot meter is a slightly more complicated process than using a conventional handheld meter is. Most reflective-light meters average all the values in a scene as a middle tone, and while they can easily be fooled by shadow and highlight areas, they're forgiving. Spot meters assume that all the light values that they measure are 18-percent-gray tones. So, the exposure will be affected even when the spot meter reads a middle tone—unless it is 18-percent gray. You should be familiar with light values and film response in order to successfully work with a spot meter. Often, the area being read is either lighter or darker than middle gray, making it necessary for you to compensate for this difference.

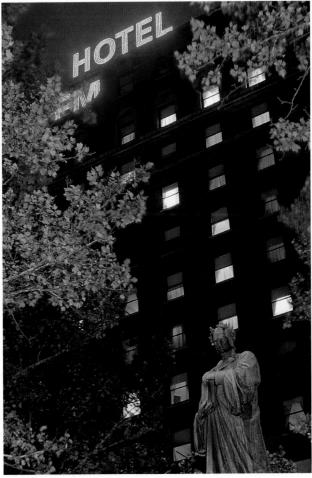

Spot meters can measure exposure by utilizing just a small portion of the scene. Here, I metered the statue, which appeared as a middle-gray tone in a scene with many shadow areas. Shooting with my Canon F1 and a 135mm telephoto lens, I exposed Agfachrome CT 100 film for 15 seconds at f/8.

# USING YOUR CAMERA AS A LIGHT METER

In this era of the sophisticated SLR, using your camera's internal light meter provides many advantages. For example, you have a variety of metering choices at your disposal. And when you use the light meter in conjunction with automatic-exposure modes, picture taking is simplified.

TTL metering measures the average light falling onto the film. The most prevalent type is center-weighted metering, which is the descendant of the average reading that SLR cameras of yesteryear provided. As its name implies, a center-weighted meter is influenced most by the middle of the frame. The meter averages the edge and corner values, but at a smaller percentage. Although each camera manufacturer has its own guideline for these sensitivity proportions, the breakdown is generally 60–40 or 75–25. (The higher number is the percentage of the exposure the center influences.)

While the built-in spot meter eliminates your need to jockey between your camera and your light meter when you photograph, it can't match the pinpoint accuracy that a handheld spot meter offers. This primarily involves the angle of view of the area being measured. A handheld spot meter reads a scene at a 1-degree angle and is independent of the camera. When you work with this type of meter, you can walk up to a specific part of the scene and measure it without having to move your camera.

The internal spot meter does, however, have limitations. It reads a scene at a 3-to-5-degree angle, but the actual size of the area being measured is influenced by the lens' focal length. So, a wide-angle lens reads a much larger portion of the scene than a telephoto lens does. Furthermore, you would need a 300mm lens in order to match the precise coverage of a handheld spot meter.

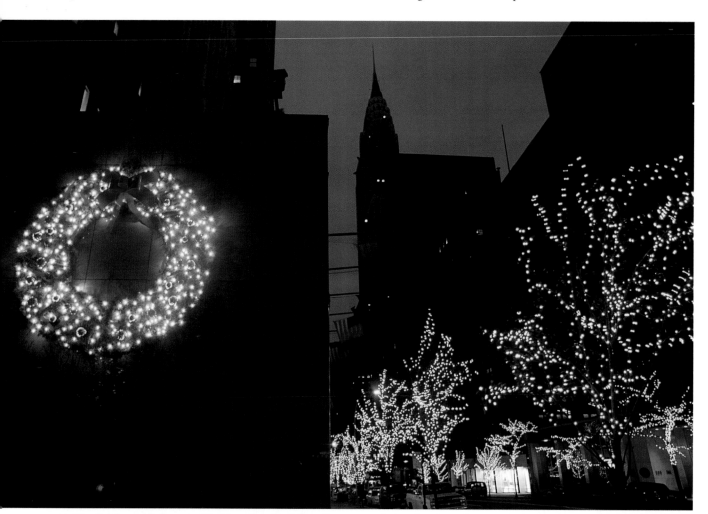

Holiday lighting adds flavor to this silhouette of buildings. Because the scene consisted primarily of shadow areas, a reflective reading wouldn't have rendered an accurate exposure. I determined exposure in an unorthodox manner for this shot: I measured the light values from the wreath. The wreath contained highlights and shadow areas that canceled one another out, thereby resulting in an average reading. Shooting with my Canon F1 and a 24mm wide-angle lens, I exposed at ƒ/8 for 20 seconds on Ektachrome 100X.

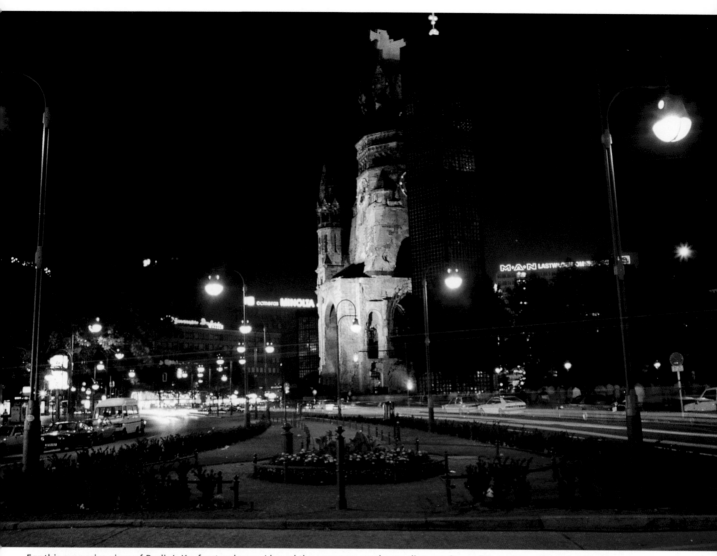

For this expansive view of Berlin's Kurfurstendamm, I based the exposure on the reading my Canon F1's center-weighted-metering pattern provided. Although the center of the frame is brighter than the edges, the metering seemed to balance the scene. It works because the subject consists primarily of midtones. Shooting with a 28mm wide-angle lens, I exposed at *f*/11 for 8 seconds on Ektachrome 160T.

# BRACKETING

The information that you get from the light meter is actually just a starting point because it is difficult to predict how a night subject will reproduce on film. As a result, it is necessary to bracket exposures. Here, you photograph two or more variations of the same scene while increasing or decreasing exposure. This aids in overcoming the ambiguous nature of nighttime illumination. Such factors as reciprocity failure decrease the predicted density in exposure times longer than 1 second.

The standard procedure for bracketing exposure consists of shooting three frames of the same subject: one properly exposed, one underexposed, and one overexposed. You should shoot the first frame following the meter's suggestion, and then decrease and increase exposure for the succeeding frames. This will ensure achieving an optimal exposure.

The number of bracketed frames you shoot and the increments between each exposure depend on several variables. When you use a negative film, usually you have to shoot only two frames: one that is normally exposed and one that is one to two stops overexposed. Negative film has an exposure latitude that extends from two stops of underexposure to three stops of overexposure. Although

this range varies with each negative film, the margin for error is still forgiving. The only exceptions are the new higher-contrast, slow-speed films, such as Kodak Ektar 25 and Agfa Ultra, which have a limited exposure latitude.

While negative film gives you a great deal of leeway when it comes to exposure, slide film is relentlessly rigid. With a limited exposure latitude that goes from one stop of underexposure to one stop of overexposure, the margin for error is quite small. Because of the precise nature of transparency film, you must bracket at least three frames in $^1\!/_2$- to 1-stop increments depending on the light values in the scene.

Some purists feel that bracketing is a waste of film and point out that it limits each roll of film to a fraction of its potential. As an alternative, they suggest taking a concise reading of the scene and shooting a single frame. The final decision requires an understanding of the film's limitation, the light source, and the necessary compensation for reciprocity failure. Although this is an admirable idea, it doesn't apply to shooting at night. Given the enormous expenditure this type of photography demands in terms of both time and equipment, I regard film as the cheapest link in the chain.

Night subjects often offer a wide range of acceptable exposures, and bracketing enables you to choose the best of several images. For this sequence I first took a reflected-light reading of the sky. The meter suggested an exposure of 4 seconds at ƒ/11 (bottom right). Keeping the same aperture, I bracketed this normal exposure by shooting for 2 seconds at ƒ/11 (above), and then by increasing the duration of the exposure to 8 seconds (top right). The meter's initial reading provided an acceptable image, but the best exposure is the slightly underexposed version. I made all three photographs with my Canon F1, a 24mm wide-angle lens, and Agfachrome 100 RS Professional film.

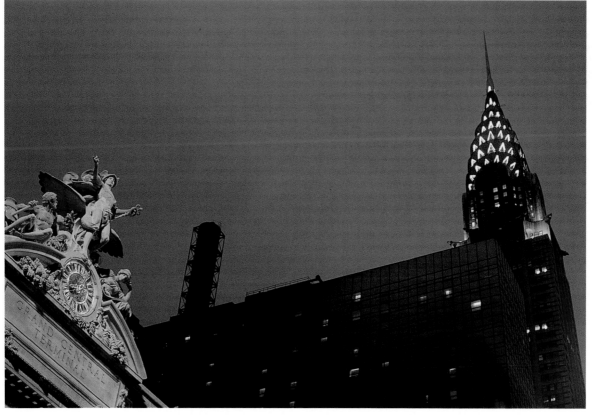

# RECIPROCITY FAILURE

The law of reciprocity states that corresponding changes of the shutter speed (duration of exposure) and the aperture (intensity of exposure) will yield identical results. So, if you double the shutter speed and halve the aperture, or double the aperture and halve the shutter speed, the same amount of light will reach the film. For example, an exposure of 1/4 sec. at $f/11$ is the same as 1/8 sec. at $f/8$. This pertains to exposures that last 1 second or less. At longer exposure times, the film's silver halides don't get exposed at the same rate. As a result, predicting what the final image will look like is difficult.

Reciprocity failure occurs when the duration of exposure falls outside the prescribed range. For most nighttime situations, exposure times are often several seconds or more. As a result, the film is less efficient at absorbing light, which leads to a loss of film sensitivity. To compensate for this and to correct the change in density, increase exposure by $^1\!/_2$ to 1 stop. Opening up is preferred to lengthening the exposure because an increase in exposure time makes the effects of reciprocity failure more noticeable.

When you use color film, reciprocity failure can affect the color balance in your images. Color film is made up of three emulsion layers that are exposed in unison when the exposure time is within a film's predetermined range. When the exposure times are longer than several seconds, each layer is exposed independently of the other. The layer with the most exposure will dominate the color balance, and the layer with the least exposure will lack color. Each type of film behaves differently. Density changes and suggested filtration options are listed inside every box of professional film. Amateur films aren't intended for critical use, so most manufacturers don't include information about reciprocity failure with them.

The effect of reciprocity failure on color varies with the length of exposure. Exposure times of 2 or 3 seconds produce a minimal color cast, but exposures that last 2 or 3 minutes result in a very prominent cast. In order to know how a particular film responds, you should test it before you use it seriously to determine the color-correction filter that works best with it.

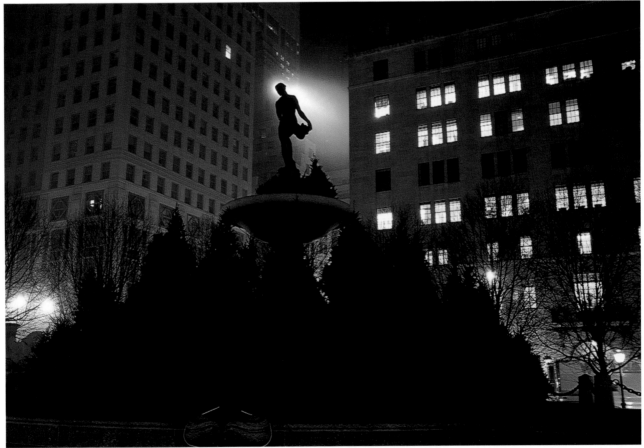

The strength of this picture of the Pulitzer Fountain in New York comes from the appealing interior illumination and the backlighting in the scene. I used my Canon EOS-1 and a 20–35mm zoom lens to capture a wide view of this subject. The exposure was 30 seconds at $f/8$ on Fujichrome 100 RD film.

I noticed this view of a skyscraper one evening while staring at its reflection in the window of another office building. You can always depict a commonplace subject in a compelling manner simply by altering the way you look at it. I thought that this scene would prove interesting in the final image if I incorporated both the skyscraper and its reflection in the frame. As I composed the image, I grew concerned about reciprocity failure, however, because of the long exposure time this shot required. Shooting with my Canon F1 and a 28–85mm zoom lens, I exposed Agfachrome CT 100 for 30 seconds at $f$/11.

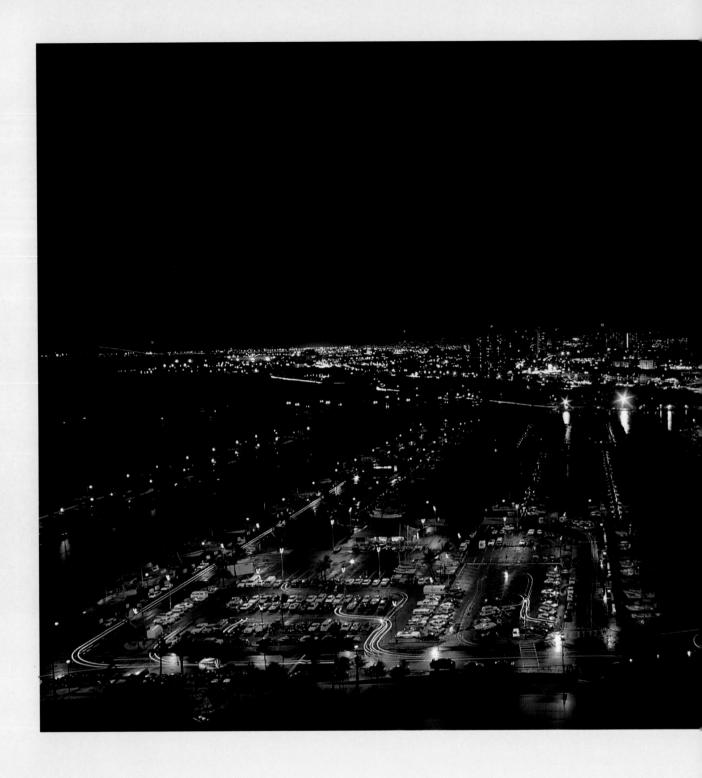

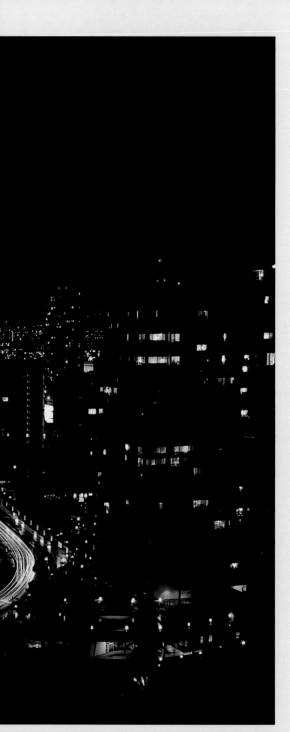

# THE UNPREDICTABLE NATURE OF NIGHT LIGHT

Night-photography subjects depend on artificial illumination. Gone is the predictability of sunlight, replaced by a dozen or so forms of artificial light. Each of these creates light in a distinct—and distinctly problematic—manner. The success of photography after dark depends on your ability to understand and take advantage of each form of light, as well as to counteract any adverse effects.

The most dominant characteristic of artificial illumination is the color of light it produces. Every light form corresponds to a specific color temperature, which renders that color cast on film. With certain types of illumination, such as mercury-vapor light, the color of the light is apparent to the eye. But you shouldn't be fooled by appearances. Determining exactly how the light will reproduce on film is hard.

# ARTIFICIAL ILLUMINATION

Your perception of color is based on viewing an object in white light. The color receptors in your retinas are sensitive to red, green, and blue light. When these three primary colors are present in equal amounts, they cancel one another out, thereby creating white light. White light is able to show a full spectrum of color. Sometimes the light is dominated by one or more of these colors, but you continue to "see" an object's hue by recalling the color from your visual memory. Naturally, film doesn't have this ability, so it renders the object with a bias toward the dominant color. The basis of nighttime photography, then, becomes a quest to identify and correct light of limited color.

The first step in creating a successful photograph under artificial illumination is to observe the color cast. You can then determine the color temperature of the light. For example, most street lamps shimmer with a yellowish glow that helps create a sense of security. A parking lot, on the other hand, might have lights that produce a green-cyan cast that reminds you of a bad science-fiction movie.

Lower-wattage tungsten bulbs, which are usually found in the home, have lower color temperatures than their higher-wattage counterparts. Because this holiday display used a 100-watt bulb, it is noticeably warm. I made this shot with my Canon F1 and a 50mm standard lens, exposing Kodachrome 64 for 4 seconds at f/8.

In either case, function is its only concern. The sole purpose of these forms of monochromatic light is to provide economically efficient illumination. They aren't meant to establish an environment conducive to night photography. The next time you find yourself in a situation that uses either of these types of light, pay attention to the unflattering illumination that bathes objects in the scene. Its limited spectrum of color is very noticeable.

But the effectiveness of corrective filtration is limited with most light sources. Only those kinds of light that produce a full spectrum of color can be adjusted to match a subject's color. Other light forms, such as high-intensity discharge lamps, are limited in terms of color rendition (see page 80).

To utilize the various techniques that will enable you to shoot effectively under such conditions, you need a working knowledge of color temperature. This is the measurement of an incandescent light source on the Kelvin scale. Different light sources allow the predominant wavelength to create a specific color. The Kelvin-scale values range from 1800K for candlelight, to 3200K for tungsten light, to 5500K for daylight and flash, and to 11,000K for open shade. When you shoot daylight-balanced film, the respective color balances for these Kelvin values are warm red, warm yellow, normal, and very blue. Being aware of color temperature provides you with a guideline for adjusting a film type to the light source you're working with. The result: optimal-color night photography.

You can correct incandescent light sources by using color-conversion filters to achieve a full spectrum of color. Unfortunately, most nighttime subjects are illuminated by high-intensity discharge lamps, which produce a limited spectrum of color and are often monochromatic. Furthermore, they don't respond well to filtration, although some solutions are possible (see chart).

### COLOR-CONVERSION FILTERS

| To convert: | To | Use this filter: |
| --- | --- | --- |
| 3200K | 5500K | 80A |
| 3400K | 5500K | 80B |
| 3800K | 5500K | 80C |
| 5500K | 3200K | 85B |
| 5500K | 3400K | 85 |

Most of these observations about artificial-light sources are based on transparency films. Slide films tend to differ from one another in daylight conditions; some are warmer than others. Under artificial illumination the differences among films are even more dynamic and noticeable. For a while I liked Agfachrome because its magenta/blue color cast more effectively rendered nighttime scenes than daytime scenes. I find that cool films seem to fare better at night than films with an extra-warm rendition do; they have a tendency to reproduce subjects with a yellow cast.

Incandescent light sources produce light as a by-product of heat. This simple study of burning coals reveals a wide range of color temperatures. The fire's orange glow is approximately 2000K, while its outer portion, illuminated by the twilight sky, is around 15,000K. Working with my Canon F1 and a 28–85mm zoom lens, I exposed for 2 seconds at ƒ/11 on Agfachrome CT 100.

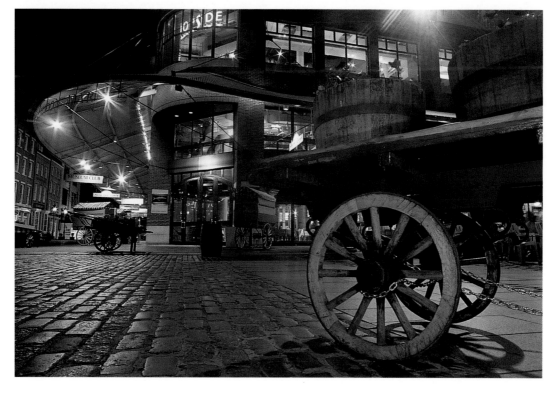

This mixed-lighting situation near New York City's Fulton Fish Market contains the primary colors of light, red, green, and blue; these independent colors create the illusion of full color. The tungsten film I shot cooled the warm tones without affecting the neon. Several pops of unfiltered flash illuminated the wagon. The combination of the flash's high color-temperature output and the tungsten film resulted in a blue tone. Shooting with my Canon F1 and a 24mm wide-angle lens, I exposed Fujichrome 64T for 10 seconds at ƒ/11.

# INCANDESCENT LIGHT SOURCES

Incandescent light sources create light as a by-product of heat. They produce a full spectrum of color wavelengths, thereby making optimal color rendition possible. These sources include sunlight, candlelight, and tungsten light. Tungsten illumination, which is the predominant light found after dark, comes in many forms: household bulbs, studio lights, and automotive headlights. The color temperature of tungsten light is usually 3200K, but it can be as warm as that of a 2600K, 75-watt light bulb or as high as that of a 3400K photoflood lamp.

Most people consider photography to be a daylight endeavor. Some would argue this point, but the reality is that each film manufacturer offers about 20 types of daylight-balanced transparency film and only one or two types of tungsten-balanced film. If you know ahead of time that you're going to shoot a subject in this kind of light, it is a good idea to get some tungsten film. You'll then be able to shoot without using a filter.

Because daylight-balanced film dominates the market, most photographers will have a roll of this film in their camera. When you shoot a scene that is illuminated by tungsten light with a daylight film, your subject will have a warm-yellow appearance in the final image. If, however, you use an 80B color-conversion filter, you'll effectively adjust the daylight film to the artificial-light source and minimize this color cast throughout the entire image. If, however, you want to eliminate only a portion of that warm rendition rather than all of it, try using a blue filter in the 10CC-to-30CC range. This will maintain the warmth of the photograph but make it less intense.

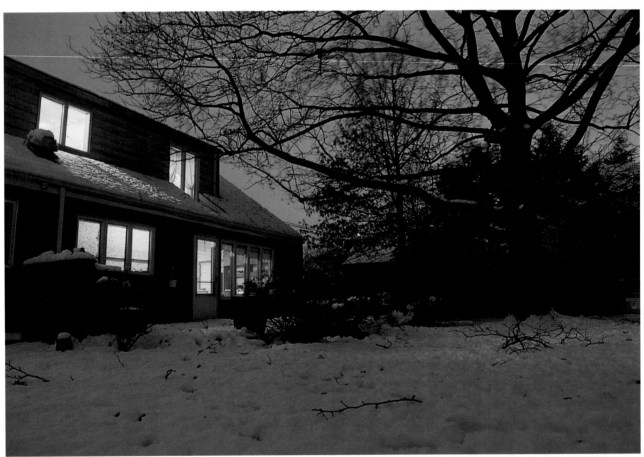

I photographed this tranquil snow scene at twilight. At this time of night, the color temperature of the ambient light is 11,000K and produces a blue cast. The tungsten illumination in the interior of the house, on the other hand, has a color temperature of 3200K and is warm in comparison. Because I photographed these two light sources on daylight-balanced film, their effects are exaggerated: the available light appears even cooler and the artificial light appears warmer than usual. Shooting with my Canon EOS-1 and a 50mm standard lens, I exposed for 30 seconds at ƒ/5.6 on Kodak Lumière.

This photograph reveals the accurate exposure determination that a handheld reflected-light meter reading can produce. By pointing my Minolta Autometer IIIF at the South of the Border sign, I was able to achieve proper exposure. With my Canon F1 and a 28–85mm zoom lens, I exposed Agfachrome 100 RS Professional film for 1/2 sec. at ƒ/8.

# HIGH-INTENSITY DISCHARGE LAMPS

High-intensity discharge lamps, or HIDs, are the most efficient forms of artificial light. HIDs work by passing an electrical current through a vapor or gas instead of a tungsten wire. The electrical current excites the atoms and ionizes the gas, thereby producing illumination. Using this type of light is advantageous for several reasons. For example, HIDs last much longer, burn much brighter, and are more optically effective than incandescent bulbs.

But HIDs do have one flaw. The excitement of the gas corresponds to a single wavelength of light. As a result, the light is composed of a single color, rather than equal amounts of the primary colors. Since HIDs don't produce a full spectrum of color, you can't achieve a critical color correction with them. HIDs are often monochromatic light sources. For example, a mercury-vapor lamp, which is often used for highway lighting or building façades, has a cyan cast. When you neutralize this color cast, the scene becomes void of color.

HIDs are sometimes hard to distinguish from one another. Often the color cast of this light is apparent only to a trained eye. In any event, you can only approximate what type of light is used, so you never know the exact filter to use. Fortunately a wide range of color acceptability exists in the forgiving world of night photography. If you want to achieve optimal color, an effective solution is to bracket the scene using various combinations of complementary filters. For example, if the light source emits a cyan light, you can use a red filter to provide balance and to render the illumination neutral. Start with the lightest complementary filter and gradually increase the strength of filtration with each set of bracketed exposures. Filters come in various strengths, such as 5CC, 10CC, 20CC, and 40CC. The higher the number, the more intense the filtration is. By experimenting with different grades of complementary-color filters, you can determine which strength works best to correct a particular

color cast. Don't forget to slightly increase exposure to compensate for the filter value. A good idea is to bracket three exposures of each filter in $^1/_2$- to 1-stop increments when you shoot.

Afterward, examine the film and take notes of the effect of each filter combination. Each brand of film will have its own color balance. Surprisingly, films produced by the same manufacturer will often differ from one another, too. For example, the Kodak films Lumière, Kodachrome, and Ektachrome all reproduce color distinctly. Their emulsions are constructed of different dyes and color couplers, so each film records the same scene differently at twilight: Lumière has a neutral-to-warm cast; Ektachrome, a blue cast; and Kodachrome, a green cast.

After the slides are back from the lab, you can learn about the intricacies of artificial light and its effect on film. While doing this, take a complementary-color filter or a Kodak viewing filter, and hold it over the slide. This will give you some idea of how to optimally adjust for color on your next outing.

While twilight is always a good time to shoot, this is particularly true when a scene is illuminated by HIDs. The presence of ambient light prevents the color cast of the light source from dominating the image. The duration of the twilight period is brief, less than 30 minutes. The remaining natural light can supplement a light source with limited color, as well as enable you to create a more successful image. You should consider the aesthetics of night photography. For example, a subject with a sodium-vapor light source is enhanced by a twilight sky. I often come upon large sculptures illuminated by sodium-vapor lighting. When I shoot them at twilight, the deep blue sky complements the yellow cast and makes the sculptures stand out against them. Ambient light allows the suppressed colors of the spectrum, such as blue light, to be present. HIDs are divided into four types.

SUGGESTED FILTRATION FOR HIGH-INTENSITY DISCHARGE LAMPS

| Light Source | With Daylight-Balanced Film | With Tungsten-Balanced Film |
|---|---|---|
| Sodium vapor | 70 blue, 30 cyan | 50 magenta, 20 cyan |
| Mercury vapor | 80 red | 80 red, 40 yellow |
| Deluxe mercury vapor | 40 magenta, 20 yellow | 70 red, 10 yellow |
| Multivapor | 10-20 magenta* | 50 red, 10 yellow* |

* For sources closest to daylight balance

## SODIUM-VAPOR LAMPS

These lamps create light by arcing an electrical current through vaporized sodium. This illumination is used for street lighting, as well as accent lighting for a building or a piece of sculpture. Sodium-vapor lamps, which have a color temperature of approximately 2200K, don't produce a full spectrum of color. They produce a yellowish glow.

Sodium-vapor light is often wrongly perceived to be similar in appearance to tungsten light. Simple filtration quickly reveals the difference. When tungsten lighting is correctly filtered, it produces a full spectrum of color. Because sodium-vapor lamps produce only yellowish illumination, they must be corrected with a complementary blue or magenta filter when you use daylight film. This serves to cancel out the yellow, rendering the image as a series of grays and blacks. Keep in mind, though, that while this filtration can tone down the color, the scene may retain little or no color, an effect that isn't always appropriate.

In this photograph of New York City's Grand Central Station, a high-pressure, sodium-vapor light source provides the illumination. Under this light, the statue appears quite yellow, but it comes to life against the complementary twilight sky. Working with my Canon F1 and a 100mm telephoto lens, I exposed at *f*/11 for 8 seconds on Agfachrome 100 RS Professional film.

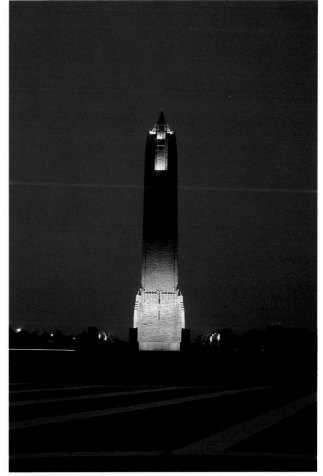

Scenes that contain light from high-intensity discharge lamps can't be corrected via tungsten film. The water tower at Jones Beach State Park on Long Island is illuminated by a sodium-vapor light. I photographed the tower early one evening, so the deep blue twilight sky complements the warm tower (left). Here, I used my Canon F1 and a 24mm wide-angle lens, and exposed for 8 seconds at *f*/11 on Agfachrome 100 RS Professional film. Next, I shot the tower using Fujichrome 64T, a tungsten-balanced film (right). With the same camera and lens, I exposed for 8 seconds at *f*/8½. This image has a strong cyan cast. The original, uncorrected version looks better.

## MERCURY-VAPOR LAMPS

Mercury-vapor lamps, as their name suggests, use an electrical discharge to stimulate vapor. They produce a bright, efficient light. Mercury vapor is an effective way to illuminate, for example, a highway, a parking lot, or an office building. I consider this the worst type of light to photograph under. Several varieties of mercury-vapor light exist, but the most popular forms are standard and deluxe. Standard mercury-vapor lamps have a color temperature of 6800K and emit a greenish light, high in ultraviolet. When you shoot under standard mercury-vapor lamps using a daylight-balanced film, the subject will have a heavy green/cyan cast. Once again, corrective filtration with red or magenta filters will eliminate the color cast, leaving the image colorless.

Deluxe mercury-vapor lamps are similar to standard mercury-vapor lamps. They do, however, differ in one significant way: the inside of their tubes are coated with a phosphor that reduces its light temperature to 3700K.

Deluxe mercury-vapor lamps are used predominantly to illuminate interior spaces, such as department stores, supermarkets, and warehouses. If you come across deluxe mercury-vapor lamps in a potential shooting situation, you'll find that using a 40CC magenta filter and a 10CC-to-20CC yellow filter will improve the color rendition.

## MULTIVAPOR LAMPS

Multivapor lamps are the HIDs that come the closest to recreating a full spectrum of color. Their behavior simulates, to a certain extent, that of an incandescent light source. Similar in design to deluxe mercury-vapor lamps, multivapor lamps have a superior color balance that results from the several different phosphors in their envelope.

Multivapor lamps cover a wide range of light temperatures, from 3200K to 5500K. Lamps at the high end of that range are used for stadium and arena lighting. As a result, shooting daylight film under them renders subjects in close to full color. The lamps' function is to

The time of night worked to my advantage while I photographed this arbor in the park. Because I made this shot at twilight, the sky was light enough to prevent the image from being a monochromatic green. The faint warm tones from the gazebo and traffic patterns provide a range of colors. With my Canon F1 and a 24mm wide-angle lens, I exposed for 60 seconds at *f*/8 on Kodak Lumière.

provide an even amount of color for events that are televised on a regular basis. For example, they enable viewers to watch "Monday Night Football" in living color. Try to imagine what would happen if a stadium used sodium-vapor lamps. Either you would see the game through a yellow cast, or you would find yourself close to watching it in black and white if the yellow light were absorbed.

## FLUORESCENT LIGHTS

Fluorescent lighting is the most popular form of interior illumination. As such, it provides a light source for skyline photographs. Fluorescent lights are similar in design to mercury-vapor lamps in that they use an electrical charge to excite the mercury in their tubes. And, once again, the various color renditions come from the different phosphors that coat the inner portion of the tubes. While most forms of fluorescent lighting aren't applicable to the Kelvin scale, one version, daylight, is what enables you to view your transparencies on a light table.

Fluorescent tubes come in seven varieties, and each produces a different color balance. The next time you walk past an office building, look at the lighting on each floor. You might notice that each window or entire floor has a different color cast due to the type of fluorescent light used. One might have a green glow, while another looks cyan. When you can see these subtleties with your own eyes, you can expect the film you're using to exploit them even further. In most cases, I feel that a skyline illuminated by a fluorescent-light interior doesn't need to be corrected. As a matter of fact, I think that the fluorescent illumination strengthens the images by providing several distinct colors of light. For example, a successful skyline image may consist of a rich blue sky as the background, streaks of red light from traffic zipping through the foreground, and hundreds of tiny squares of green light in the buildings. Each of these subjects produces its monochromatic color individually, but collectively they create a full color image.

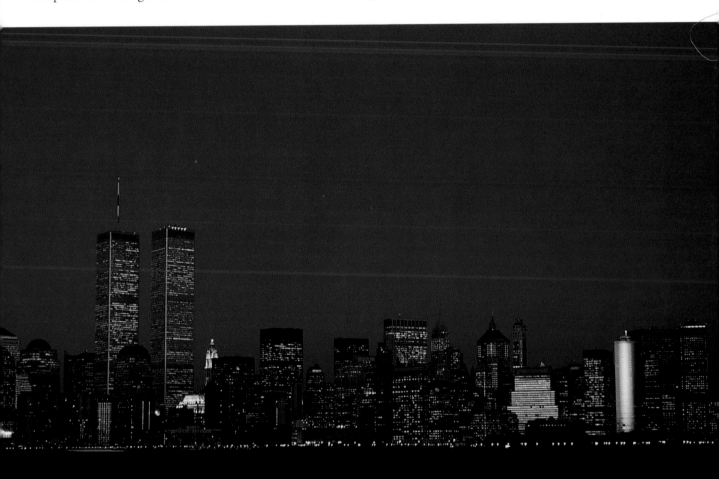

This shot of the Lower Manhattan skyline reveals another benefit of shooting at twilight: maintaining forms. Here, the ambient light defined the outer edges of this skyline. If I'd shot this same skyline later that night, the picture might have consisted of several hundred tiny windows. The illumination inside the windows is either green or yellow. This is because of the various forms of fluorescent lights each office uses. Working with my Canon F1 and a 135mm telephoto lens, I exposed for 8 seconds at ƒ/11 on Kodachrome 64.

# MIXED-LIGHTING SITUATIONS

Sometimes you'll come across a nighttime shooting situation that contains more than one form of artificial light. In order for you to deal with these successfully, your first step is to identify the dominant light source in the scene and correct it with a complementary-color filter. If the primary illumination is coming from a sodium-vapor street lamp, for example, you'll need to use a blue filter to absorb the yellow light. The filtration shouldn't be too heavy; if it is, it will absorb all of the light and deplete the scene of color.

Another solution is to adjust for two types of light. If the scene contains a sodium-vapor street lamp and a mercury-vapor lamp, you can correct for a portion of the yellow light by using a blue filter and for a portion of the cyan light by using a red filter. Unfortunately, once again, this technique can rob the scene of color if you absorb too much of the complementary light by overfiltering.

The third solution is appropriate for situations that contain three or more colors of light. Under these extreme conditions, I recommend not using a filter. Your final images will include the dominant color of each light source. Here, for example, a tungsten accent light will be a reddish-yellow, a mercury-vapor flood light will be cyan, and sodium-vapor street lamps will be yellow. If you also include a building with three or four colors of fluorescent lights, you'll have a color-rich scene derived predominantly from monochromatic sources.

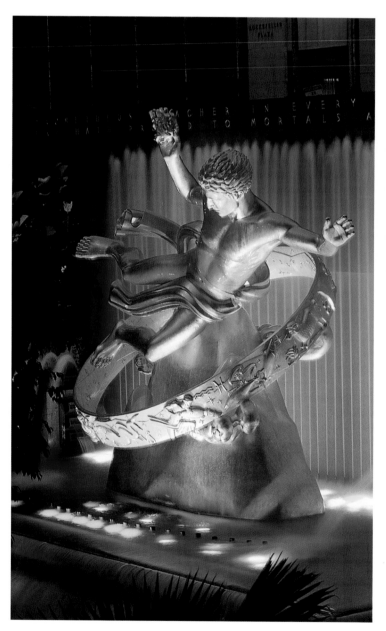

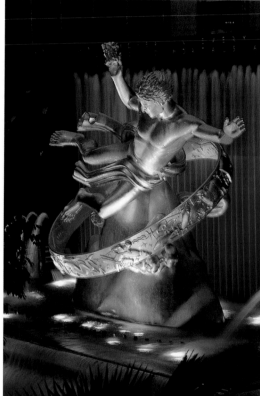

Sometimes the color of a nighttime photograph comes from colored accent lights. Although I made these two shots of Prometheus at New York City's Rockefeller Center within a minute of one another on a summer evening, they look completely different. One photograph feels somber because of the blue and green spotlights (above). The other shot, which I made when the color of the lights changed to red, yellow, and green, is much more upbeat (left). In both scenes, tungsten–halogen spotlights provided the illumination. With my Canon F1 and a 28–85mm zoom lens, I exposed for 8 seconds at f/11 on Fujichrome Velvia.

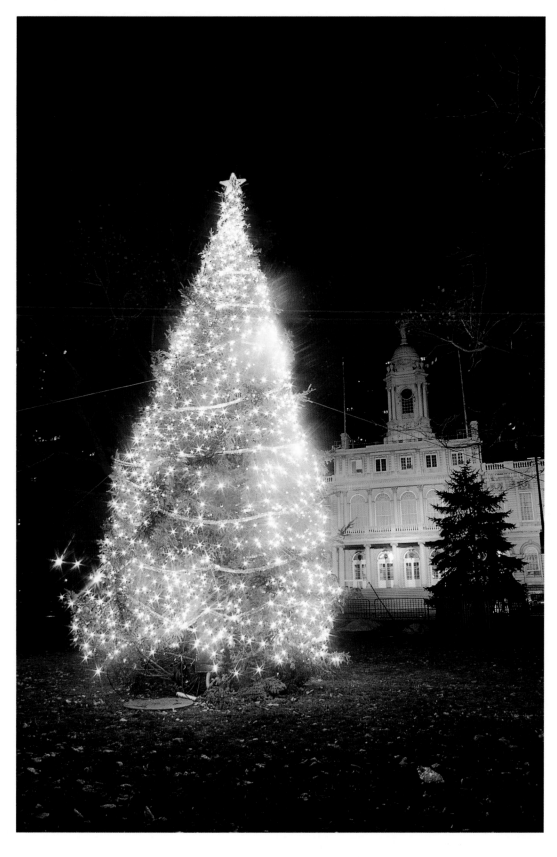

This Christmas tree in New York's City Hall Park had a set of lights whose color temperature was lower than that of tungsten lighting. The tree's yellowish appearance is juxtaposed with the mercury-vapor illumination of the City Hall façade. I find that in most mixed-light situations, it is best not to color correct unless absolutely necessary. Shooting with my Canon F1 and a 24mm wide-angle lens, I exposed Kodachrome 200 for 10 seconds at ƒ/11.

# AESTHETICS OF THE NIGHT

Photography is a visual medium, and one of its primary functions is to create a viewer-friendly image. A well-executed picture enables viewers to take a leisurely look and draw a coherent conclusion. The importance of the subject isn't as essential as the manner in which it is produced.

Take a look through photography books. You'll see color photographs, black-and-white shots, handcolored pictures, and computer-manipulated images. These photographs will range from exciting, to dull, to cheerful, to despair-ridden, to humorous, to serious. You might also discover morbid pictures of life and endearing pictures of death. Obviously, photographers can depict emotion in a scene in many ways.

# THE THOUGHT PROCESS

Although the thought process involved in shooting at night differs slightly from that associated with shooting during the day, the fundamentals are retained. Studying some of these basics can add impact to your photographs without compromising your individual style. For example, a photograph's composition should convey your intentions regarding the way you want to depict a subject as simply as possible. And the proper lens focal length is important to a photograph's design. Understanding the technical side of photography is critical because this knowledge enables you to control and present your subject in an impressive manner. Uniting technical concerns and aesthetic preferences will bring you closer to creating successful nighttime images.

While you can't be taught a specific thought process, you can absorb techniques to improve your photographs. Visual literacy is like the alphabet in that it has to be learned. This takes time, but you'll eventually become more accustomed to recognizing the visual possibilities of each potential subject more clearly. Effective night photography also depends on your familiarity with your camera equipment. The constant use of your camera, lenses, and accessories will help you transfer your thoughts to film. The more you develop your interest in various subjects and work with your gear, the smaller the number of subjects that will elude you. A consciously aware photographer can transform a mundane subject into a compelling one, regardless of the situation.

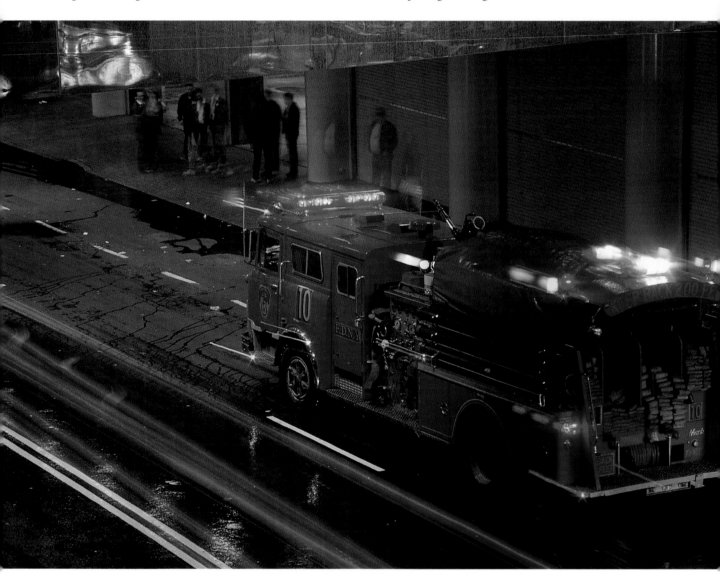

When I came upon this fire engine, I composed the image in my head first, using various elements in the scene to my advantage. I framed the top in such a way that gave the photograph a sense of depth. I also knew that the length of the exposure would produce appealing effects. The people are rendered as ghosts, and the taillights of the passing cars are collected as streaks. With my Canon F1 and a 28–85mm zoom lens, I exposed for 4 seconds at ƒ/8 on Agfachrome CT 100.

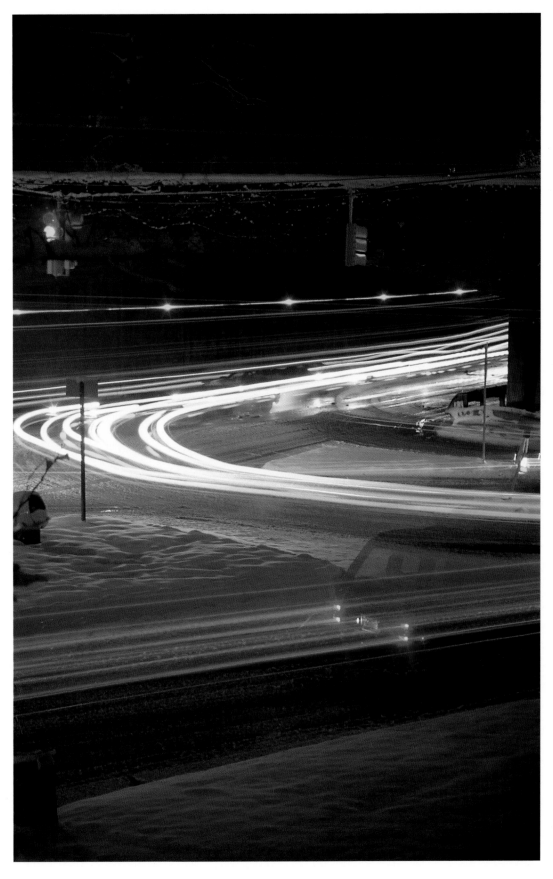

In well-composed images, sweeping curves gracefully lead viewers on a diagonal journey. Here, traffic patterns winds through the frame. Shooting with my Canon F1 and a 28–85mm zoom lens, I exposed for 30 seconds at ƒ/11 on Agfachrome 50 RS Professional film.

# COMPOSITION

Composition is the most deliberate part of the picture-taking process. Coherently depicting the objects of this three-dimensional world onto a two-dimensional surface takes a great deal of thought. You must learn to balance the placement and order of important elements in a scene. A well-composed photograph gets its point across simply, yet is still able to fully convey a feeling. Image success depends on whether or not viewers understand your purpose clearly. Although many composition rules exist, as does a surplus of opinions about how to or how not to arrange a picture, some fundamentals are essential. For example, a picture should have a single center of interest, lines should lead viewers into the picture, and the center of interest should be placed in one of the "thirds" of the frame. These are, of course, prerequisites for depicting a scene successfully, but sometimes you must go beyond the basics to create a provocative image.

I believe that photography should be considered as entertainment for the eye, and that each image should relate its own story. As with most kinds of storytelling, sometimes the result is clearly perceptible; at other times, it is obscure. The way that the objects in the scene are arranged, ordered, juxtaposed, angled, isolated, colored, or cropped determines the outcome of the photograph. Each viewer comprehends at least some, if not all, of what the photographer is trying to convey.

If you aren't sure that a particular picture will achieve your intended effect as you shoot, try to imagine how viewers will respond while they look at the final photograph. If the center of interest is apparent and your eye is led into it, you should proceed, so press the shutter-release button. However, if you look through the viewfinder and find yourself confused by what you see, you should recompose the scene.

You can't gain a working knowledge of composition solely from a book; you need the experience that comes from taking many pictures. A photograph can be subtle, depicting the quiet beauty of softly rendered color, or complex in theme, depicting an allegorical tale of street people. Whatever extreme is recorded, it is important that viewers understand the image on a visual level.

The key to building a successful image lies in its simplicity. The axiom "less is more" is quite appropriate in terms of the picture-taking process. Viewers must

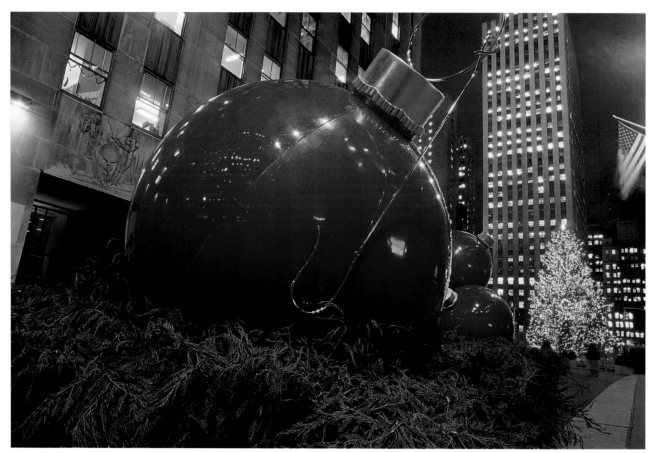

Depending on the camera-to-subject distance and lens focal length, you can create either the illusion of depth or a sense of compression in a photograph. Because these unusually large holiday ornaments are only several feet from the lens, their proportions are exaggerated: the 10-foot-high ball seems as large as a 40-story office building. With my Canon F1 and a 24mm wide-angle lens, I exposed Kodak Elite 100 for 45 seconds at ƒ/8.

understand your purpose without being distracted. All too often photographers try to say too much in a single image. Then, when the center of interest isn't obvious, viewers are confused and disoriented.

## EFFECTIVE VERSUS INEFFECTIVE COMPOSITION

In terms of night photography, a fine line exists between effective and ineffective composition. When an image is effectively composed, it doesn't contain any extraneous clutter. The challenge is to conquer the gremlins that are characteristic of night scenes. These occur primarily as by-products of the artificial-light sources that illuminate places at night.

During the day, the sun is the primary source of light. When the sun is in front of the camera, its rays shine into the lens, causing flare. You can solve this problem by altering the camera angle or waiting for the sun's position to change. This luxury doesn't exist at night. When you attempt to photograph a subject after dark, you have to contend with the physical properties of each light source that remain constant.

Artificial-light sources have only a limited area of coverage, so night scenes are filled with street lamps, accent lights, and building lights. The various forms of artificial illumination can mar pictures by flaring into your lens; these lights also can reproduce as spectral hotspots in the image. This often happens when you work with a wide-angle lens, which encompasses an extensive angle of view—and everything within it.

You can overcome this dilemma in several ways. The most obvious approach is to move the camera back from the scene and increase the focal length of the lens. This will both narrow the angle of view and eliminate the stray light. Another way is to reposition the camera so that the light source is behind something that can obscure it, such as a tree, a building, or a pole.

High-contrast situations can also impede successful composition when you shoot at night. When a scene is devoid of ambient light, it doesn't include any middle tones. All that exists is shadow and highlights; this creates a contrast ratio that film is unable to reproduce. Unlike human vision, which can see light values over a 10-stop range, film is limited on average to a 3-stop range. The resulting image contains both bright, artificial-light areas and dark portions. If you expose for the highlights, everything but the brightest part of the scene will be too dark. Conversely, exposing for the dark areas will lighten the scene unrealistically, as well as wash out the highlights. One solution is to shoot when ambient light is present, such as at twilight; during inclement weather when residual light reflects from the cloud cover; or during those times of the month when the moon provides supplemental light. Sometimes it is possible to isolate an evenly illuminated portion of the scene when the sky goes dark.

Here, mercury-vapor lighting illuminates the decaying relief in this closeup composition of George Washington, which I shot in New York City's Washington Square Park. This type of lighting produces a green cast when it is recorded on daylight-balanced film. Working with my Canon EOS-1 and a 24mm wide-angle lens, I took a reflected-light reading in order to determine proper exposure. This was 25 seconds at f/5.6 on Ektachrome 100X.

If all else fails, you can balance areas of high contrast by exposing the dark parts of the scene with flash. Compare the duration of a night photograph to the length of time a print is in an enlarger. Some portions of the scene need localized illumination. By selectively exposing these dark areas with flash, you'll narrow the light ratio and reduce contrast.

Perhaps the most ironic dilemma you'll encounter when composing a night shot involves handling darkness. The lack of illumination in a scene can make it difficult to focus and to distinguish the placement of objects in the viewfinder. As a result, your final image may not be tack sharp or effectively composed. You can solve this problem by buying and using a small flashlight. I find mine to be a vital addition to my camera bag. The illumination from the flashlight helps me focus more precisely and find the edges of the frame, which is an essential aspect of my night-photography compositions.

Before you shoot, run through the following composition pointers:

- Simplify. Keep to the point. A subject should clearly state your intention without distracting viewers.
- Previsualize. Does what you see in the viewfinder convey your intention?
- Understand your camera, particularly viewfinder coverage. Vital elements at the edges and in the four corners might not be included in the final images. Know the limitation of yours by inspecting its four corners both when you shoot and later, when you examine your images.
- Bring a flashlight. Night subjects are difficult to focus because of the lack of ambient light.
- Recheck the composition. Before you break down your tripod, take a second look through the lens. Is everything where it should be? If not, recompose and shoot a few more frames.

The symmetrical placement of objects in the frame suggests completeness and balance. I took advantage of the reflective granite in this shot of Prometheus in Rockefeller Center to create a closed form. Without the reflection, the image would contain unnecessary space. With my Canon F1 and a 28–85mm zoom lens, I exposed for 8 seconds at ƒ/11 on Agfachrome 100 RS Professional film.

Shadows, reflections, and light enable a subject to close, as well as to appear unified, by showing two sides of the subject. An object as simple as an industrial-quality outdoor lamp can make a compelling subject when its shadow is included in the frame, as I did here. Working with my Canon F1 and a 28–85mm zoom lens, I exposed at ƒ/11 for 8 seconds on Agfachrome 100 RS Professional film.

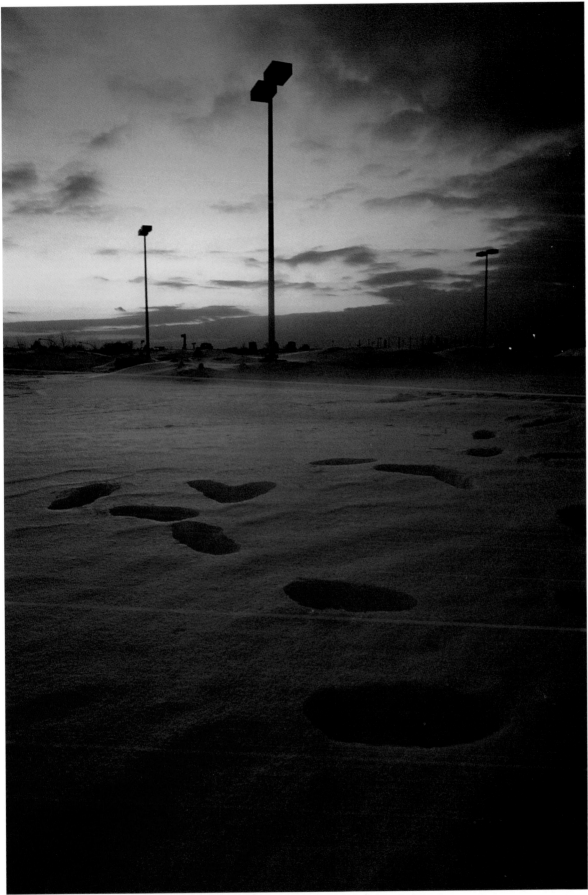

The best time to photograph a snow scene is at twilight. The cool ambient illumination gives the scene a blue cast. I made this shot with my Canon F1 and a 24mm wide-angle lens. The exposure was 8 seconds at ƒ/11 on Ektachrome 100.

Controlling the perspective—the size relationship of objects at different distances—in a photograph involves the relationship between the focal length of the lens and the distance it is from the object being photographed. Image magnification and the angle of view are inherent qualities of each focal length, but the perspective is primarily a function of the camera-to-subject distance.

A wide-angle lens provides an expanded angle of view, but it distorts perspective by rendering objects close to the camera proportionally larger than those farther away. A wide-angle lens also includes more elements of the scene than a standard or a telephoto lens does from the same distance. This is because wide-angle lenses reproduce objects smaller than other lenses do. As a result, wide-angle lenses are able to incorporate more of the scene in the photograph.

But this ability doesn't suggest that a wide-angle lens controls perspective. The proximity of the object to the lens actually determines perspective. For example, when you focus a 24mm wide-angle lens on an arbor that is 2 feet away, the garden fills the viewfinder. The resulting photograph will reveals that the garden is out of proportion to the rest of the scene, thereby creating an illusion of a greater distance between the garden and a gazebo that is 60 feet away.

To prove this to yourself, the next time you are out on the street, take a look around while holding your clenched fist several inches from your face. Your fist will appear larger than a street sign, delivery truck, or even an office building because of its proximity to you. This has nothing to do with your eyes changing perspective, but with the relative distance influencing perspective.

Image magnification adheres to the same principle. Objects closest to the camera appear larger than those that are farther away. And since each focal length has a different degree of magnification, the proportion of the scene can be exaggerated via either expansion or compression.

Many people believe that telephoto lenses compress the distances between objects in a scene, but this is another illusion. If you photograph the statue of Prometheus at New York City's Rockefeller Center using lenses with two different focal lengths—a 24mm wide-angle lens and a 100mm telephoto lens—from the same distance, you'll get two distinct photographs. One picture will show an expanded view of the scene, and the other will record an intimate view.

If you then enlarge the wide-angle image until it is the same size as the telephoto image, you'll notice that the pictures have the exact same proportions. The compressed appearance of a telephoto image, then, is simply a result of the extreme image magnification of a faraway object.

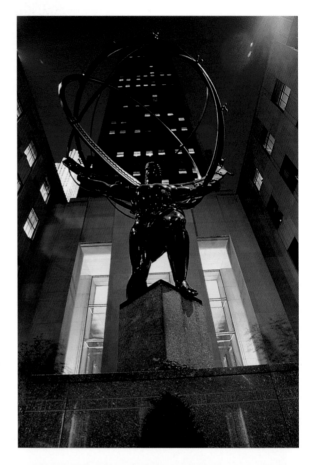

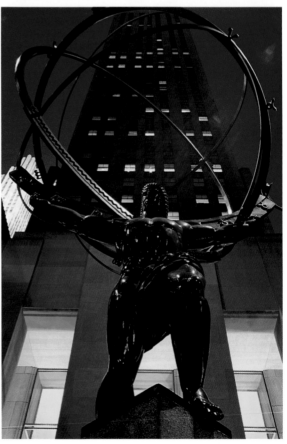

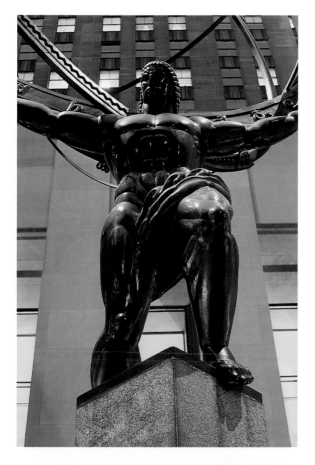

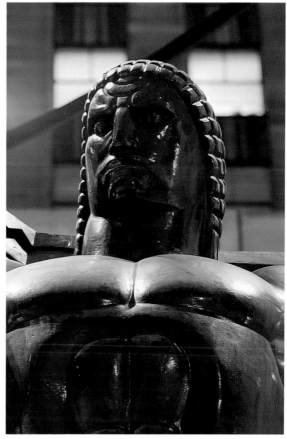

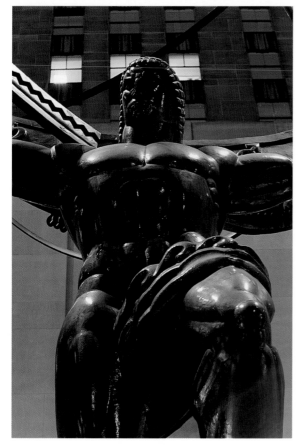

Interchangeable lenses give you the luxury of altering image size with each lens. The focal length controls the magnification of the image, as seen in this series of pictures, which I took from the same shooting position. I used five different focal lengths: 20mm (far left, top), 28mm (far left, bottom), 50mm (top left), 80mm (bottom left), and 200mm (above). Working with my Canon EOS-1, I exposed for 8 seconds at $f$/5.6 on Fujichrome Velvia.

# DEPTH OF FIELD

Being able to control the range of focus in a scene is another critical technique for effective composition. More commonly known as depth of field, the range of focus measures the area of sharpness in a photograph, from the nearest point to the farthest point. All photographers are aware of depth of field, but few exploit it. And when they utilize depth of field, they rarely do anything other than render as much of the scene as possible in focus. Few photographers take advantage of limiting focus to a narrow slice of the scene or using the area that isn't in focus as a compositional element. Before you can make full use of any of these techniques, you need to have complete command of the basics of depth of field.

Depth of field is controlled by the combination of aperture size and subject distance. It is a common misconception that lens focal length influences depth of field. While it is true that lenses with short focal lengths offer extensive depth of field and that lenses with long focal lengths provide less depth of field, the zone of sharpness is actually controlled by the size of the aperture. Don't confuse this with the aperture setting, or $f$-stop. An aperture setting of $f/8$ on lenses with three different focal lengths, such as 24mm, 50mm, and 135mm, permits the same amount of light to strike the film. However, the resulting depth-of-field measurements differ. This is because the diameter of the aperture associated with each focal length differs. The 24mm lens has an aperture diameter of 3mm when set at $f/8$, whereas the 135mm lens has an aperture diameter of 17mm at the same setting. In order for the same amount of light to strike the film when you use a short lens and a long lens, you have to use a wider aperture with the longer lens.

The reason for the increase in image sharpness with smaller aperture sizes results from smaller circles of confusion. These circles are made up of light that constitute the subject. When these points of light enter the lens, they're transformed into tiny discs as they form the image. The number of discs that create the image is a constant. When the discs are large, the area of sharpness in the image is limited. When the discs are small, the area of sharpness is extensive, thereby rendering the image quite sharp.

The other variable that controls depth of field is the camera-to-subject distance. The size of the disks of light becomes smaller as this distance increases; this, in turn, produces a sharp image. Objects closest to the camera won't have the same zone of sharpness as objects that are farther away.

While a smaller aperture setting can include more elements of the scene in focus, there comes a point when the subject is so close that depth of field is limited. A 50mm macro lens set at $f/5.6$ and focused to 10 feet has a range of focus that actually extends from 8 feet to 13 feet. But when this lens is used at a distance of 12 inches, it provides minimal depth of field—just an inch or so. Stopping down to $f/32$ will increase depth of field by only one inch. When the subject is this close to the lens, focus has to be precise. Conversely, the farther an object is from the camera, the greater the depth of field is. When used in conjunction with a small aperture, the area that is rendered sharp can increase to infinity.

Composing skillfully includes not only the ability to arrange the objects in the scene, but also the ability to emphasize those objects. Through controlling depth of field, you can get across the visual message of the image fluently. Often photographers don't use focus as a compositional device. Instead, they concern themselves with the technical aspects and the linear composition, striving for maximum depth of field even when the objects in focus are unimportant to the scene. By knowing what to emphasize through focus, you can maintain complete control over the image.

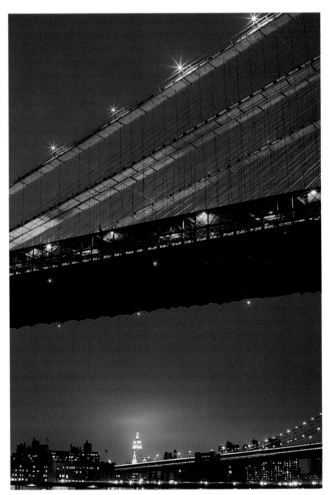

An effective compositional technique is to isolate a segment of the subject. This image of a small area of the Brooklyn Bridge shot on a rainy night is recognizable, yet it consists merely of different-sized lines at various angles. With my Canon F1 and a 28mm wide-angle lens, I exposed for 3 minutes at $f/16$ on Kodachrome 64.

According to the aperture setting you choose, you can adjust depth of field to produce extensive or limited depth of field. I photographed both of these snow scenes with my Canon EOS-1, a 50mm standard lens, and Kodak Lumière. To render the entire scene in focus, I selected an aperture of ƒ/22 and exposed for 30 seconds (right). In the second shot, I wanted to show only the main subject in focus, so I decided to use an aperture of ƒ/1.8 and exposed for 1/2 sec. (above).

## DEPTH OF FIELD

At an aperture of ƒ/5.6, each lens focal length produces a specific depth-of-field range. The longer the focal length, the larger the diameter of the aperture but the smaller the depth-of-field range. Suppose you're shooting with a lens that is set at ƒ/5.6 and focused on a subject 10 feet away from you. With a 24mm lens focal length, the depth-of-field range extends from 4–24 feet; with a 50mm focal length, the range extends from 8–13 feet; and with a 135mm focal length, the range extends from only 9½–11 feet.

## APERTURE DIAMETER AND DEPTH OF FIELD

In order for two focal lengths to produce the same depth-of-field range, their aperture diameters must be the same. Suppose you're focusing on a subject that is 10 feet away from you. Using either a 24mm lens set at ƒ/4 or 135mm lens set at ƒ/22 will provide a depth-of-field range that goes from 7–16 feet because the lenses' aperture diameters are identical, 6mm. Conversely, because a 24mm lens set at ƒ/5.6 has an aperture diameter of 4.3mm, a 50mm lens set at ƒ/5.6 has an aperture diameter of 9mm, and a 135mm lens set at ƒ/5.6 has an aperture diameter of 24mm, their depth-of-field ranges differ from one another.

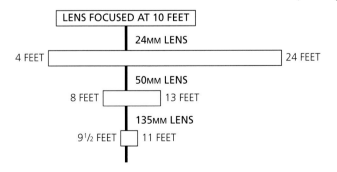

LENS FOCUSED AT 10 FEET

24MM LENS
4 FEET — 24 FEET

50MM LENS
8 FEET — 13 FEET

135MM LENS
9½ FEET — 11 FEET

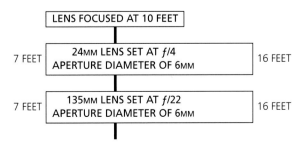

LENS FOCUSED AT 10 FEET

7 FEET — 24MM LENS SET AT ƒ/4 APERTURE DIAMETER OF 6MM — 16 FEET

7 FEET — 135MM LENS SET AT ƒ/22 APERTURE DIAMETER OF 6MM — 16 FEET

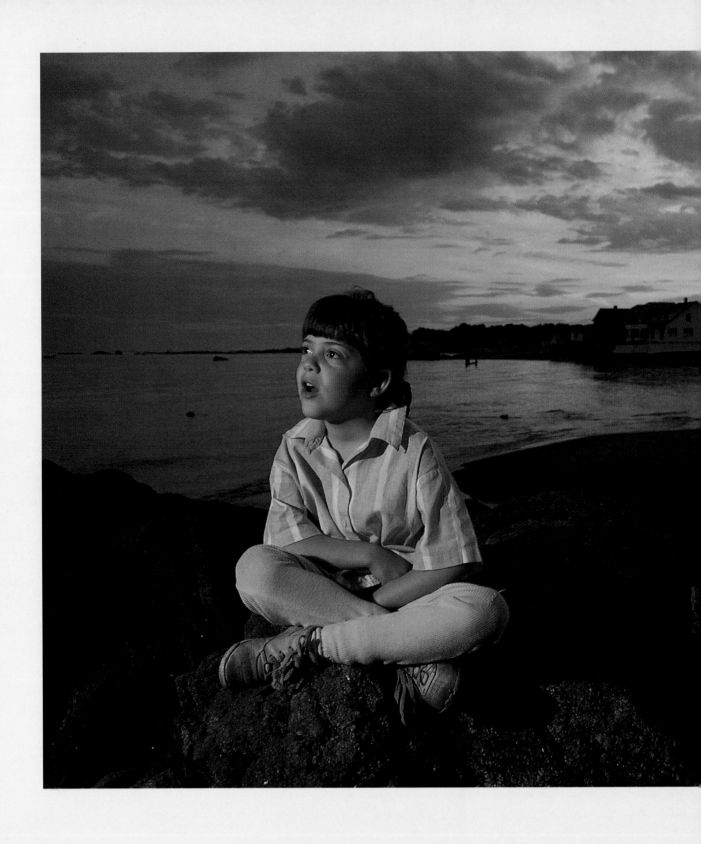

# PHOTOGRAPHING PEOPLE AT NIGHT

If you were to ask 10 photographers about their favorite subject to photograph, 9 would probably tell you that it involved people. Such a revelation wouldn't be a surprise. The pleasure that comes from depicting the human element is evident in the windows of one-hour photo labs: rolls of snapshots, composed of people in various situations, churn through the machine. While documenting Jillian's first steps or Grandma's ninetieth birthday bash, people meticulously record the progress of their immediate world. But when the sun goes down, it seems as though they put their cameras away until the next day. And for the rare occasions when they take night portraits, they usually "blast" their subjects with electronic flash.

Photographers who have "broken through to the other side" have discovered that photographing people at night is a relatively easy form of expression. A dramatic picture of a subject against a cityscape invites viewers, a photograph of the action of a stage production frozen in time excites viewers, and a snapshot of last year's July Fourth barbecue delight viewers. Whatever the photographer's intention, the documentation of humans after dark requires an understanding of the limitations of night photography and basic portraiture.

# SHOOTING PORTRAITS

Two basic categories exist for night portraits: proactive and reactive. In proactive, or posed, portraits, subjects know that they're being photographed. They either look directly into the camera or appear, at the very least, to be aware of its presence. You might, for example, decide to shoot a silhouette of a friend at the beach at sunset. Often a sophisticated lighting setup is essential to a proactive portrait. The ratio, direction, and quality of light are prepared to capture a preconceived moment on the subject's face. Reactive portraits, on the other hand, aren't posed. Here, the subjects aren't aware that they're being photographed. When you shoot a reactive portrait, your goal is to record a spontaneous moment. For example, you might catch a tennis player who is losing a match looking frustrated in between games. Another possibility is capturing the twinkle in the eye of a child who is about to eat an ice-cream cone.

Many times, you can shoot both a reactive and a proactive portrait of the same subject. Suppose, for example, that you're attending a wedding. When you photograph the happy newlyweds' first dance, you capture them gazing into each other's eyes, thereby shooting a reactive portrait. You can then quickly turn this into a proactive-portrait situation by calling out the names of the bride and groom and getting them to look at you while you take their picture again.

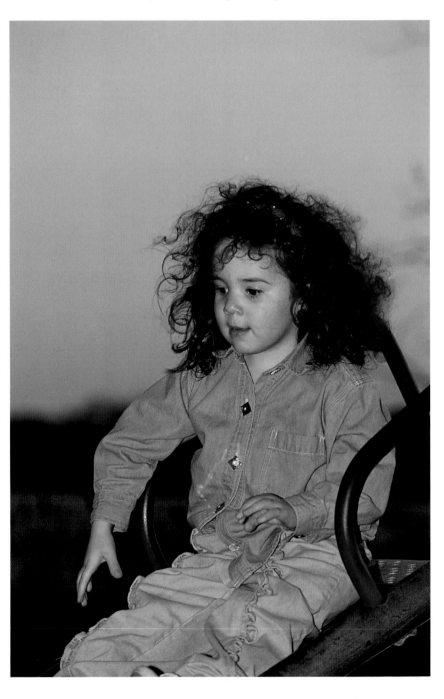

I shot this portrait shortly before twilight, when ambient light was still present. The flash exposure acted more as a fill light than as a main light. My subject's face was in shadow, so I "opened up" the dark areas via direct flash. With my Canon EOS-1 and a 50mm standard lens, I exposed for 1/30 sec. at ƒ/11 on Kodak Lumière.

# COMPOSING NIGHT PORTRAITS

A photograph that satisfies all of the various technical concerns but lacks an appealing aesthetic is a picture of little substance. It is important not to overlook the most basic function of the portrait: to capture a compelling expression on your subject's face. The most influential aspect of creating a portrait comes from traditional photography. Although each photographer has an individual style in terms of shooting a portrait, you'll find that the following practical advice can be helpful:

- **Use the right focal length.** People should rarely be photographed with a wide-angle lens. It distorts the proportion of facial features. Also, because of its width, a wide-angle lens may include extraneous elements, such as street lamps or a dark patch of sky. Instead, it is best to use a short telephoto lens with a focal length that ranges between 85mm and 135mm lens for portraits.

- **Use flash carefully, and keep an eye on the flash at all times.** If it is on the same axis as the lens and your subject's eyes, the notorious red-eye problem will result. Also, if you hold the flash off-camera or bounce it off the ceiling, the flash may not accurately cover your subject.

- **Pay attention to the background.** Don't photograph subjects with trees, street lamps, or street signs directly behind them. If you do, you'll have a branch, light pole, or street designation growing out of your subjects' heads. Being aware of this potential problem is the first step; slightly moving the camera or the subject is the solution.

- **Avoid distracting backgrounds.** If the area behind the subject is too bright or distracting, change your position. If you can't, try using a fast shutter speed and flash. The synchronization, or synch, speed of the camera, especially at 1/250 sec., is sufficient to underexpose the ambient portion of the scene without affecting the flash exposure.

- **Have enough film with you.** In fact, have more than enough film with you. Then, if you need more, you'll be prepared. And even if you don't need to use it, knowing that you have it is reassuring. It is awful when you're just getting "warmed up" with a subject and discover that you've run out of film.

- **Be patient.** If you're shooting a portrait in the street scene and want to include automotive taillights, wait for the right moment. Determine the exact spot where the cars will enter and exit the frame. Begin the exposure before the car appears, and end the exposure after it passes. If the duration is 8 seconds, for example, base your exposure on that number. This strategy applies to including pedestrians, too.

- **Have some idea of the kind of portrait you want.** If it is formal, find a location that can serve as an appropriate backdrop. Stay away from brightly illuminated areas. For candids, wait for those special moments when your subject expresses some form of emotion. If you want to shoot a theatrical portrait, you'll need to combine the formal approach, your subject's candid expression, and your own conception.

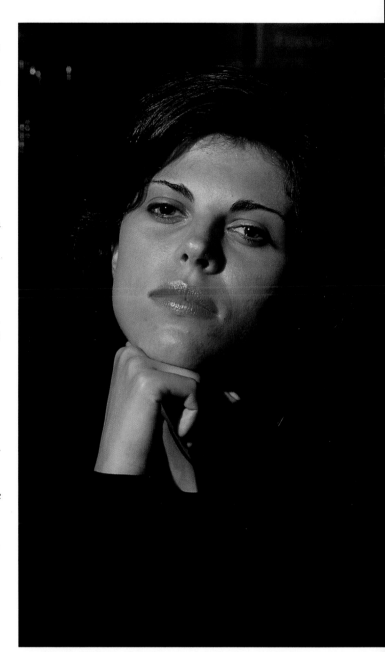

In order to get close to this subject, I selected a short telephoto lens. Working with my Canon F1 and a 100mm lens, I used a Vivitar 285 flash, held off-camera and set on manual. The exposure on Ektachrome 100 was 1/60 sec. at *f*/8.

# CONTROLLING PORTRAITURE LIGHTING

Night portrait photography can be regarded as a hybrid version of studio photography. You'll find that most shooting situations are a mixture of active and passive control of the ambient light, while others give photographers free rein, and still others dictate the lighting completely. These various limits give the night portrait its edge.

Some shooting opportunities enable photographers to fully control the intensity and direction of the light source, which is usually an electronic flash. For example, photographers recording the fun of a Halloween party play an active role in controlling the illumination in the scene because the camera and light source travel around in unison. When photographers place the flash in the hotshoe on top of the camera, they can either use the unit as a direct flash or tilt the head and reflect the light off a bounce card. They can exercise another option as well: attaching the flash to the camera via a synch cord and holding the flash off-camera. Here, the direction of light is independent of the camera's angle of view.

The active control of electronic flash extends to using more than one flash unit. You can place several flash units around the perimeter of the subject and trip all of them by setting off the on-camera flash. The units that go off after the initial burst of light from the first flash are called slave units. Basically, instead of being wired directly to the camera, they have light sensors that trip them. When the slaves detect the burst of light from the on-camera flash, the sensors in the slaves set them off.

Sporting events and rock concerts present photographers with a different set of circumstances (see pages 119–23). In these situations, the illumination is passive, indicating that the photographers have little control over them. Often, the subject is at a great distance, making it necessary to use a telephoto lens and at the same time preventing the use of electronic flash. Generally, the lighting in a stadium or on a stage provides enough illumination to expose the film; however, a fast shutter speed, such as 1/125 sec. or 1/500 sec., is required to freeze the subject's motion in order to capture the peak moment. As a result, the size of the aperture must be increased.

In another passive-control situation, the existing artificial illumination is used as the light source. Photographers have little control over the look of the final image, and the color of light usually doesn't flatter the subject. Tungsten lighting shot with daylight film gives subjects a pleasant warm-orange glow. But the multivapor lights found in sports stadiums are usually unacceptable for portraits, and HIDs don't flatter people at all. If it becomes necessary to shoot a portrait under the illumination of a street lamp, you'll find that it is best to use a negative film, which allows color to be adjusted during the printing stage.

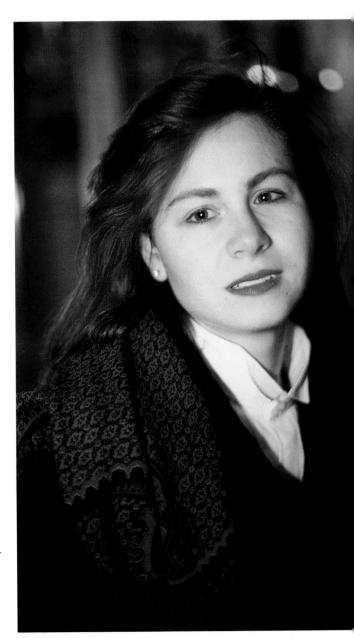

Here, a bounce card softened the flash's output and redistributed the light evenly. I knew that using direct flash for this portrait would have created harsh lighting, as well as red eye. To make the warmly illuminated background a bit cooler, I photographed my subject with tungsten film; this choice, in turn, necessitated the use of an 85B filter over the flash to correct for the film's blue color cast. Shooting with my Canon EOS-1, an 80–200mm zoom lens, and a Canon 430EZ flash, I exposed for 1/60 sec. at ƒ/11 on Ektachrome 320T.

The third, and most common, situation photographers face involves active and passive control of the light. The freezing of human motion combined with an accumulation of time requires a working knowledge of both available light and electronic flash. Success depends on balancing the two sides evenly. The ambient-light portion of a scene provides more exposure latitude than the flash portion; this must be accurate, otherwise the picture fails.

You can control the color and intensity of existing light in a few different ways. For example, if you want to subdue the green cast of mercury-vapor illumination, using complementary filter combinations on the lens and flash will minimize it. But using a magenta filter on a lens neutralizes the color of the ambient light while it adds a magenta color cast to the subject. The green filter, on the flash, counteracts this effect. When you use a green filter, which is equal in density to the magenta filter on the lens, on the flash, the color of the subject is neutralized.

Suppose that the background is too bright. The aperture setting dictates the effect of the flash on the film, and the shutter speed controls the effect of the ambient light. So, to reduce the intensity of the available light, simply adjust the shutter speed. If you set your camera at the fastest shutter speed the flash synchronizes at (1/60 sec. to 1/250 sec., depending on your camera), the background will be barely noticeable in the final image because it won't have enough exposure to register on film.

Each of these scenarios represents only a microcosm of conditions that can exist when you shoot portraits at night. And the conditions are secondary because whenever and wherever you shoot a portrait—day or night, studio or street—your subject's emotions and expressions are the vital elements. Be aware that it is easy to get caught up in the technical aspects of night photography. Yet, in the end, the lighting or the composition by itself won't matter: if the subject's gesture or expression is off, the photograph won't appeal to viewers. But don't mistakenly ignore the technical side of producing a photograph. To successfully capture telling moments on film, you must understand the myriad of diverse techniques that are available to you.

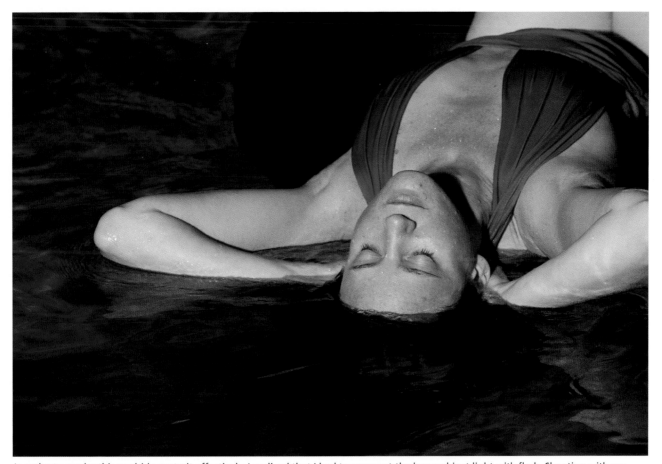

In order to render this poolside portrait effectively, I realized that I had to augment the low ambient light with flash. Shooting with my Canon EOS-1 and an 80–200mm zoom lens, I decided to use a Speedotron 400 watt-second pack with one head. The exposure was 1/250 sec. at f/11 on Ektachrome 400X.

# BALANCING LIGHT SOURCES

When you shoot a portrait against the backdrop of the night, you might be reminded of studio photography. For both types of photography, you pose the subject in the equivalent of a large, dark room and need to supply the correct amount of illumination. But with night portraits, your control is limited to lighting the subject. Unlike the interior of a studio, the backdrop of the night consists of arbitrary elements that you can't control. These include, but aren't limited to, neon street signs, automobile-light trails, accent lighting, and natural traces of ambient light. In order to shoot a successful picture that combines a portrait and a night landscape, you must balance the passive-control lighting of the background and the active-control lighting of the portrait.

Nighttime portraits are shot over two separate time planes. Background elements determine the duration of the ambient exposure, which may be several seconds or longer. Brightly illuminated cityscapes, for example, require a shorter duration of exposure than moonlit scenes do. During the course of exposure, everything that takes place within view of the camera is collected on film. A pedestrian or automobile may pass through the frame during this collection of time. The pedestrian will become a blur while automobile taillights will form a single streak of light.

The burst of light from the electronic flash provides the second time plane and occurs within the duration of the overall exposure. The action, expression, or motion of the person being photographed is captured in between the ambient portion and the flash portion of the exposure. When these two parts of the exposures are combined, the results are often compelling. You can create special effects by manipulating both the ambient light and the flash. For example, the subject might be frozen, yet streaks of light might dash through the frame.

Balancing these two time planes within the same exposure is the cornerstone of a successful nighttime portrait. Remember, though, that a night portrait requires two separate exposure readings, one for the ambient light, and the other for the subject. I find that it is acceptable to slightly underexpose the background in order to help emphasize the subject as the center of interest, as well as to cut down on the length of exposure. This also eliminates the need for your subject to remain perfectly still for an extended period of time, even with electronic flash. Live subjects rarely can remain motionless for more than a few seconds.

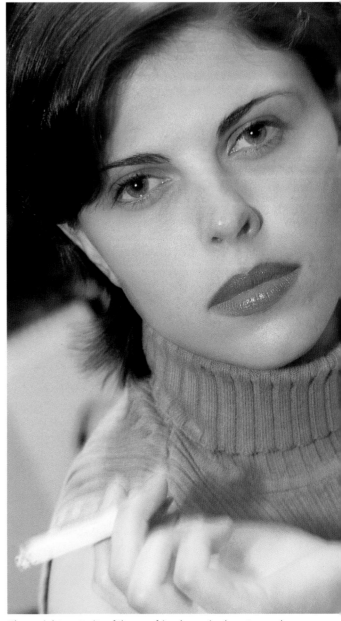

These night portraits of Ilona, a friend, required me to use slow shutter speeds to balance the light values in the scene. In the moody closeup of her, the shutter speed produced some visible motion (above). With my Canon EOS-1, 50mm standard lens, 2X lens extender, and Canon 430EZ flash set on TTL, I exposed Fujichrome 800 for 1/15 sec. at f/11. For another portrait, I first took a measurement of the flash output with my flash meter, which suggested an aperture of f/5.6 (right). Next, I took a reflective reading of the background sign; this indicated an exposure duration of 1/4 sec. at f/5.6. After placing my Canon EOS-1 and 20-40mm zoom lens on the edge of a pole, I set my Canon 430EZ flash on manual and shot Ektachrome 100 at the recommended exposure.

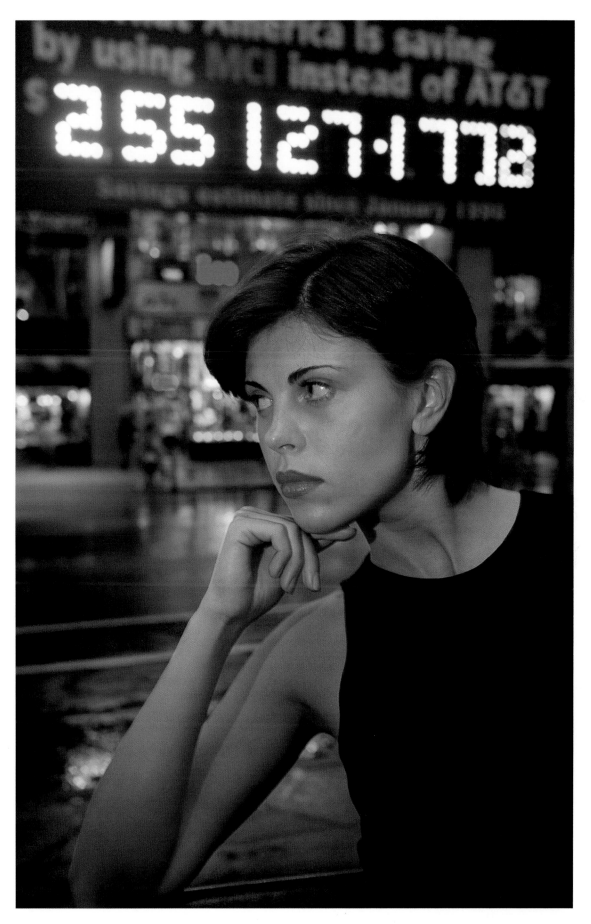

# CALCULATING EXPOSURE

Artificial light produces a multitude of color schemes in night-photography situations. Instead of a single light source illuminating the scene, many light sources simultaneously establish the lighting. Keep in mind that each light form has its own agenda, as well as its own method of producing light. For example, the yellow light from sodium-vapor lamps provides efficient illumination on city streets, the warm-orange glow of tungsten lighting accentuates a building or statue, and neon light, which can be any color, is used to get people's attention. Often a main street or thoroughfare contains these light sources, as well as others.

When you use a daylight-balanced film at night, you'll notice a wide range of color reproduction in the scene. When you photograph a subject against this arbitrary backdrop, the results can be intriguing. This involves passive control of the light, so you need to calculate exposure by reading the ambient light. To do this, take a reflected-light reading of a middle tone in the scene or an incident-light reading when applicable. Although I find that acceptable exposure occurs over a range of several stops, I feel that slightly underexposing works best with daylight film. When you underexpose the scene, the subject doesn't have to compete with the background.

Once you determine a working aperture, your next step is to measure exposure on the subject. I use a flash meter because it gives me the most accurate exposure readings. If you don't have a flash meter with you, you'll find that a dedicated flash unit can be a big help—but familiarity with it is imperative. When you know how this type of flash reacts, you can make the necessary adjustments.

Calculating exposure when you work with a manual flash involves knowing the unit's guide number (GN—see page 116). Some photographers feel that using the flash at

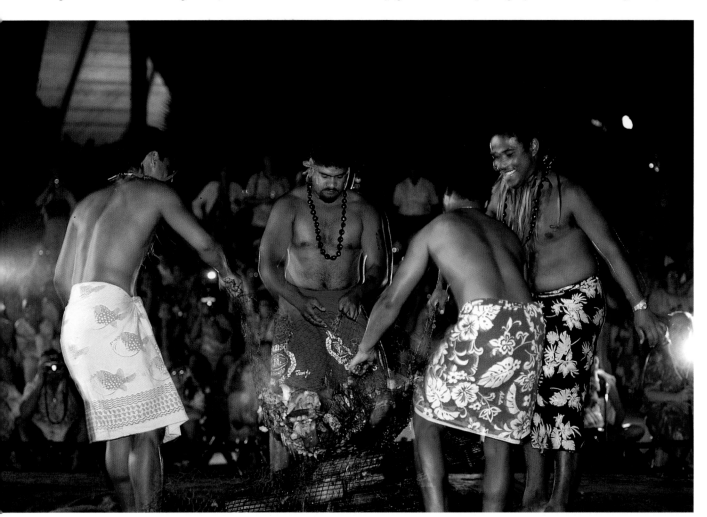

For this shot of participants in an Imu ceremony, I dragged the shutter. Working with my Canon F1 and a 28mm wide-angle lens, I set my Vivitar 285 flash on manual and exposed Kodachrome 64 for 1/15 sec. at ƒ/8.

its manual setting affords them the best control in these situations. Another method evolves out of the experience and knowledge you gain from using your flash. Some photographers tape a set of aperture settings that correspond to various flash-to-subject distances on their camera. If you're shooting on manual, you must remember that the studio of the night doesn't have a wall or ceiling to let light reflect back to the subject. As a result, you need to increase flash exposure by $1/2$ to 1 stop.

These techniques are helpful, but using a negative film rather than a transparency film improves your chances for success. As mentioned earlier, negative films have a wider exposure latitude than transparency films do. So if a print-film exposure is off by a stop or two, the picture will still be correctable. But if the flash output isn't precise, a slide-film image will be unusable. Don't shoot negative film when an image is intended for publication unless you have no other choice. Any shooting situation that warrants the use of transparency film demands an accurate light measurement.

When you photograph an inanimate object, bracketing ensures an optimal exposure; however, when you shoot a portrait of a living subject, this technique is impractical. It doesn't make sense to run the risk of improperly exposing a flattering portrait. The solution is to shoot the entire roll of transparency film at the same exposure and then to have a clip test done. A clip test involves processing a couple of frames on the roll separately in order to determine the proper amount of exposure required. If the film is slightly underexposed or overexposed, you'll be able to correct the problem during processing. If you plan to do a clip test, it is a good idea to shoot several frames of lesser content at the beginning of the roll. This approach lets you avoid testing the good frames.

The welder's torch provided the only illumination in this available-light portrait. I took an average reading of the scene using my camera's internal meter. With my Canon EOS-1 and a 20–35mm zoom lens, I exposed for 1/30 sec. at f/4 on Kodak Lumière.

# USING ELECTRONIC FLASH

Electronic flash units are lightweight, portable units that provide bursts of artificial light. They have the capacity to paralyze the motion of everything they encounter, but this isn't their only function. Electronic flash can override the various forms of artificial illumination with a quality of light that simulates daylight. And you can alter the direction of light by holding the flash away from your camera, thereby creating a three-dimensional illumination to emphasize the subject.

The use of electronic flash has been simplified to the point where photographers merely have to turn the flash on and then press the camera's shutter-release button to activate the unit. Today, most flash units can automatically control the light output. A sensor on the flash head measures the amount of light on the subject, and when the subject has received enough illumination, the flash cuts down the light output.

Flash units often work in unison with the camera, as in TTL metering. Here, the light output is measured through the camera's lens, which guarantees a more precise reading—and consequently a more precise exposure determination—than other metering methods provide. Don't get too comfortable, however. Although contemporary technology has taken the guesswork out of using electronic flash, the strength of a photograph still depends on how the photographer utilizes the existing light in a scene. It is imperative to use the illumination to its best advantage.

To fully understand the effects of flash, you should first consider a situation without flash. The duration of a night-photograph exposure can be several seconds or longer. While this may be feasible when it comes to shooting inanimate objects, it is less practical when it comes to photographing people. In most cases, an exposure slower than a fraction of a second, 1/30 sec. or 1/15 sec., produces a blur on film. After all, most people are incapable of staying still for several seconds. As such, flash is a vital tool.

Electronic flash supplies a quick burst of light that lasts only from 1/750 sec. to 1/2000 sec., and is able to stop the action of a moving subject or to record the fleeting expression on a subject's face. The duration of light is so brief that it isn't possible to actually see its effect on a subject. When you mount the flash on your camera, the light is always directed toward the subject, but sometimes the flash coverage doesn't match the lens' focal length. In these situations, by putting a Fresnel adapter over the flash face, you can adjust the beam of light to expand its coverage. Through concentric circular grooves, this type of adapter redirects the light, thereby accommodating the wide-angle lens. This problem often occurs with wide-angle lenses whose focal lengths exceed 28mm.

Electronic flash units can freeze action. To do this effectively, however, you must set the shutter to the highest speed it synchronizes at. Otherwise, ambient light can affect the final image. In this action shot, the flash provided all of the necessary illumination in a brief burst. Shooting with my Canon EOS-1, a 24mm wide-angle lens, and a Speedotron 400 watt-second pack with a single head bounced into an umbrella, I exposed Ektachrome 400X for 1/250 sec. at ƒ/8.

An electronic flash unit can help make nighttime portraits dramatic. I photographed my friend Ilona wearing a black dress on a busy city street. To emphasize my subject, I used my Canon 430EZ flash with my Canon EOS-1 and a 50mm standard lens. The exposure was 1/30 sec. at $f$/8 on Fujichrome Sensia.

# ON-CAMERA FLASH

The most basic method for using electronic flash is to mount it on the hotshoe on top of the camera. With the flash in place, you can blast your way through rolls of film without the threat of low light levels affecting exposure in the final images. The resulting illumination comes from the camera position, but direct flash isn't flattering for photographing people. Because it produces a harsh quality of light, the subject's skin tones become washed out, the contrast ratio between the subject and the background increases, and the subject is likely to develop red eye (see below).

You might wonder why direct flash is used so frequently. When you consider that you live in a microwave society, where ease of operation usually supersedes quality, this isn't too hard to understand. After all, direct flash is a simple, foolproof way to illuminate a subject. On-camera flash is perfect for snapshots, in which the intent is to preserve precious moments of loved ones, not necessarily to create a technically perfect image. I regard direct flash as merely a fill light that impersonates a main light source. I find direct flash to be effective when it supplements the ambient light in a scene, but I think that it produces unflattering results when used as a primary source of light.

### ELIMINATING RED EYE

Be careful not to use direct flash too close to your subject. If you do, red eye might result. This unappealing look is a result of light directly entering the retina and reflecting off blood vessels. You can eliminate this problem several ways. One is to reposition a subject's line of view so that it isn't on a direct axis with the lens. Another solution is to move the flash unit off the axis of the lens. You can accomplish this either by using a bracket that elevates the flash or by attaching a synch cord to the flash and holding it away from the camera (see page 111). You can also prevent red eye by mounting the flash unit on a lightstand.

When you shoot a two-dimensional scene at night, you discover that an on-camera flash unit provides flat, even illumination. For this shot, I used my Canon EOS-1 in program mode, an 80–200mm zoom lens, a Canon 430EZ flash set on TTL, and Kodachrome 200.

# OFF-CAMERA FLASH

The use of an off-camera flash presents a different concern. When you hold the camera to your eye with one hand, and the flash with your other hand, it is possible for the light to miss its target. A simple solution to help improve your aim entails taping a small flashlight over the top of the flash head. Because you can see the flashlight's illumination through the viewfinder, you'll be able to maximize the effectiveness of the flash. Don't worry about the flashlight's illumination; the power of the electronic flash will override its effect.

The illumination from an artificial light source usually isn't flattering. Its color temperature, direction, and intensity are inconsistent with the control you need to exercise in order to make a good photograph. The use of an off-camera flash transforms a passive-control, available-light situation into an active-control opportunity. At one time or another, night photographers crave a dramatic light to illuminate their subject. They want to depart from the flatness of the frontlighting created by on-camera flash. Separating the flash from the camera produces a softer, more dimensional illumination. Holding the off-camera flash to one side of the subject illuminates one side of the face and leaves the other side in shadow.

You can operate the flash away from the camera via either a synch cord or an off-camera hotshoe adapter. A synch cord is a wire that plugs into a camera's synch port and links it to the flash. Hotshoe adapters permit flash units to operate in the TTL mode while positioned away from the camera. When you do this effectively, your subject can benefit from the resulting studio look. Off-camera flash is most successful when the subject is on the same axis as the lens. Be aware, however, that the flash must be accurately aimed at the subject. This can be troublesome because holding the flash outward for long periods of time can be cumbersome and tiring. And at other times, you may simply not be paying close enough attention to where the flash is pointing. Another problem occurs when the unit's exposure sensor doesn't measure the same light value as the camera, which results in an improperly exposed image. Cameras with TTL flash metering can overcome this potential problem.

Keep in mind that when used at close range, a flash unit is more intense than ambient artificial light, so the flash overrides it. Electronic flash produces a full spectrum of color and has a color temperature of 5500K, making it similar to daylight. And when you photograph people, you'll probably want the light to be slightly warmer than the flash output. Using a warming gel over the flash head enables your subjects to bask in the newfound warmth of flash illumination.

Light can be used to emphasize a portion of a scene. In this shot, the actress is the main subject. By holding the flash away from my camera, I was able to illuminate her without spilling light onto other elements in the scene. I used a flash meter to determine exposure readily. Shooting with my Canon F1, a 24mm wide-angle lens, and a Vivitar 285 flash set on manual, I exposed Kodachrome 200 for 1/30 sec. at ƒ/11.

# BOUNCE FLASH

The quality of illumination from an on-camera flash improves greatly when the flash bounces off a neutral surface rather than strikes the subject directly. The bouncing expands the coverage of illumination that, in turn, produces a softer light. But the great outdoors rarely provides places to bounce light, and the few surfaces that exist are rarely neutral: gray, white, black, or tan. And unless the area that the light reflects off is neutral, it will influence the color of light.

I recommend carrying a bounce card in your camera bag to eliminate the need to find an acceptable surface that you can bounce your flash off. A bounce card is simply a white index card that you can attach to the back of the flash (with the head positioned up). The card doesn't actually bounce the light as much as it redirects some of it. The result is a softer, more even illumination. And the best part is that you can produce this pleasing quality of light anywhere.

Bouncing flash off a random surface, such as a ceiling or wall, requires extra flash power. Today's dedicated flash units have features that can automatically calculate the power. These include infrared sensors, TTL flash metering, and preflash exposure indicators. When using your flash at its manual setting, you must calculate the required power. Here, you need to measure the total distance that the flash travels, not the camera-to-subject distance. A rule of thumb is to estimate the distance between the bounce surface and the subject. After you determine this distance, add $1/2$- to 1-stop exposure to compensate for the light spread at the bounce surface.

The light bouncing off the card doesn't travel farther than a few inches. As a result, little compensation—possibly $1/2$ stop—is needed. The card is most effective when positioned at a 45-degree angle because the redirected light is able to fully cover the subject.

Many exotic bounce devices are on the market. The simplest is a piece of white plastic that you fasten to the flash with Velcro. More complex types can simulate the quality of light that a softbox produces, which is soft and shadowless. Unfortunately, these require more power to operate and limit the output of light. Despite the variety of bounce devices available, I prefer using a $3 \times 5$-inch white index card attached to my flash unit with a rubber band because I find it comfortable and effective.

When light is bounced off an object or into an umbrella, it provides soft illumination. For this portrait of a nurse and her "photon-emitting" stethoscope, I bounced a Norman strobe into a small, white umbrella to achieve this effect. The long exposure time enabled me to record the light trail coming from the stethoscope; I created the trail with a penlight. Working with my Mamiya 645 and a 55mm lens, I exposed Agfachrome 100 RS Professional film for 8 seconds at *f*/8.

# USING FLASH WITH AMBIENT LIGHT

You should always use the backdrop of the night to your advantage. The ambient light can create a magical image. While shooting a portrait of a friend beneath the Brooklyn Bridge, I asked her to stay still for several seconds after the flash went off so that the photograph would include the skyline in the background. When you combine a long exposure time with electronic flash, you can make your subject stand out against an emerging skyline, holiday lights, or moonlit waves.

A third variable, electronic flash, affects the reciprocal nature of the shutter speed and the aperture. Once you determine the flash exposure, only the aperture can affect it.

This is because in this three-variable equation, the aperture controls the overall density of the image. Opening up or stopping down the lens over- or underexposes, respectively, the entire scene.

The shutter speed has a limited role; it can affect only the density of the ambient portion of the scene, not the area exposed by flash. The duration of the flash is brief, ranging from 1/750 sec. to 1/2000 sec. In order to control this type of situation, you'll find it best to set the aperture so that it corresponds with the flash. Your next step is to fine-tune the ambient part of the scene by increasing or decreasing the length of time the shutter stays open.

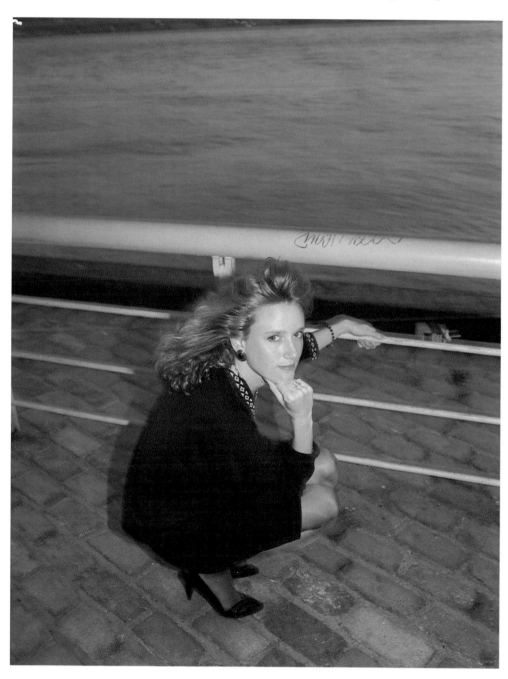

As I started to shoot this portrait at twilight, I decided to augment the ambient light with flash. I placed an orange filter over the flash and held it off-camera. I used tungsten film to take full advantage of the blue sky. Working with my Mamiya 645 mounted on a tripod, a 55mm lens, and a Vivitar 285 flash with an 85B filter, I exposed Ektachrome 160T for 1 second at $f/8$.

# USING FLASH AT SYNCH SPEED

You can diminish the impact of a bright or distracting background by using the synchronization, or synch speed—the fastest shutter speed that can be used with a focal-plane shutter—and by utilizing flash just for illumination. Every camera has a synch speed that falls between 1/60 sec. and 1/250 sec. This is the minimum duration that the shutter must remain open in order to receive the proper light output from the flash. Since the duration of the flash is so short, it completes its cycle in the middle of these fractional exposures.

Today, most new cameras have a synch speed of 1/250 sec., which is more than fast enough to eliminate unwanted backgrounds. For example, suppose that a light measurement of cityscape suggests an exposure of 1/2 sec. at f/8, and you decide to shoot a portrait against it. If you photograph the subject at this exposure, both the subject and the cityscape will be properly exposed. But if you concentrate on the portrait instead of the background, you can minimize the presence of the background by shooting

at the fastest possible synch speed. If your camera synchs at 1/250 sec., the flash exposure will remain constant, but the cityscape in the background will be underexposed by seven stops. The resulting shutter speed will now be 1/250 sec. Although the difference between the subject and the background is seven stops of light, the length of the exposure won't affect the portion of the scene exposed by flash. This is because the flash duration is brief and concentrated, so it can affect only objects within its range.

When you use flash for a night portrait, remember not to use a shutter speed that is faster than the synch speed. The flash exposure must be synchronized to the opening and closing of the shutter. If the shutter speed exceeds the synch speed, the curtain on a focal-plane shutter will expose only a portion of the frame. This is because the shutter will close before the flash cycle is completed. So, if the camera has a synch speed of 1/60 sec. and the shutter speed is set at 1/250 sec., the shutter curtain will be out of synch and will interfere with the exposure.

When you use flash, the aperture controls the overall exposure, while the shutter controls the ambient exposure. For one shot, I exposed for 1/15 sec. at f/8 (left); for the second picture, I exposed for 1/250 sec. at f/8 (right). The portrait exposure stays the same, but the background became darker when I increased the shutter speed. Here, I used my Canon EOS-1, an 80–200mm zoom lens, a Canon 430EZ flash set on manual, and Kodachrome 200.

# DRAGGING THE SHUTTER

Dragging the shutter refers to a photographic technique in which a flash exposure is combined with a slow shutter speed. The result is an overall blurred-motion image with areas that the flash has frozen. The actual shutter speed depends on both the lens' focal length and the subject's mobility, but a starting point is approximately 1/15 sec. Usually the aperture setting should match or underexpose the ambient portion of the scene by one stop. And the ambient exposure should come close to matching the flash output. With this technique, the shutter speed is generally lower than the setting ordinarily used for handholding. You can handhold your camera during a 1/8 sec. or 1/4 sec. exposure. Of course, the image will blur, but the flash will freeze part of it. Through experimentation and practice, you'll arrive at a comfortable median of acceptability and produce successful images.

You can combine a long exposure with flash via two methods. With one approach, the flash goes off at the beginning of the exposure. Most of the time you don't notice this because the shutter speed is a fraction of a second, but it becomes apparent during exposures that last several seconds. Here, the shutter opens, the flash goes off, and then the shutter closes at the end of the exposure. Essentially, the action is stopped first by the flash, and then motion is collected for the duration of the exposure.

With the other approach, which is called rear-curtain synchronization, the flash goes off at the end of the exposure. This technique provides a smoother line of motion—a smoother look—to the image because the action is frozen during the final part of the exposure. A 4-second exposure of a person against a holiday setting will expose the scene, and the flash will go off before the shutter closes.

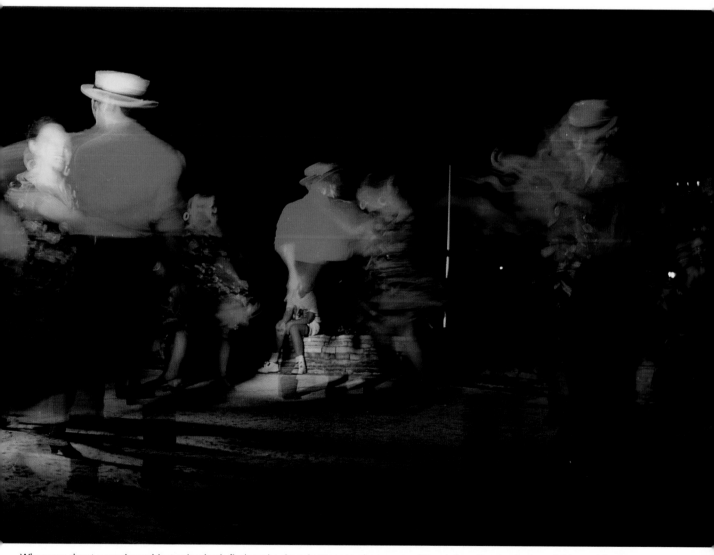

When you shoot a moving subject using both flash and a slow shutter speed, you can achieve interesting results. I used this combination while photographing these dancers in San Juan, Puerto Rico. The resulting image is both frozen and blurred. Working with my Canon F1, a 24mm wide-angle lens, and my Vivitar 285 flash set on manual, I exposed Kodachrome 64 for 1/8 sec. at f/5.6.

# WORKING WITHOUT A FLASH METER

It is possible to work with an electronic flash in manual mode without the use of a flash meter. You can utilize the information on the back of the flash in order to shoot an accurate manual exposure; however, a more precise method is to determine exposure with the flash unit's GN, or power rating. The formula for calculating exposure based on the GN is known by the acronym DIG, which stands for "distance into guide." To arrive at the required aperture setting, you divide the guide number by the distance:

GN ÷ D = $f$-stop.

For example, if you're using a flash with a GN of 120 and the subject is 10 feet away, the appropriate aperture setting is $f/12$. You then round off this exact aperture figure to $f/11$.

Unfortunately, most GNs aren't very accurate, so you should test your flash to ascertain its true GN. You can do this by applying the DIG formula in reverse. For example, you can shoot a subject at a distance of 10 feet from the camera with ISO 100 film, using different apertures. Then when you view the film, the exposure that looks the best becomes part of the formula to determine the new GN. Suppose that you're using a flash unit with an indicated GN of 120 and the best exposure is at $f/11$. You would then multiply the distance by the aperture to arrive at the corrected GN:

D × $f$-stop = GN.

Here, the new GN is 110.

When you want to use a specific $f$-stop with your flash and need to know the effective distance, you can use another formula, which is known by the acronym FIG. This stands for "$f$-stop into guide," or:

GN ÷ $f$-stop = D.

Here, if you want to use an aperture of $f/8$ with a flash unit that has a GN of 120, you'll divide 120 by 8 to determine a distance of 15 feet.

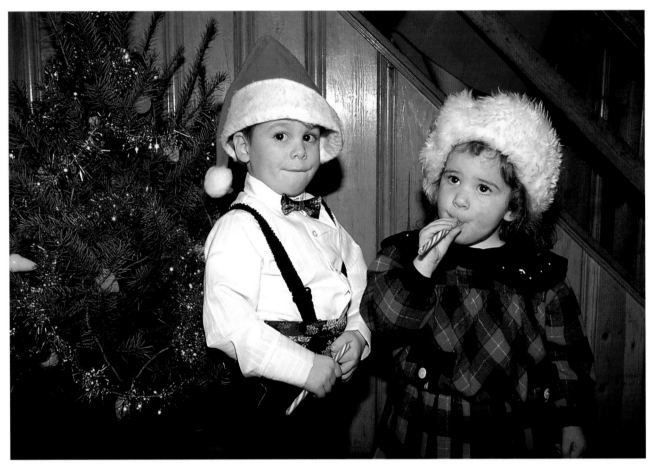

By choosing my camera's automatic mode, I was able to concentrate on the expressions on the children's faces in this holiday portrait. With my Canon EOS-1, a 50mm standard lens, a Canon 430EZ flash set on automatic TTL, and Ektachrome 100X, I made this shot without a flash meter.

As soon as you determine the flash exposure at one distance, you can easily adjust the exposure for another distance. Each time the distance is doubled, the exposure must be increased by two stops in order to maintain the density. Conversely, when the distance is halved, the exposure must be decreased by two stops to maintain the same density. A reliable way to remember the exposure difference between distances is to compare it to the aperture scale. The difference between each distance of 2 feet, 2.8 feet, 4 feet, 5.6 feet, 8 feet, 11 feet, 16 feet, and 22 feet is one stop of light. For example, a flash exposure requiring an aperture of $f/8$ at a distance of 11 feet will change to $f/5.6$ if the distance is 16 feet, and to $f/11$ if the distance is 8 feet.

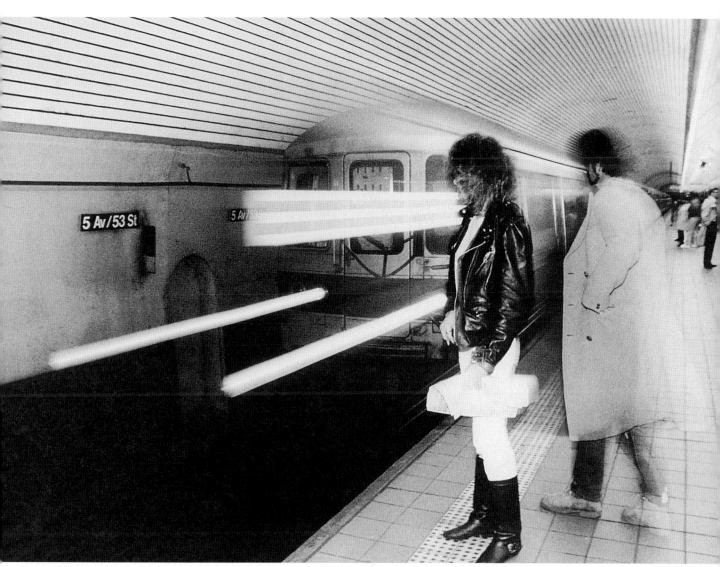

Because I was working without a flash meter, knowing the strength of my flash unit's output enabled me to freeze a portion of this motion study. I made this shot in a subway station with my Canon F1, a 24mm wide-angle lens, a Vivitar 285 flash set on manual, and Kodak Tri-X Pan Professional film. The long 8-second exposure resulted in the subway-car light trails.

# ADDING WARMING FILTERS

Changing the color output of the flash is a subjective decision; however, some choices are fundamental. The light output from a flash unit often is slightly blue, so placing a warm, light-orange filter over the flash when you shoot a portrait is a good idea. The denser orange filters are useful for correcting the blue tone of tungsten film. Some manufacturers offer warming filters as accessories; however, I've found that a packet of colored acetate swatches from companies like Rosco offers an inexpensive alternative. These sample books usually cost less than 10 dollars. The Rosco swatches are approximately the same size as the flash element, and I can easily tape them over it. Experimenting with different tints will change the look of your portraits.

To warm up the color temperature of flash, which leans to the cool side, you simply need to use an orange gel over the flash. This pair of photographs shows you these two effects. For the first portrait, I didn't place a filter over the flash (above). The resulting image is acceptable, but a blue cast is apparent. For the second shot, I used an orange gel to warm up the scene, thereby creating a more pleasing look (right). I made both shots with my Canon EOS-1, a 50mm standard lens, a Canon 430EZ flash set on TTL, and Fujichrome Velvia.

# NIGHTTIME EVENTS

A well-lighted outdoor venue provides you with one more place to shoot a dramatic photograph at night. Major outdoor sporting events, such as baseball, football and tennis, are played throughout the year and offer ample opportunities for making pictures. Concerts are another potential outdoor subject. When the weather is warm, rock, jazz, and classical concerts are performed in an assortment of venues, including large sports stadiums.

Although sports photography differs from concert photography in a number of ways, the fundamental approach to shooting sports and concerts is the same. The subjects are sometimes relatively inactive for extended periods of time, so making them look interesting on film can be difficult. Since you're often photographing subjects from quite a distance, you're required to work with telephoto lenses. And because the shutter speed has to be fast enough to freeze the action, usually 1/250 sec., the aperture must be close to wide open. For your camera to accommodate these settings, a fast film with an ISO rating of 800 or 1600 is necessary. Keep in mind, though, that the faster the film speed, the more prominent the film's grain structure is. And this increased granularity limits detail, color saturation, and enlargement possibilities.

Some people think that when you photograph an event as a representative of the press, you have more advantages. The shooting position certainly is advantageous, but the amount of time you're allotted to cover the event isn't. As a spectator, you get to spend the whole evening at the show, while as a member of the press you stay for only a short time. In fact, when I am on a concert assignment, I usually photograph the performers through only three or four songs. So until you're established, you should build a portfolio of images from shooting events at smaller venues. And it is always wise to call ahead of time to find out if you must secure permission to photograph the event. The answer depends on a number of variables: the performer, the venue, and your intended use.

Even as a spectator, you can get a good shot of a sporting event. From my seat, I photographed the New York Mets' Howard Johnson getting hit in the head by a pitch. Shooting with my Canon F1 and a Sigma 100–300mm zoom lens, I exposed Kodak Tri-X Pan Professional 400 film, which I'd pushed to ISO 1600, for 1/125 sec. at f/5.6.

# CONCERTS

Capturing the crowning moment of a concert is a challenging yet fulfilling experience. It enables you to preserve the excitement of a favorite performer on film. Unfortunately, you have to contend with variables of a passive nature: people getting in the way, continually varying light values, and image blur as a result of subject motion. Since most of the time you can't use a tripod, photograph through people's heads, or ask performers to stay still, you need to remain persistent. The only sure way to achieve a successful image is take out a low-cost insurance policy: shoot plenty of film. The strong allure of depicting such low-light events compels photographers to find ways to overcome these obstacles.

The technical aspects of concert photography offer limited alternatives. When shooting a concert or any other stage production, you must adjust the exposure to compensate for the passive-control lighting. During the performance, the spotlights frequently change and, as a result, so do the light values in the scene. This is apparent to the eye, so the best time to shoot is when the lighting appears bright. Even at peak illumination, however, you must use a fast shutter speed to stop action. A shutter speed of at least 1/125 sec. is necessary, but I recommend setting your camera at 1/250 sec. Keep the following suggestions in mind when you shoot concerts:

- **Use a fast film.** Flash is almost never permitted, so you'll take the majority of your concert pictures in available light. Because of the low-light levels and subject motion, you'll need to use a film with an ISO rating of at least 400. An ISO 1600 film is preferable. Also, transparency film is required if the pictures are destined for publication. Remember, though, that slide films demand more precise exposure calculations than print films do.

- **Use a spot meter, and aim it at your subject.** It will provide the most accurate exposure determinations possible. If the subject is too bright or too dark, take a spot-meter reading of any middle tone in the scene.

I made this shot of the Eagles in concert from behind the first section of the orchestra. I determined exposure by taking a spot reading of one of the band member's midsections. Working with my Canon EOS-1 and an 80–200mm zoom lens, I exposed Fujicolor 800 for 1/250 sec. at *f*/2.8.

Because of the nature of spotlights, a reflected-light reading of the entire stage can fool the camera into improperly exposing the scene. If your camera doesn't have a built-in spot meter, you'll need to use its standard meter and then add an extra stop or two of exposure to compensate.

**Use a zoom lens.** With this type of lens, in essence, you're carrying several focal lengths in one compact unit, so it is more effective than a telephoto lens. When you work in a crowd, switching lenses isn't always practical. An 80–200mm zoom lens is a workhorse at concerts. If you want an even closer view than the 200mm focal-length setting affords, you should add a lens extender. The most common lens extender, the 2X, effectively doubles the focal length of a lens. But be aware that these lens extenders require a two-stop exposure increase, so the lens in effect becomes two stops slower. For example, a 135mm F2.8 lens becomes a 270mm F5.6 lens with a 2X extender.

- **Make sure that your hand is steady when you shoot.** Tripods and monopods are almost always excluded from concert venues, so you're required to handhold your camera. Holding a telephoto lens steady can be particularly difficult. A trick is to take a deep breath when you press the shutter-release button. Resting your camera-and-lens assembly on a seat, wall, or rail will sometimes enable you to keep it steady during exposures that are just out of the handheld range. When you use a 135mm telephoto lens, for example, the shutter speed shouldn't be less than 1/125 sec. But resting the camera on a solid surface will permit you to shoot at shutter speeds that are several stops slower.

- **Remember to photograph the fans as well.** Their expressions can range from sheer delight and adoration, to simple enjoyment and amusement, to outright boredom. Fans provide you with a memorable documentation of the show even when you can't get close to the stage.

While on an assignment photographing an Eagles concert, I had only the time it took the band members to perform three songs in order to adequately cover the concert. Quite unfortunately, at the end of the second song, I noticed that the film in my Nikon N90 hadn't rewound. Fumbling in the dark, I replaced that camera with a Nikon F3. The entire ordeal probably lasted only 90 seconds, but it seemed like an eternity under these less-than-ideal circumstances. Luckily, I captured this decisive moment of the band before I had to leave. With my Nikon F3 and a 400mm telephoto lens mounted on a tripod, I exposed Fujicolor 800 for 1/250 sec. at ƒ/4.5.

# SPORTING EVENTS

Nighttime sporting events are a challenge to shoot. Because so many people are drawn to sports figures, it seems only natural that photographers want to capture these athletes in action. Whether you're shooting a Pee Wee league softball game or an NFL football game, your objective is the same: to capture a dramatic moment. For example, you might make it your goal to photograph a player stopped in midair in pursuit of the ball. These moments are fleeting, so you must always be prepared to shoot if you hope to record a memorable sports picture.

You do, of course, have many other picture possibilities to consider when you shoot sports. The art of photography may be concerned with capturing a moment, but no one ever said that this moment is restricted to an airborne icon. A compelling sports photograph can show players anticipating their next move, or looking dejected after a defeat or jubilant after a victory. At the end of a baseball game, the winning pitcher and catcher shake hands, and the other members of the team come on the field to congratulate the pitcher. Each of these scenarios tells a story, yet it isn't restricted to action.

While an amateur photographer's chances of getting great shots are more limited than those of a professional, spectators do have opportunities. A fan might not have the mobility that a sports photographer on the field has, but it is still possible to get decent pictures at a stadium game. Every sport has its own methods of visually communicating the elements of the game, and these provide natural subjects. When you shoot a sport that uses a ball, it is a good idea to include the ball in the picture. The key is to be aware of who will have the ball at specific moments. This knowledge comes from understanding some of the intricacies of the particular sport.

For example, when runners are in scoring position at the second and third bases during a baseball game, there is a good chance of a play at home plate. The pitcher controls the game, so shoot some frames of this player pitching, and pay close attention to the reaction after a home run or a strikeout. Photograph the batters, too. If you are a spectator, where you sit determines which players you can photograph most effectively. The first-base side provides the best angle for photographing right-handed batters. Left-handed batters benefit from a shooting position on the third-base side. You should also try to predict where the next play will be. A runner on first base sets the stage for a force-out or double play at second base.

Football has its own photo opportunities. For example, if the team is on the one-yard line, you can be sure that the ball is going to the fullback. Photograph the quarterback, who is the leader of the team; every play passes through the quarterback's hands. It is best to photograph the quarterback from behind the line of scrimmage so that you get a clear view.

After you cover the key team members, you should concentrate on your favorite players throughout the game. It doesn't make sense to try to tell the story of the whole game. For example, you might decide to stay in front of the receivers. If you're expecting a pass to the receiver, position yourself downfield on the sideline so the action doesn't pass you by. If the play is close to the end zone, position yourself to the right or the left of the goalpost. Once again, you should look for jubilation pictures: coaches and managers shaking hands after the game, players patting one another's shoulders, and players smiling at the fans. You might also decide to record the agony of defeat: the quarterback hanging his head low or a lone player sitting on the bench and gazing onto the field.

Remember that at a stadium you're usually far away from your subject, so you'll need a telephoto lens to bring the action close. While the stadium lights, which are usually multivapor lights, provide sufficient illumination, the fast shutter speed required—usually 1/250 sec. or 1/500 sec.—calls for a wide-open aperture setting, such as $f/2.8$. Unfortunately, these $f$-stops can narrow depth of field quite a bit. So, when you use a long telephoto lens, such as a 400mm, you must focus precisely or you won't have a picture. Perhaps the most important point to remember is that no matter what sport you're shooting, you must control the chaos of the game by isolating those portions of the scene that tell the real story of the action on the field.

Keeping the following suggestions in mind will enable you to successfully shoot a tennis match. Naturally, you should try to include the ball in the picture. Standing parallel to the net lets you include both players in the frame. Lenses with focal lengths in the 50mm-to-100mm range are useful in these situations. If you stand at the backcourt, you can concentrate on the player on the opposite side of the court. A 135mm-to-300mm lens is ideal here. Finally, attempt to record the players' emotions, especially those of the more animated ones. After the match, watch to see if the players shake hands and be ready to shoot.

I made this shot of a football special-team squad waiting for the ball to be whistled dead after a punt from across the playing field. Working with my Canon EOS-1 and an 80–200mm zoom lens, I exposed for 1/250 sec. at ƒ/4 on Fujicolor 800.

Sports photography often depends on telephoto lenses in order to bring the action closer. I was standing about 40 yards away from this football player, in the back of the end zone, so I needed to use a telephoto lens. I wanted to fill the frame with the wide receiver as he prepared to make a reception. Working with my Canon EOS-1 and a 400mm telephoto lens, I exposed Fujichrome 800 for 1/250 sec. at ƒ/4.

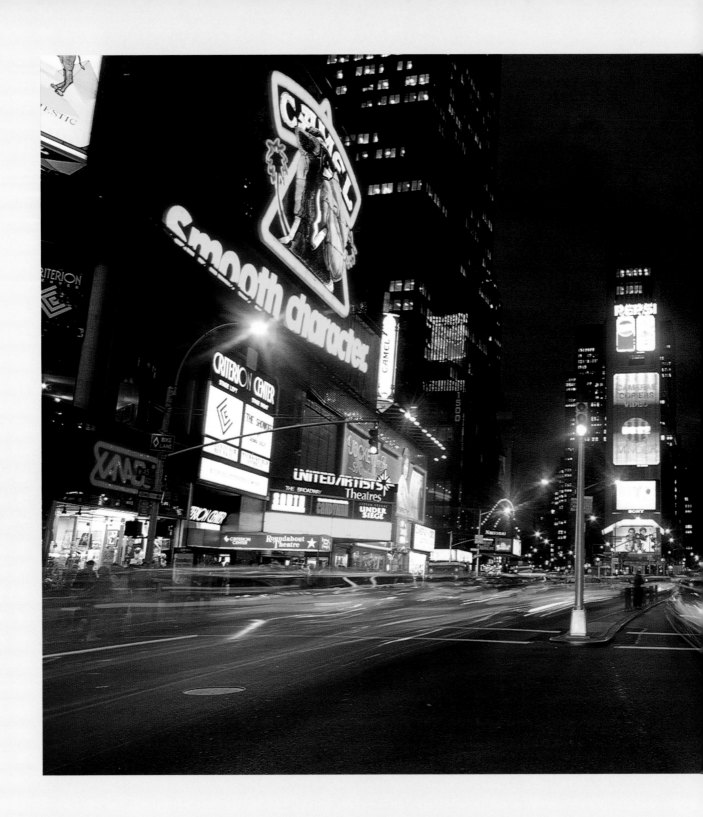

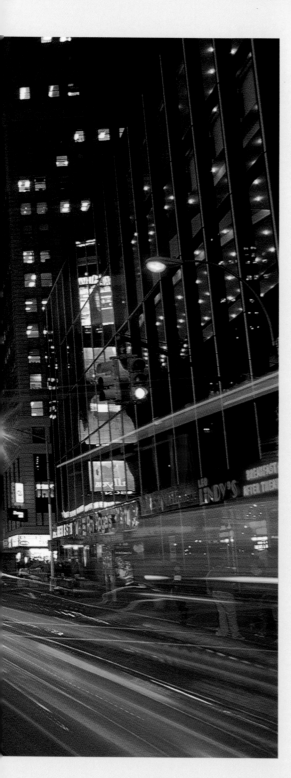

# CHAPTER SEVEN

# ADVANCED TECHNIQUES

The collection of light on film often blends the arbitrary nature of a painting with the aesthetic realism of a photograph. The best of both mediums can be combined in a single image because you can manipulate the universe of the long exposure through light, time, and film, thereby altering the reality of a preconceived situation. Both animate and inanimate objects can be included in the same image, yet they can be in two different time planes.

The advanced techniques for gathering light on film can be divided into two parts: light painting and random collections of light. The first section deals with the effects of the selective control of a light source, as if it were a paintbrush on film. Here, photographers play an active role in determining the look of the photograph. The second section describes techniques for photographing passive forms of light that include fireworks, star trails, and traffic patterns. The night becomes a boundless canvas for individual expression, and photographs with an unlikely, dramatic quality can be achieved. The imagination is no longer concerned solely with the reproduction of reality, but also with the interpretation of reality within the boundaries of limited light.

# LIGHT PAINTING

As a photographer, you have two options during a long exposure. You can wait for the exposure time to lapse, or you can take advantage of the time and paint with light. If you choose the latter, you'll realize that various techniques can contribute to personal expression. During the time that the shutter opens and closes, a dark portion of the scene can be illuminated, a central part of the composition can be accentuated, and colors in the scene can be altered. You can also introduce light in specific places and control it as if you were painting.

I've discovered that three types of light painting exist. The first requires a continuous light source, such as a flashlight. The length of time that you illuminate the subject is extensive because the light intensity is low. But this time increase is beneficial because it gives you more control of the light source.

The use of electronic flash is another type of light painting. Here, the intensity of the flash allows an entire scene to be illuminated by several "pops" of electronic flash. As such, flash painting is the quickest of the three methods. Through the selective illumination of specific sections of a scene via flash, the coverage of the flash is unlimited.

The third technique is a bare-bones simulation of the Hosemaster, which is, in essence, an expensive light-painting system (see page 132). You don't need to invest in a sophisticated device when you can achieve similar effects with tools found in a hardware store and camera shop. This version of the Hosemaster requires a bit more work, but it can produce pleasing results.

The average light painting requires several minutes of exposure, thereby making it susceptible to reciprocity failure. Fortunately, familiarity with the type of film and the filtration you use will counteract any adverse effects, as well as prevent you from wasting your time. Time is essential to a light painting because it allows photographers to selectively add color and intensity to portions of the scene. In much the same way that oil, acrylic, and watercolor are a painter's mediums, light is a photographer's medium. Through light painting, the final image becomes more than a reproduction of a scene; it becomes an imprint of its creator's imagination.

I find light painting beneficial for illuminating smaller subject matter. Don't try to imitate the illumination from a conventional light; instead, use light painting to control the form, composition, and center of interest. A penlight was the sole source of illumination for these two floral images. The light source hit the iris from every side, but predominantly from behind (right). Because I used a slow film, the exposure was about 2 minutes. With my Canon F1 and a 28–85mm zoom lens at its macro setting, I exposed Fujichrome Velvia at ƒ/5.6. In the portrait of the rose, light, shadow, and color help create a unique image (above). The glow of the rose is a result of the light source that I held behind the flower. I illuminated the background via a small lantern covered with a red gel. The light source plays a role in emphasizing the subject, and the shadow controls its form. Working with my Canon F1 and a 28–85mm zoom lens set on macro, I exposed Kodachrome 200 for 90 seconds at ƒ/8.

# PAINTING WITH A CONTINUOUS LIGHT SOURCE

A small flashlight is transformed into a paintbrush during a long exposure. This battery-powered marvel allows you to illuminate a portion of a scene with gentle strokes of light. The effect is under your complete control. You can, for example, enhance the scene so subtly that you are the only one who is aware of the manipulation. Another effect can be blatant: Elements of the scene that were devoid of light earlier are now sufficiently illuminated. You can also use the flashlight to outline the subject or to create a brighter background.

Unfortunately, light painting has some restrictions. For a situation to qualify for the use of a flashlight, the exposure has to be long enough to accommodate the light painting. Since the light output from a flashlight isn't very intense, it takes quite a while for it to register on film. The exposure time often exceeds a minute, and is often several minutes long.

The camera is also the subject in this example of outlining the subject. By positioning the tripod in the mirror, I was able to outline my camera and tripod while the camera recorded their reflection. I also used a flashlight with red and green gels over it for this line tracing. With my Canon F1 and a 24mm wide-angle lens, I exposed Agfachrome 100 RS Professional film for 2 minutes at f/5.6.

Ambient light can affect exposures of this duration. To counteract overexposure, you must choose an aperture setting that underexposes the scene by at least two stops. The period of light painting shouldn't go beyond this time frame. For example, if the ambient exposure is 90 seconds at f/4, you should set the aperture at f/8. Nothing is worse than investing time in a light painting only to have overexposure negate its effect.

Determining exposure for the actual light painting isn't an exact science. Your goal is to get a base exposure, and then to bracket by increasing the duration of light with each frame. A specific technique can help you calculate exposure. Begin by figuring out the distance between the light source and the subject. Next, take an incident reading of the light at this distance. In general, I base the exposure on a 1 sec. duration, and let the meter select the aperture. If the light reading suggests an aperture setting of f/4 at 1 sec. but the ambient exposure requires an aperture of f/8, I'll lengthen the exposure duration of the flashlight to 4 seconds. Keep in mind that for the exposure to be consistent, the beam of light must cover the scene evenly. If you don't have an assistant or feel that this technique is limited to distances that your arm span can handle, you can take a reflected-light reading; however, it won't be as accurate as the incident-light reading.

Sometimes, you'll find it worthwhile to use flash to create a base exposure. You should then underexpose this calculation by two stops in order to provide an effective base. This will help both to define the subject and to reduce the contrast in the scene. Larger subjects sometimes need the aid of electronic flash to open up shadow areas.

Subject outlining is another version of painting with light. Here, you trace the shape of the subject with a penlight. Be aware, though, that the intensity of the light, the rate at which it moves, and the size of the beam make exposure difficult to determine. I've found that when I use a small, 3-volt flashlight, fresh batteries, and ISO 100 film, the starting exposure is approximately f/5.6. The intensity of light and the pinpoint area that it covers make it acceptable, if not preferable, to overexpose the subject. You simply must make sure that the duration of the flash exposure doesn't exceed the ambient exposure. The subject itself won't be noticeably affected in the final image, but the light tracing may appear brighter.

Subjects whose shape and contour can be enhanced with light are ideal for this technique. To outline these subjects, you should complete the following steps:
- First, estimate how long it will take to complete the exposure.
- Find a position that enables you to comfortably trace the object.
- Take a meter reading. It is best to outline subjects that are in subdued light because the duration of the exposure may overexpose the scene.

- Outline the subject in slow, steady motions. Be careful to keep the light source even throughout the exposure.
- When composing, keep in mind the areas that won't be covered with the light.

I've seen simple light tracings that took less than a minute to complete, as well as some that took hours to finish. The longer images involve tracing every single part of the scene that you intend to include. Whenever you attempt such a painstaking creation, you must use a larger aperture setting to counteract ambient-light pollution. The decrease in exposure requires the light source to move slowly and evenly for it to register effectively on film. One more tip: Wear black clothing, so you won't appear as a ghost in the final image.

Here, I illuminated this guitar with a small flashlight during the long exposure. To achieve this continuous-lighting effect, I placed green and red gels over the flashlight. Shooting with my Canon F1 and a 28–85mm zoom lens, I exposed Kodachrome 200 for 3 minutes at ƒ/5.6.

# PAINTING WITH FLASH

Painting with flash subscribes to the same premise as painting with light, but its effect can be different. Flash units have the power to illuminate large areas of a scene with a single burst of light. This shortens the duration of exposure. Unlike painting with a flashlight, which acts like a point source, painting with flash provides a broad range of light. Large, expansive subjects are perfect candidates. These include beach houses, landscaped grounds, and statues.

A scene that is illuminated via this method may only require several bursts of light; therefore, the exposure times aren't too susceptible to reciprocity failure. In some cases, either when the flash unit has limited power or when different gels are used to change the color of the subject, exposure times can be several minutes long. But this is more the exception than the norm.

Calculating exposure when you paint with flash is less complicated than it is when you paint with a flashlight. Your first step is to establish the distance that you will be from the subject, and base your readings on it. Next, determine the flash exposure and set the $f$-stop. Suppose that you'll be shooting with flash at an average distance of 10 feet. At this distance, the flash meter suggests an aperture setting of $f/8$. The scene may require 10 pops of electronic flash, one pop for each section. Depending on the scene, it may take a minute or two to complete the exposure. Whatever the base exposure turns out to be, the shutter should be on the "B" setting. If the ambient light in the scene is prominent, figure out how long the shutter can remain open before the exposure will be affected. If the ambient exposure is 45 seconds at $f/8$, be sure to complete flash painting in that time.

Next, calculate the coverage of the flash. You can do this most accurately with a flash meter, but your eye can serve as a viable substitute. Watch for the edges of the flash output. Overlap the bursts from the flash, so that just as one burst ends, the next begins. A slight overlap, however, will ensure even exposure because the edges of a burst are generally less intense than its center.

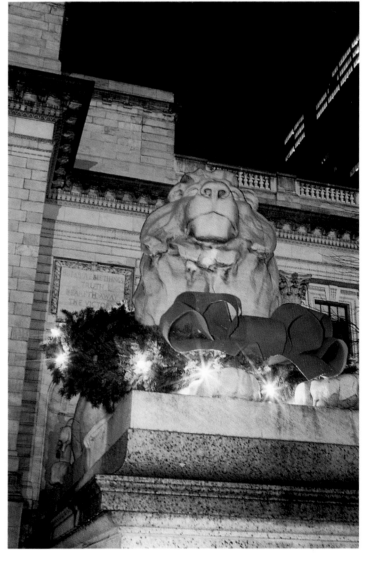

I made the first shot of the lions outside the New York Public Library without flash or corrective filtration (above). The sodium-vapor lamps produced a green color cast. With my Canon F1 and a 28–85mm zoom lens, I exposed for 15 seconds at $f/4$ on Kodachrome 64. I then switched to tungsten film because I knew that the resulting cyan tone, although not accurate, would be better than the green tone (right). Next, I covered my Vivitar 285 flash with a red gel to correct the statue's color. With the same camera and lens, I used three pops of flash and exposed Ektachrome 320T at $f/11$ for 45 seconds.

Painting with flash can be fun and can produce some compelling images. I was experimenting with this technique when I made this shot of a western-style boot. I outlined and painted the boot with a penlight. Shooting with my Nikon FM2 and a 60mm micro lens, I exposed Ektachrome 64T at ƒ/4 for 45 seconds.

Painting this tree-swing scene required three pops of flash. Rather than show the swing with just small traces of motion, I decided to exaggerate its movement by pushing it during each pop of flash. Shooting with my Canon EOS-1 and a 20–40mm zoom lens, I exposed Fujichrome Velvia at ƒ/8 for 30 seconds.

# BARE-BONES LIGHT PAINTING

The effects of the sophisticated Hosemaster lighting technique can be closely duplicated using common objects. This crude version is fairly simple to create. You need at least one flashlight, cardboard templates, diffusion material, a camera system, and patience.

The Hosemaster light-painting system has four components: a power supply/light source, a control nozzle, several feet of fiber-optic hose, and a filter box for the camera. Light is carried from the power supply/light source to the nozzle through the fiber-optic hose. The handheld control, or nozzle, can emit light in much the same way that a garden hose sprays water. The nozzle dictates the direction, intensity, and shape of the light. It also controls the filter box on the camera. This box contains several diffusion filters of different intensities. With a push of a button, a filter can be added, changed, or taken away. The various effects the filters create through diffusion give the final image its painterly quality.

A photograph can take on a painterly quality, especially when it depicts a traditional subject, such as a fruit basket. To achieve this effect here, I began with a flash exposure that I underexposed by two stops to provide a base. Next, I placed a diffusion filter over the lens. Finally, I used a penlight to add highlights. Shooting with my Canon F1 and a 28–85mm zoom lens, I exposed Fujichrome Velvia for 3 minutes at *f*/5.6.

Sophisticated light-painting systems work as follows. First, you decrease an evenly illuminated flash exposure of a subject by two stops in order to create a base exposure. The flash vaguely defines the main subject. You then apply various degrees of diffusion to highlight the critical portion of the scene. The bare-bones light-painting system utilizes the fundamentals of this technique.

The light painting begins with a burst of flash that underexposes the scene by two stops. A diffusion filter is then placed over the lens. I prefer using a manufactured diffusion filter, such as a crumpled piece of cellophane, a petroleum-jelly smudge over a skylight filter, or a clear plastic bag. Each offers a distinct aberration. But altering the amount of diffusion is difficult with the bare-bones approach. You must change the filter by hand each time, which increases the risk of shaking the camera. After a few practice sessions, however, you'll master this task.

This simplified version is a physically challenging method of photography. The light source, a flashlight, doesn't offer the control that a complex light-painting system does, nor does it produce the same quality of light. Nevertheless, it is functional and inexpensive, and it produces satisfying results. The homemade special effects give an esoteric quality to your work. The light source is self-contained: there is no nozzle or fiber-optic hose. I find Maglight flashlights especially useful because I can change the beam of light from broad to narrow with just a turn of the head. When the need arises, the cardboard cutouts over the flashlight can offer additional control or enhance the light spread. You should decide on the size of the light beam and the degree of diffusion before the picture begins. And keep a record of the filter, distance, and light spread in order to maintain continuity.

One problem that can alter the image is light temperature. The flashlight has a color balance that is warmer than that of tungsten illumination. So if you shoot daylight film, the area of the image illuminated by the flashlight will take on a yellow-orange color. Sometimes the effect is acceptable, but most of the time, it can undermine the results of a conscientious project. One solution is to use a blue filter over either the light source or the lens. I recommend placing it over the flashlight in order to prevent changing the camera's position. You can also use tungsten-balanced film for light painting. The light source will be slightly warmer. In this situation, the flash output should match the tungsten film, so you should use an orange filter over the flash. If you don't filter the flash, the scene will reproduce with a cool color cast.

The technique that I think works best is to filter the flash with a light-blue filter when using daylight film. This combination creates a blue underexposed image. When the light-painting part of the sequence begins, the flashlight doesn't have to be filtered. In essence, it is finishing the exposure that began as a dark, cool image by adding intensity from a warm light source.

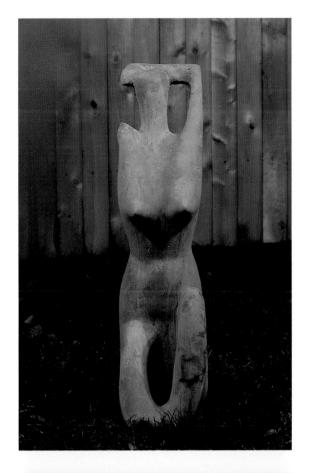

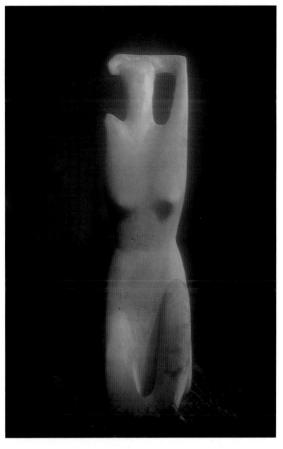

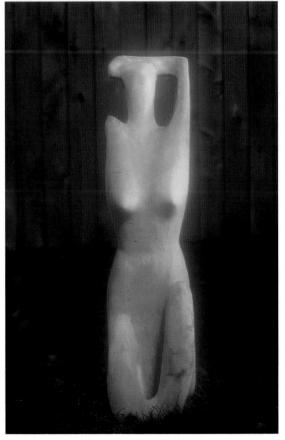

These three photographs of an abstract garden statue demonstrate the phases of a bare-bones light-painting system. I chose Fujichrome Velvia, a daylight-balanced film, for this sequence, but a tungsten film would have worked just as well. I also used my Canon EOS-1 and a 50mm standard lens. The first photograph demonstrates the effect of the base exposure (top left). To determine this, I turned to a flash meter, which indicated an exposure of ƒ/2.8 for 1/2 sec. I used a bounce card to soften the light, and a low-density blue filter to provide the light with a slightly cool quality. I wanted to create a 2:1 light ratio, so I exposed the left side of the image with two pops of flash and the right side with one pop. The next photograph shows the effect of the light painting by itself (top right). Here, I took an incident reading of the light source from a distance of 42 inches, and the meter suggested an exposure of 1 sec. at ƒ/4. Since I wanted to shoot at ƒ/8, it was clear that the light source had to illuminate every portion of the statue for at least 4 seconds. In the final image, the color of light is a warm orange, the contrast is intense, and the subject is separated from the background. The third shot is a result of combining these two exposures on the same film (left). The blue illumination from the flash counteracts the warm glow from the flashlight to some extent. I placed a plastic bag over the lens after the flash exposure to diffuse the light, thereby giving the image a painterly quality. The entire exposure took approximately 8 minutes to create.

# RANDOM COLLECTIONS OF LIGHT

The duration of a night exposure can be several seconds or more, thereby turning an image into a collection of light. Inanimate objects are rendered as still lifes, but other elements of the scene accumulate as well. Arbitrary forms of motion may reproduce as blur, but light forms become saturated streaks. I find the collection of time especially interesting. Each single image can represent a passage of time. This can be as simple as a series of red lines from automobile taillights, or as intense as the circular path of star trails. Also, a fireworks display fills the sky with ribbons of color and is more arbitrary because you never know exactly where the light displays will appear. In each situation, the duration and the arbitrary nature of the light ensure that every image will be an original.

## SUGGESTED EXPOSURES FOR SHOOTING LIGHT SOURCES AS SUBJECTS

| Subject | Suggested Exposure for ISO 100 Film |
|---|---|
| Fireworks display | Bulb at $f/8$ (cover lens between bursts) |
| Star light trails | 1–4 hours at $f/5.6$ |
| Automobile light trails | 30 seconds at $f/8$ |

The shutter-priority mode provides the ease of automatic exposure by enabling you to select an appropriate shutter speed while the camera selects the aperture setting. I made this picture of traffic-light patterns using the automatic-exposure mode. The exposure was long enough to accumulate the light patterns in the image. Shooting with my Canon EOS-1 set on shutter-priority mode, a 50mm standard lens, and a 2X lens extender, I exposed for 15 seconds on Ektachrome 100.

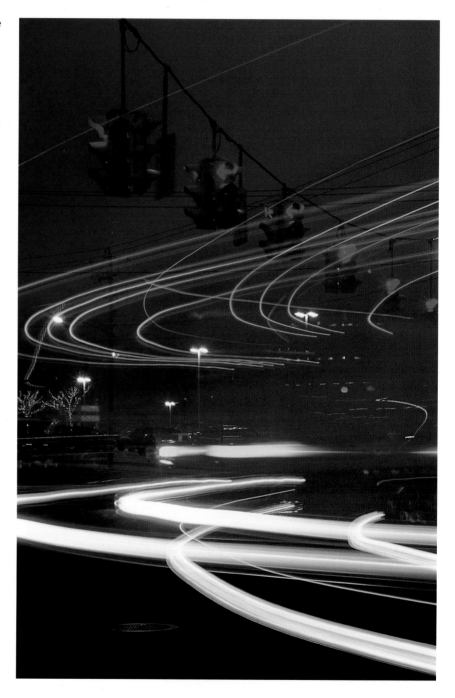

# RECORDING TRAFFIC PATTERNS

Traffic patterns recorded during a long exposure are the most common types of random light sources. The pattern of light is predictable, and you can easily integrate it into a composition. In addition, its effect can intensify the rendering of an inanimate object, such as a building, a statue, or even a tree. Sometimes the patterns of light become the subject itself; these saturated areas of color can dominate the image.

Regardless of your intention, several techniques guarantee striking images. The most successful light trails are from smooth lines of traffic. In order for you to achieve this result, the light source must pass through the frame at a steady speed. Many ineffective light-trail images occur when the light source either doesn't make its way through the entire frame or stops for a certain length of time before continuing.

The angle of view plays an important role in capturing a light trail. When the camera looks down on traffic, it can create a linear effect. From this perspective, the light source is off-axis to the lens and doesn't shine directly into it, so lens flare is reduced. Furthermore, the illumination given off by headlights is rendered as white streaks; here, it doesn't overexpose the scene.

Determining exposure for automobile light trails is as unpredictable as it is for measuring most other light sources; however, some initial steps do exist. The first is to establish the amount of time it takes for a car to pass through the scene. A wide-angle lens requires more time for the subject to pass than a telephoto lens does. Generally, the exposure times are between 10 seconds and 45 seconds. You must then maintain this duration; you can alter the exposure as needed by changing the aperture.

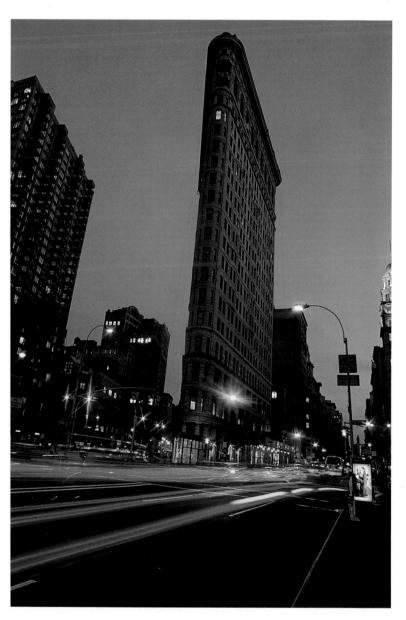

The automobile taillights in this shot provide a colorful accent in this otherwise monochromatic scene. Shooting with my Canon F1 and a 24mm wide-angle lens, I exposed Agfachrome CT 100 for 8 seconds at ƒ/11.

# SHOOTING FIREWORKS

Fireworks displays in the overhead sky are one of my favorite nighttime subjects. Each burst blossoms into streaks of red, blue, green, yellow, and/or pink that captivate both the spectator and photographer in me. As a spectator I'm dazzled by the sight, but as a photographer I'm challenged.

Capturing these elusive fireworks displays is an art form. It is no easy task to successfully render these arbitrary collections of light on film. The location of each burst is unpredictable, which, in turn, makes it difficult to compose. Just when you think you know the approximate area, the burst occurs in another part of the sky. Many photographers make the mistake of moving their camera after each burst. This method usually keeps you one step behind the fireworks. While you may get lucky, often you waste time and film.

Instead, observe the first few bursts through the viewfinder of your tripod-mounted camera. When you find an area that is frequently bombarded, point the camera at that location. This will give you the best idea as to which section of the sky the fireworks will appear in. Once you determine this spot, set up your camera and leave it in that position for the rest of the show. Sometimes the expanse of the burst is larger than the confines of the frame, while at other times the bursts are smaller and get lost in the vast, dark sky. Be aware that you'll have little control over the composition of your images. But shooting film generously will increase your chances of shooting dramatic fireworks pictures.

You can photograph fireworks several ways. The first is to isolate the bursts in the black sky. Often these become abstract renderings of light. Another approach is to include an inanimate object, such as a statue of a patriot, in the scene. This element provides the image with a sense of scale. Furthermore, it can render a potentially boring inanimate subject a bit more interesting. You can also include separate bursts of light on the same frame of film by locking the shutter on the "B" setting and covering the lens with an opaque card in between bursts. You don't need to alter the aperture setting. I use this approach when the fireworks fill a large expanse of the night sky; in these situations, I select a wide-angle lens.

You can use basically any camera to shoot fireworks. The only requirement is a "B" setting that will let the shutter remain open during the long exposures. For a fireworks photograph to have a positive impact on viewers, it must be the right density. Overexposing the scene creates a too-bright look, and underexposing it makes it too dark. Since you can't measure the illumination of a fireworks display, a light meter is useless. It would read the darkness in the sky and overexpose the bursts of light, thereby producing a washed-out photograph. Instead, exposure is derived from a suggested aperture setting. Suppose that you're shooting ISO 100 film. You'll start with an aperture of $f/8$ (the length of the exposure is the length of the burst, during which the shutter remains

open), and then bracket one stop over and one stop under this setting. Remember, you're bracketing not only for exposure, but also for content.

It is best to think of a fireworks photograph as an interpretation of the display. As a spectator, all of your senses are stimulated. The crackles of each burst, the smell of its powder, and the mood of the crowd are all factors that you can't transfer to film. A spectator can enjoy the display and all of its grandeur, but a photographer is limited. The pictures of a fireworks display communicate only on a visual level. Bursts of bold reds, magentas, and yellows can draw viewers into your final images; subtle pastels can, however, be pleasantly soothing.

For the most part, I consider pictures of fireworks mundane because of the way the fireworks are shot: either over a skyline or as lone bursts of light. But I find that fireworks can make interesting pictures when photographed from ground level. This was the approach I took to shoot a neighborhood fireworks display (above). The resulting image shows flows of light that have a different look. With my Canon F1 and a 24mm wide-angle lens, I exposed for 15 seconds at $f/11$ on Ektachrome 100X. For another shot, I positioned my camera so that the fireworks bursts appeared behind a telephone pole (right). I illuminated the street sign via several pops of electronic flash. Working with my Canon F1 and a 28–85mm wide-angle lens, I exposed at $f/11$ for 15 seconds on Agfachrome 100 RS Professional film.

# CAPTURING STAR TRAILS

Star-filled skies provide endless photographic opportunities. A camera mounted on a tripod for an extended duration can reveal streaks of light from each star. And while it may sound like work for an astronomer, shooting star trails isn't different from photographing any other random light sources. Collecting starlight on film doesn't require special equipment or a knowledge of astronomy. All it demands is an investment in time to record streaks of light while the earth rotates.

Capturing star trails calls for the right equipment: a camera with a "B" or time setting, a cable release, a sturdy tripod, and a great deal of time and patience. Of course, the weather has to cooperate. Clear nights provide ideal conditions for shooting star-trail pictures. You should also make sure that your location isn't susceptible to artificial-light pollution from industrial lighting or street lamps; this reduces the contrast in the image. The area you choose should contain a piece of sky that is free from air traffic. If this is impossible, you might find that the trail of light from an airliner passing through the frame can make an interesting image. The most common way to shoot a star trail is to use the North Star as the center of the photograph. On clear nights, many stars are visible in the sky. An exposure duration of several hours inevitably yields an image with circular paths of light. To achieve this effect, mount your camera on a tripod, set the shutter to "B," find a part of the sky that you want to photograph, position the camera, and focus on infinity. Then go have a sandwich, take a nap, read a book, or watch television. Whatever you do, just make sure that you close the shutter by dawn.

When you decide which lens focal length to use, keep in mind that the wider the lens, the longer the duration necessary to notice the effect. The following formula will enable you to determine the minimum duration it takes each focal length to produce a noticeable streak:

700 ÷ Focal Length = Minimum Duration In Seconds.

For example, a 28mm lens requires a 25-second exposure to record a streak (700 ÷ 28 = 25), while a 135mm lens needs only 5.2 seconds to produce a streak (700 ÷ 135 = 5.2). This effect becomes readily apparent when you use a super-telephoto lens or a telescope. A 2000mm focal length produces a streak almost immediately, at 1/3 sec. These exposure durations reflect the minimum time needed to capture a star trail. The circular effect, with its long streaks of light, takes several hours to record on film.

When you collect light on film, you are, in essence, manipulating the universe. Arbitrary elements, such as fireworks, automobile light trails, and star motion, create original, one-of-a-kind photographic images. The expanse of time and motion are collected on a single frame of film, which constitutes a departure from the reality-based world photography is usually associated with.

Capturing star trails often requires exposure times of several hours. In this length of time, even the darkest areas of a scene are exposed. For the first shot in this sequence, I held the shutter open for as long as it took to expose the scene with four pops of flash (above). For the second shot, I once again used four pops of flash, but I let the shutter stay open for 2 hours in order to record star trails (right). I might not have needed to use flash, but there is detail throughout the scene. The treetop on the left side isn't noticeable in the first image, but it is clear in the second. I made both shots with my Canon EOS-1 and a 20–35mm zoom lens. The exposure on Kodak Lumière was 2 hours at *f*/5.6.

# GLOSSARY

**Aperture** The opening on a lens that controls the amount of light that enters the lens and reaches the film. On most lenses, aperture control is variable. The numbers that represent the aperture settings are called *f*-stops. The lower the number, the more light the aperture lets into the lens. The size of the aperture determines depth of field. An aperture setting of *f*/4 allows one more stop of light to enter than *f*/5.6 does, and one less stop of light than *f*/2.8.

**Aperture diameter** The actual size of the aperture setting that has primary control over depth of field. The aperture diameter increases with focal length. A 24mm lens set at *f*/5.6 has an aperture diameter of 4.3mm, whereas a 135mm lens set at *f*/5.6 has a diameter of 24mm.

**Arc lamp** A lamp that produces light by passing an electrical discharge through two carbon rods. Its light emission is very bright and contains a large quantity of ultraviolet light.

**Artificial light** Any form of synthetic light, including high-intensity discharge lamps, fluorescent lamps, and tungsten bulbs.

**Backlighting** Illumination that originates from a position behind the subject and directly opposite the camera.

**Circles of confusion** Discs of light on the image formed from points of light on the subject. The smaller the disc is reproduced, the sharper the image. The larger the disc, the less sharp the image. If you take an out-of-focus picture of a light source, the points of light will reproduce as blurry discs on the film.

**Clip test** A test in which a portion of a roll of film is processed separately to determine if the developing time should be modified.

**Color balance** Adjustment in color photography ensuring that a neutral scale of gray tones can be reproduced accurately without a color bias.

**Color temperature** A measurement using the Kelvin scale to rate the color quality of illumination. Daylight has a color temperature of 5500K; tungsten light, 3200K; and open shade, 11,000K.

**Complementary colors** Colors of light that are opposite each other on the color wheel, such as red and cyan. When combined, complementary colors produce white light because they absorb each other's wavelength, thereby cancelling one another out. If you photograph a predominantly green scene, a magenta filter will neutralize the color cast.

**Contrast** The brightness range of a scene or the range of tones in an image. A high-contrast scene has bright highlights and dark shadows. A low-contrast scene has neither bright areas nor dark shadows; it contains middle tones. Ideally, a scene consists of a detailed shadow, a highlight area, and a range of middle tones.

**Conversion filter** A color filter that enables a daylight-balanced film to accommodate a tungsten light source, and a tungsten film to be used in daylight.

**Depth of field** The distance between the nearest and the farthest points of the subject, where everything is recorded with acceptable sharpness.

**Diffusion filter** A supplementary filter that softens the image by scattering the light rays that pass through it.

**Exposure** A combination of the intensity of light and the length of time it sensitizes the film.

**Exposure meter** A handheld device that measures the light value of a scene.

**Fill light** Light directed into shadow areas to reduce the lighting ratio and show detail.

**Film speed** The rating of a film's sensitivity to light, which is indicated by the film's ISO number.

**Fisheye lens** A 7.5mm or 15mm wide-angle lens that has a field of view of 180 degrees. Because fisheye lenses have the shortest focal lengths of all the lenses, they offer maximum depth of field.

**Flare** Unwanted light reflection that scatters into the lens and causes a loss of contrast. Flare can ordinarily be avoided via the use of a lens shade.

**Flash** A portable, electronic light source that emits a brief burst of light. Electronic flash devices can be as simple as a flash bulb or as complex as the automatic flash units used on cameras.

**Focal length** The distance from the lens to the focal plane when the lens is focused at infinity. The longer the focal length of a lens, the greater its magnification power. Measured in millimeters, focal length is determined by multiplying the width of the lens barrel by the distance of the rear element from the film plane.

**F-stops** The numbers on a lens that indicate aperture settings. They're determined by dividing the lens' focal length by the diameter of the aperture. If the aperture diameter of a 100mm lens is 9mm, the *f*-stop will be *f*/11.

**Gelatin**   A natural protein made from animal fat used as the transparent medium that holds the light-sensitive silver halides in suspension, thereby creating film emulsion.

**Gray card**   A neutral-color piece of cardboard with an 18-percent reflectance. A gray card's artificial medium tone is used to measure the light reflecting off the subject in order to determine exposure.

**Graduated filter**   A half-clear filter that gradually transforms into a neutral-density or color filter and is used to balance conflicting light values in a scene.

**High-intensity discharge lamps (HIDs)**   Light sources that produce illumination by passing an electrical charge through a vapor or gas instead of a tungsten wire. HIDs, which constitute most of the light sources found at night, include sodium-vapor, mercury-vapor, and multivapor lights.

**Highlights**   The brightest parts of the subject.

**Hyperfocal distance**   The closest distance that can be rendered sharply when the lens is focused on infinity. The aperture diameter of the focal length and the distance are variables of hyperfocal distance.

**Incandescent light sources**   These light sources are among those that produce light as a by-product of heat, such as sunlight, candlelight, and tungsten bulbs.

**ISO**   A rating that indicates a film's speed, as well as its sensitivity to light. The higher the ISO number, the more sensitive the film is. An ISO 400 film is faster than an ISO 100 film.

**Kelvin**   A unit of measurement used to indicate the color temperature of a light source.

**Lens extender**   A supplementary device that is mounted between the lens and the camera to increase the magnification of a lens. The most common type is a 2X multiplier, which doubles the focal length and the maximum aperture. When a 135mm F2.8 lens is fitted with a 2X extender, it effectively acts like a 270mm F5.6 lens.

**Macro lens**   A high-quality lens with an extended focusing range, making it possible to reproduce a subject in a 1:2 to 1:1 ratio (depending on the lens) without the use of auxiliary equipment.

**Mercury-vapor lamp**   A high-intensity discharge lamp that produces light when an electrical discharge passes through mercury gas. It emits a greenish quality of light and is used for outdoor illumination.

**Monopod**   A one-legged device that is used to steady the camera, which is mounted on its head and can be tilted and swiveled. It is especially useful for sports and concert photography, as well as for situations that don't require timed exposures, because it dampens only vertical motion, not side motion.

**Multivapor lamp**   A high-intensity discharge lamp that produces light by passing an electrical charge through a composite gas in a glass envelope coated with phosphors to create the illusion of a full-color spectrum. Multivapor lamps range in color temperature from 3200K to 5500K and are used for stadium lighting.

**Negative**   An image with tones that are the exact opposite of those in the subject. A negative requires a second step to create a positive. The image's contrast and density can be manipulated during the printing process. Negative, or print, films offer a wider exposure latitude than transparency, or slide, films do.

**Neutral-density filter**   A colorless filter that reduces the amount of light that reaches the film without changing the color or quality of light.

**Optical axis**   An imaginary line that goes through the center of the lens. Light rays passing through this axis always travel in a straight line.

**Overexposure**   A problem that arises when the film's emulsion receives too much exposure to light. Negative film becomes dark when it is overexposed, and transparency films become lighter.

**Perspective**   The impression of depth that results when a three-dimensional scene is represented by a one-dimensional object. You can alter perspective by magnifying the image and changing the camera-to-subject distance.

**Photoflood**   A type of lamp that uses a tungsten filament and a dish reflector. It has a slightly cooler color temperature (3400K) than an ordinary tungsten bulb.

**Quartz lamp**   A term for a lamp that uses a tungsten–halogen filament.

**Reciprocity**   The balanced relationship between the duration (shutter speed) and the intensity (aperture setting) of an exposure. The same amount of light strikes the film whether you double the exposure time and halve the light intensity, or double the light intensity and halve the exposure time. For example, an exposure of $f/8$ for 1/8 sec. is the same as an exposure of $f/11$ at 1/4 sec.

*Reciprocity failure*   The point at which film response becomes unpredictable. When exposure is 1 second or longer, the silver halides in the film emulsion aren't processed at the same rate, resulting in underexposure. With color films, long exposure times produce a dominant color cast because the film's three layers aren't being exposed equally.

*Shadow area*   The darkest part of the scene that maintains detail.

*Shutter*   The mechanism that opens and closes the lens, thereby determining the duration of exposure, usually in one-stop increments: 1/15 sec., 1/30 sec., 1/60 sec., etc. These shutter speeds are indicated on a dial located on the top of the camera.

*Sodium-vapor lamps*   A high-intensity discharge lamp that produces color by passing an electrical charge through vaporized sodium. It emits a yellowish light.

*Spot meter*   A meter that reads a very small section of a scene. This can be as narrow as 1 degree. Spot meters come in two varieties, handheld and in-camera.

*Telephoto lens*   A lens whose increased magnification provides a close view of distant objects. Telephoto lenses range from 70mm to 200mm. Lenses with focal lengths that exceed 200mm are called super-telephoto lenses.

*Transparency*   A positive image produced on a transparent material. Transparencies are commonly called slides. Slide film has less exposure latitude than negative, or print, film.

*Tungsten-balanced film*   A type of film that is specially balanced to properly reproduce color under a tungsten light source.

*Tungsten light source*   An incandescent light source that uses a tungsten filament contained in a glass envelope. It produces light at a color temperature of 3200K.

*Underexposure*   The result of too little exposure to light. An underexposed negative is light and lacks detail, while an underexposed transparency is dark and has some detail.

*Visible spectrum*   The wavelengths that human vision can see as light, ranging from 400 to 700 nanometers and producing a full spectrum of colors from violet to red.

*White light*   The continuous spectrum of all the visible wavelengths. When these wavelengths are separated, the results are seen as color. Equal amounts of red, green, and blue light form white light.

*Wide-angle lens*   A lens with an expanded angle of view. Wide-angle lenses range from the 7.5mm (circular-image) and 15mm (full-frame) fisheye lenses with their 180-degree views to the moderate 35mm lens.

*Zoom lens*   A single lens consisting of several focal lengths, such as 35–80mm and 70–200mm.

# INDEX